Turn Simple Shapes into Cool Cartoons

24 Step by Step Tutorials

By

Diane Bell

Version 1.0 – 2019

COPYRIGHT

All rights reserved, including the right of reproduction in whole or in part in any form.

Contents

COPYRIGHT .. 2

DEDICATION ... 5

INTRODUCTION ... 6

WHAT YOU'LL NEED ... 7

ANIMALS .. 8

 Peanut the Laughing Elephant 9

 Sid the Skateboarding Tiger 13

 Fang .. 19

 Crime Fighting Cat .. 23

 Dog Pooped ... 27

 Paula the Waving Penguin 31

 Art the Bear ... 35

 Guilty Cat ... 41

 Monkey Business ... 45

 Bella the Bunny ... 49

 An Elephant and Her Peanut Butter 53

 Max the Mouse .. 67

 Buttercup the Cow .. 57

 Gary the Gator .. 61

 Moe the Lion .. 67

PEOPLE .. 76

 Nervous Nick ... 77

 Fred .. 81

 Big Benny ... 85

 Moody Meg .. 89

 Hello from Henry .. 93

 Singing Sara .. 101

 Cici the Fortune Teller ... 105

 Steamed Stan .. 111

 Messy Mike .. 115

A FINAL WORD...or two ... 121

DEDICATION

This book is dedicated to my grandfather, Levite LaFrance. His favorite place in the world was in front of the TV watching cartoons. The joy those characters brought to my grandfather's face inspired me to draw. Pépé this book is for you.

INTRODUCTION

Welcome. This book is for both kids and adults - anyone who enjoys drawing cartoons. By completing the 24 step-by-step tutorials provided in *Turn Simple Shapes into Cool Cartoons,* you'll learn to see things in a funny way and improve your drawing skills.

The examples in this book, start by using simple shapes like circles, ovals, squares, and rectangles. With detailed instructions, you'll learn to turn them into cool cartoons. However, you're not limited to only these shapes. There are plenty of others to try - like an egg, peanut, or pear. Experiment with them all. Each one will give your character a fresh look and help you develop your own style.

Basic shapes also make things like hands easier to draw. I've included a few characters with hands, so you'll have a chance to practice drawing them.

Here's another added benefit I think you'll like. Drawing cartoons is fun and can build your confidence. It won't be long before you're eager to share your work with what I call "The Three F's" - friends, family, and Facebook (or other social media sites). I share my work every chance I get. It's my way of spreading smiles.

As a final note, I'd like to offer three pieces of advice for success.

1. Have fun while practicing.
2. Have fun while practicing.
3. Have fun while practicing.

Now let's start drawing.

WHAT YOU'LL NEED

Cartoon drawing doesn't have to be expensive. All you'll need to begin, is paper, a pencil (or two) and an eraser. A pen will come in handy if you plan to ink the cartoon. That's it.

You can spend a lot of time browsing through art stores. There're so many pencils, pens, and paper to choose from. It's frustrating. My advice is to start with what you have available and build from there. By limiting your supplies, you'll master them quickly - and with less frustration. It's all about having fun.

Once you're comfortable with the basic tools, you'll want to add things. Experiment with colored pencils, markers, and artist quality paper.

ANIMALS

Peanut the Laughing Elephant

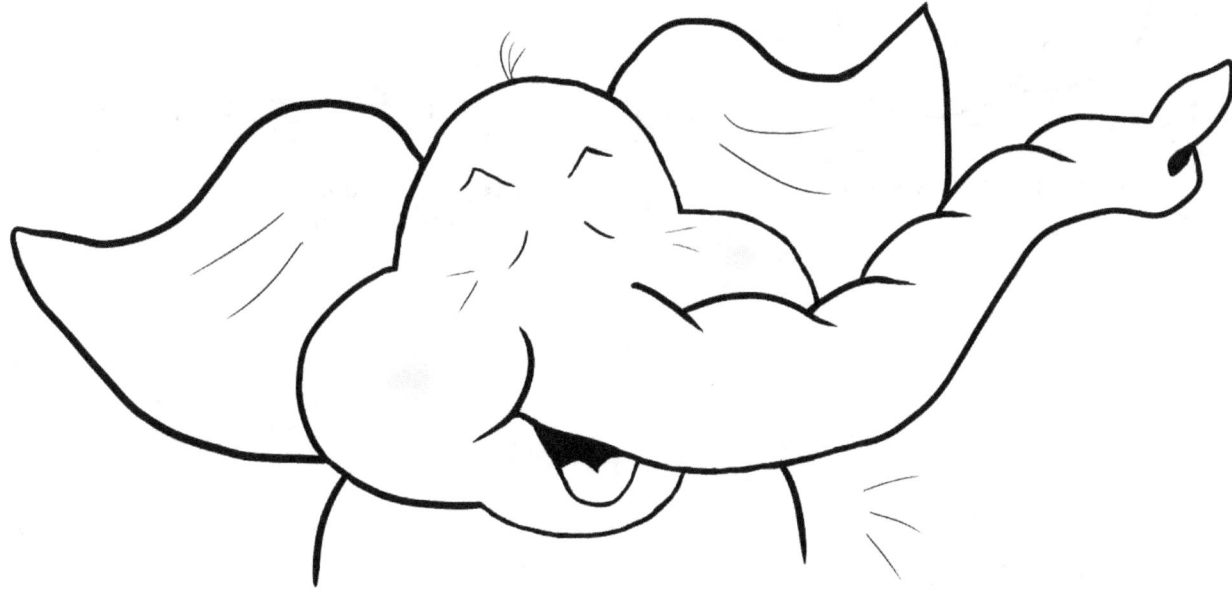

Turn Simple Shapes into Cool Cartoons

Step 1: Draw two ovals.

Step 2: Carefully erase the unwanted pencil

Step 3: Lightly sketch the guidelines where the eye, nose, mouth, and ears will go.

Step 4: Next, sketch the eyes.

Step 5: Draw the nose.

Step 6: Give Peanut a smiling mouth...

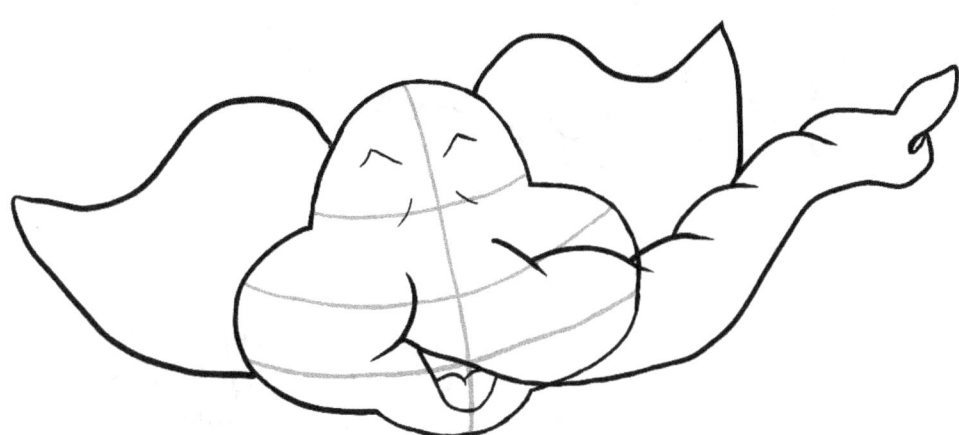

Step 7: ...and huge elephant ears.

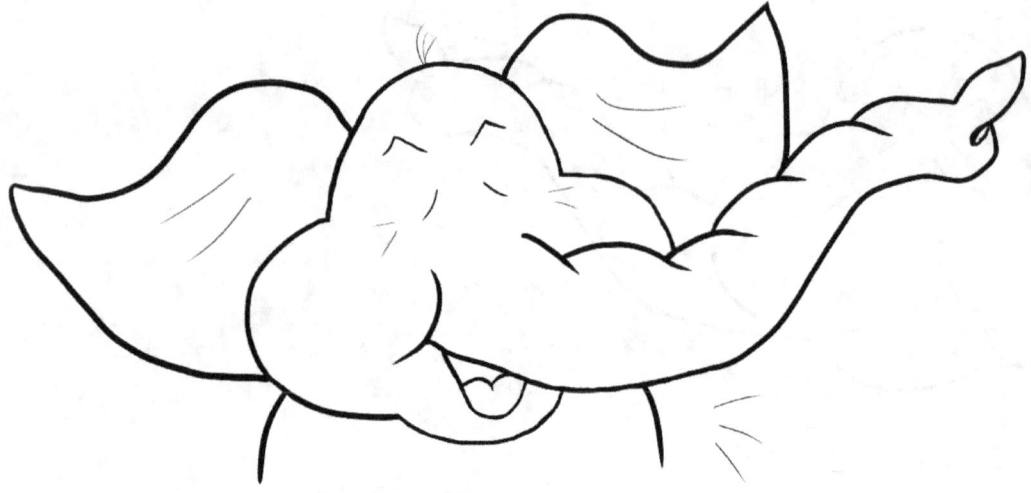

Step 8: Erase the guidelines. Add a few strands of hair, lines suggesting Peanut's body, wrinkles in his ears, and the corners of his eyes. Then, draw laugh lines on the right side of his mouth.

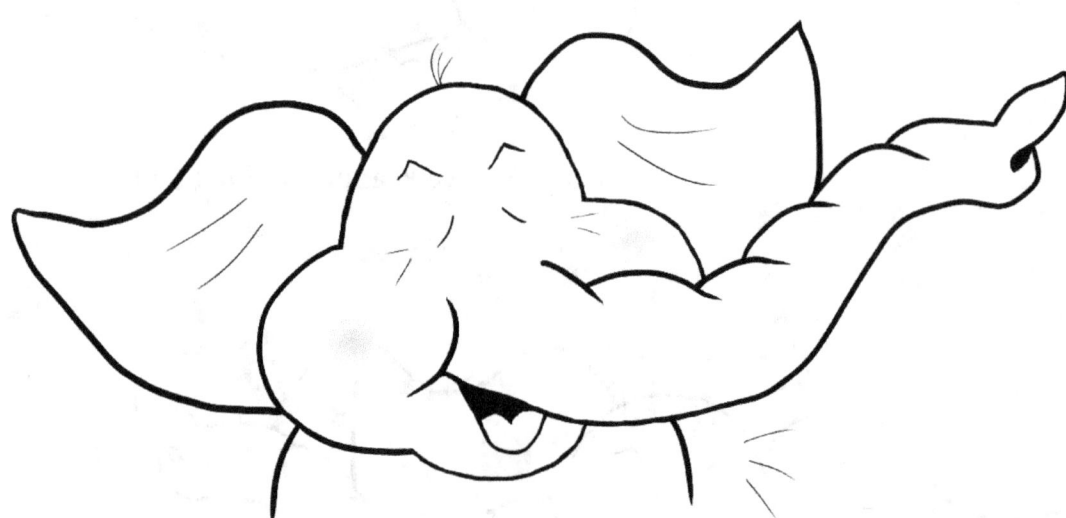

Step 9: Darken Peanut's mouth and the tip of his trunk. Shade his cheeks and you're done. Congratulations.

Sid the Skateboarding Tiger

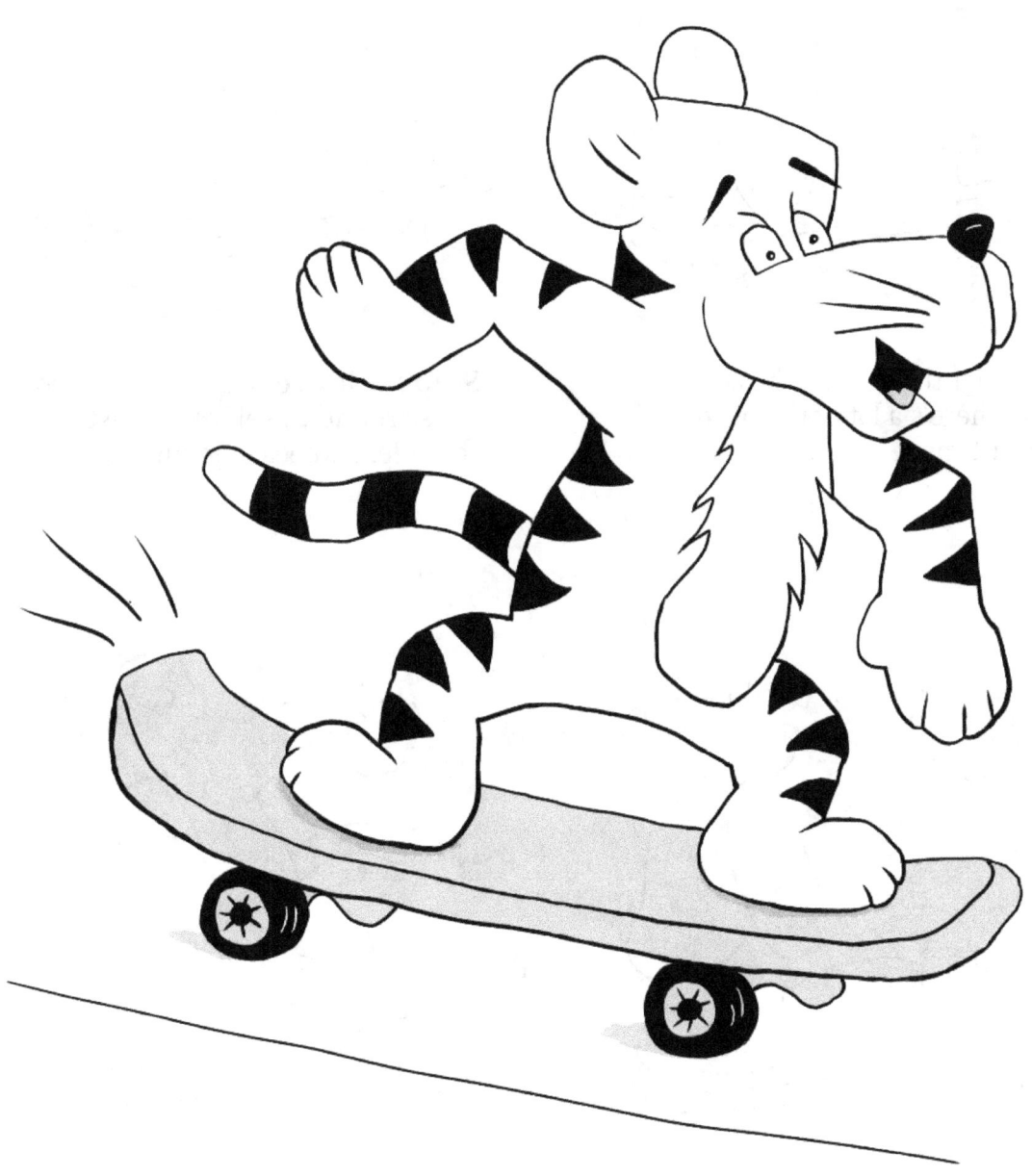

Turn Simple Shapes into Cool Cartoons

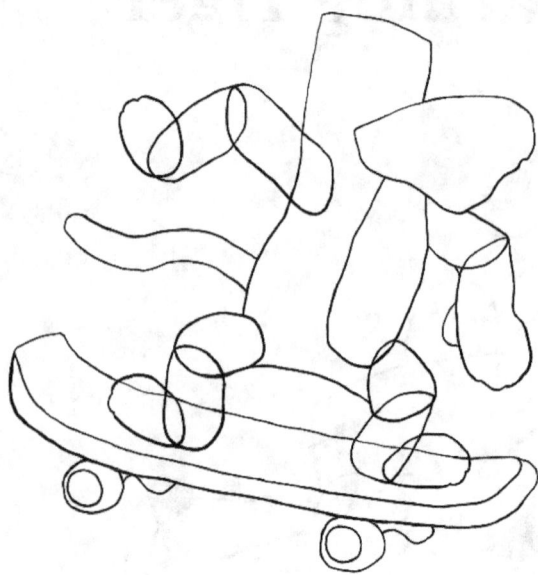

Step 1: Lightly draw the basic shapes. There's a lot of them, so take your time.

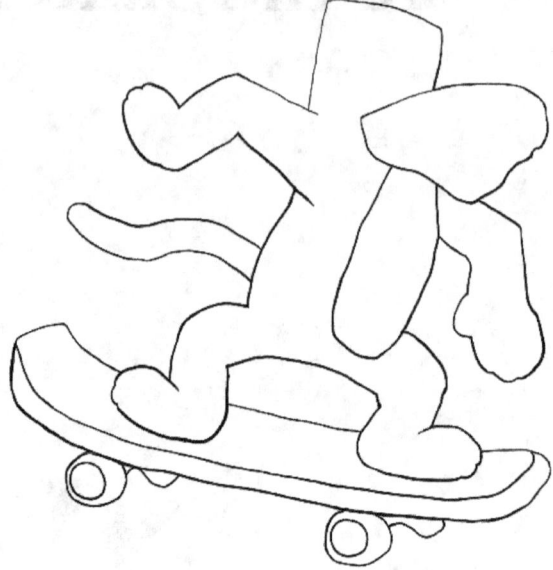

Step 2: Next, erase the unwanted lines around the elbows, wrists, shoulders, knees, and ankles.

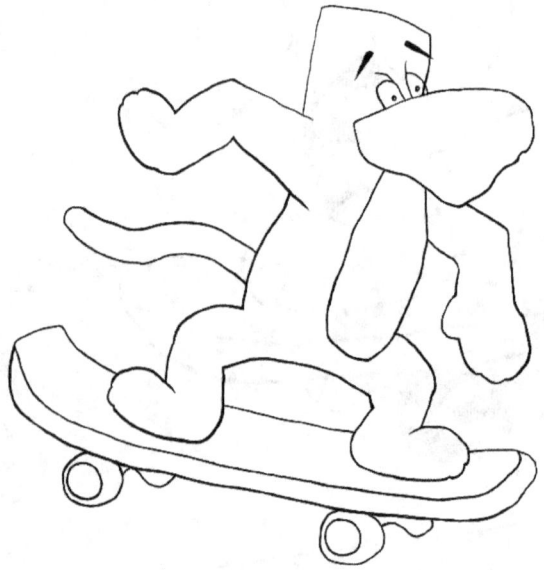

Step 3: Let's give Sid some eyes so he can see where he's going.

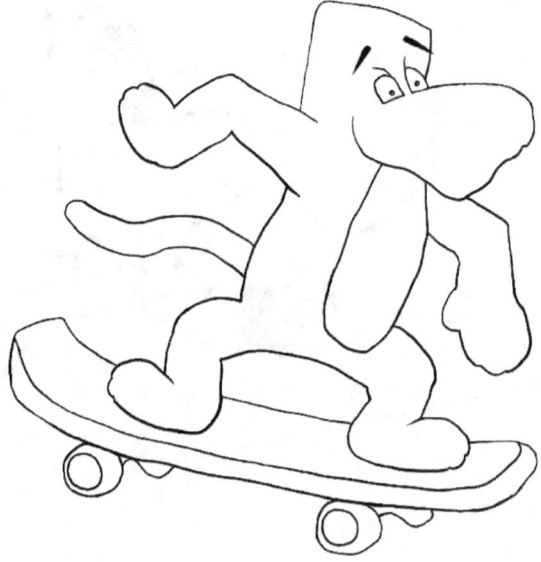

Step 4: Now we need to erase the forehead line running through Sid's left eye.

Turn Simple Shapes into Cool Cartoons

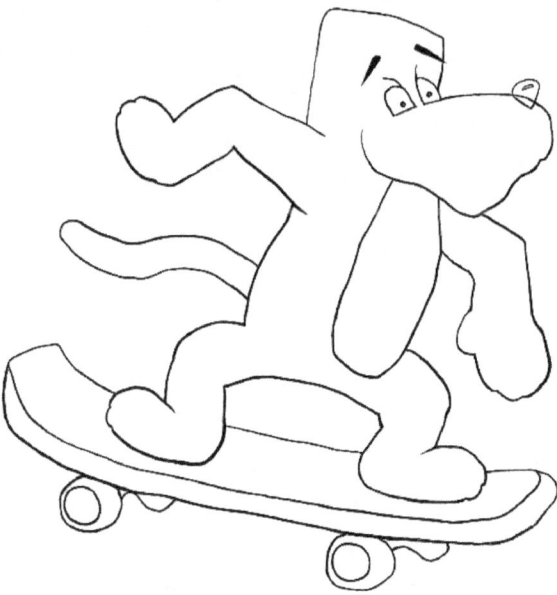

Step 5: Draw his nose.

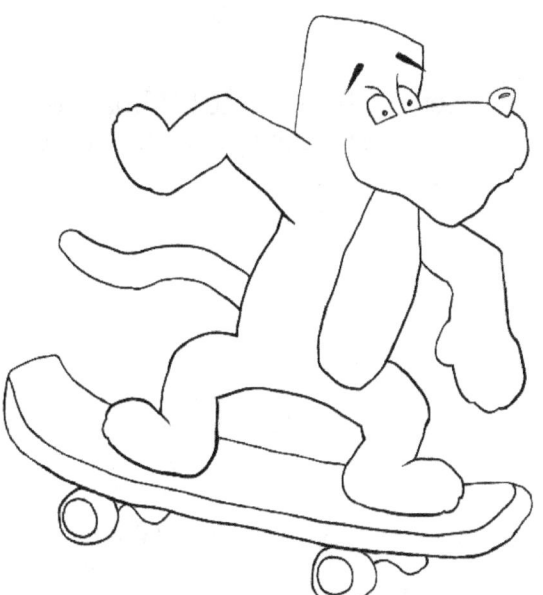

Step 6: Erase the unwanted pencil line that runs through the nose.

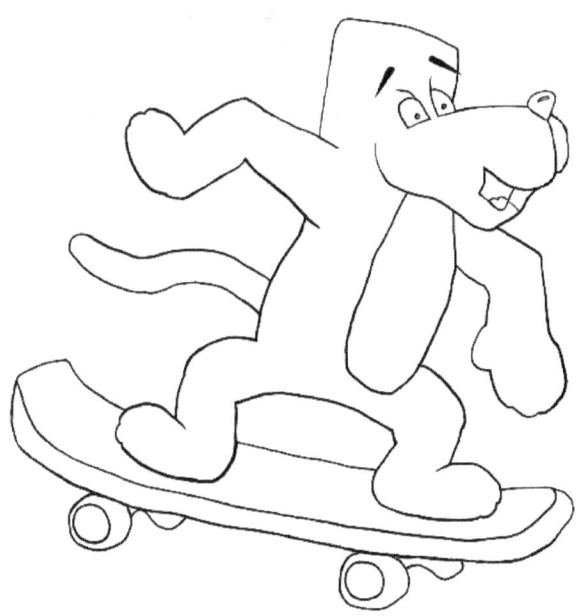

Step 7: Now draw Sid's mouth.

Turn Simple Shapes into Cool Cartoons

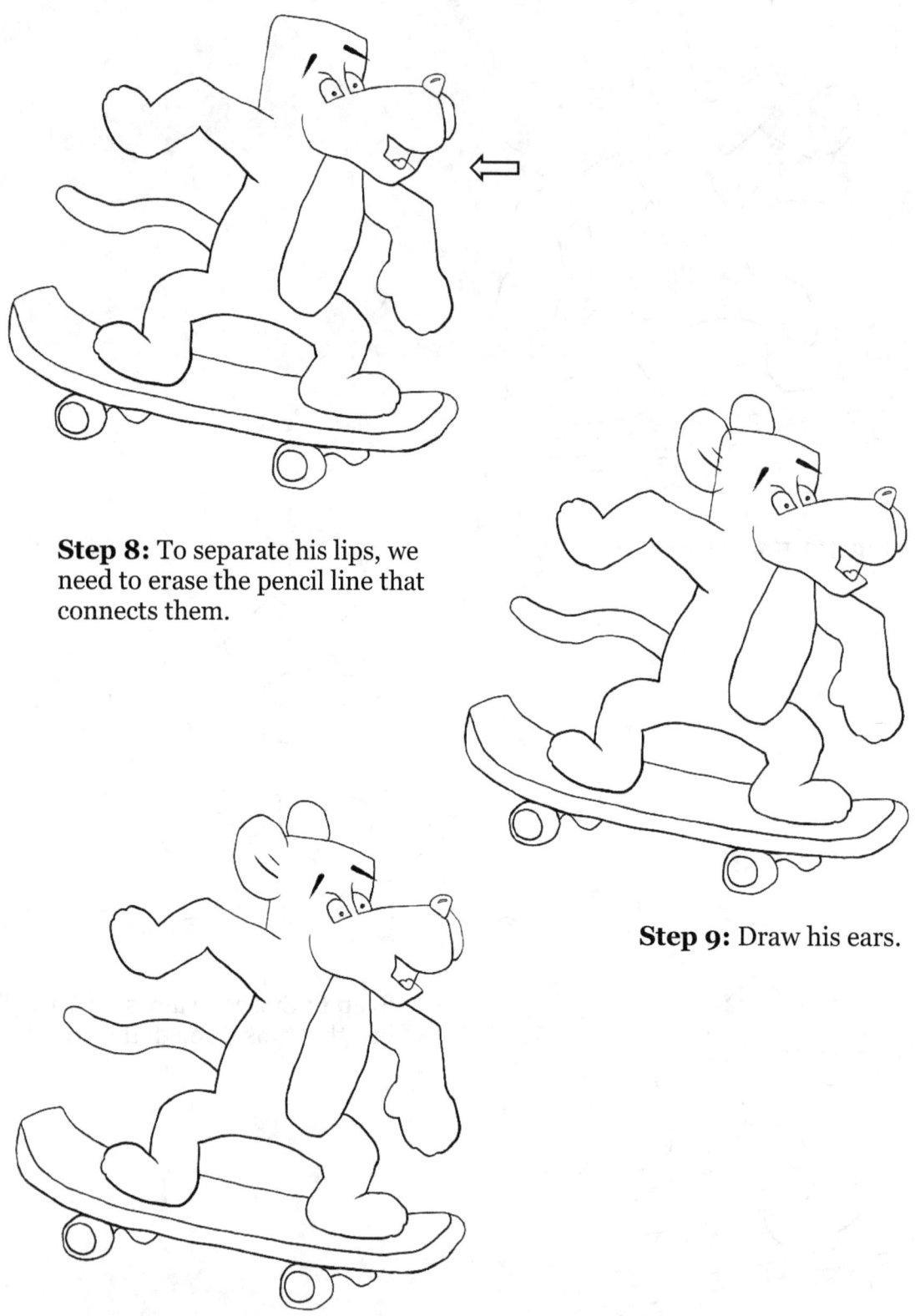

Step 8: To separate his lips, we need to erase the pencil line that connects them.

Step 9: Draw his ears.

Step 10: Then, erase the line that runs through Sid's right ear.

Turn Simple Shapes into Cool Cartoons

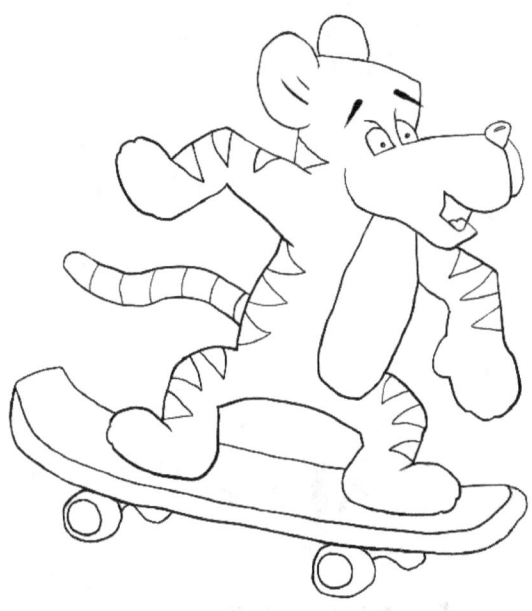

Step 11: The tiger strips come next.

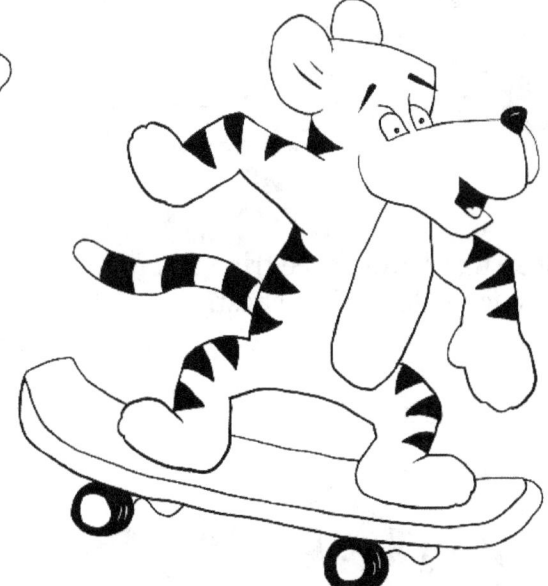

Step 12: To make Sid stand out, we need to darken the strips, nose mouth and tires.

Step 13: Shade the skateboard, hub caps, and tongue with grey.

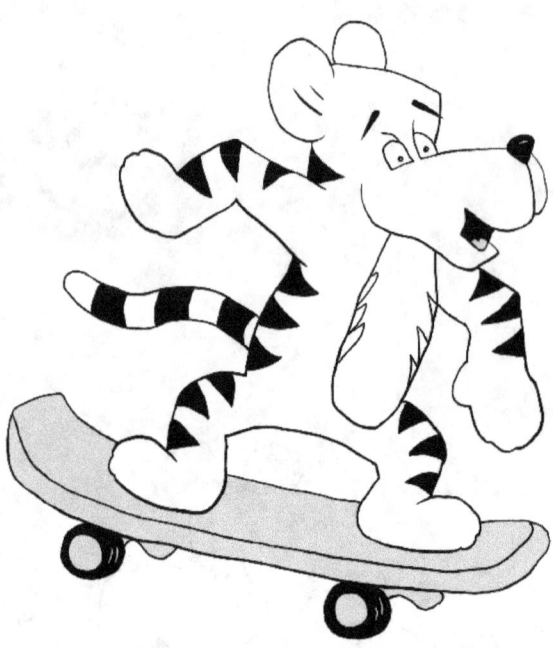

Step 14: Draw three triangles on each side of Sid's chest.

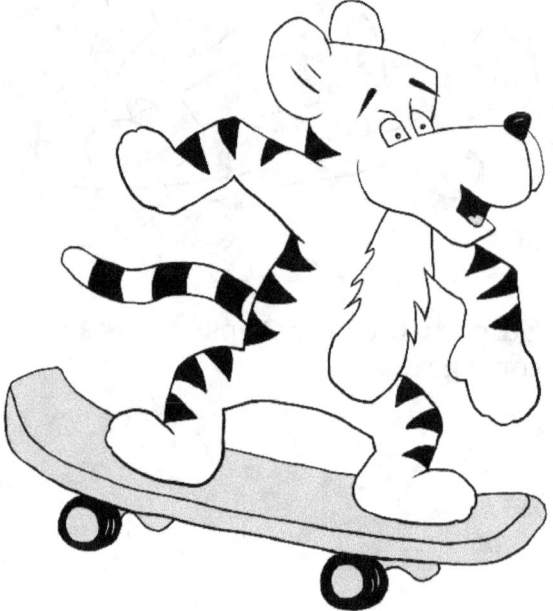

Step 15: To shape the fur, erase the stray pencil marks. Sid now has fur on his chest.

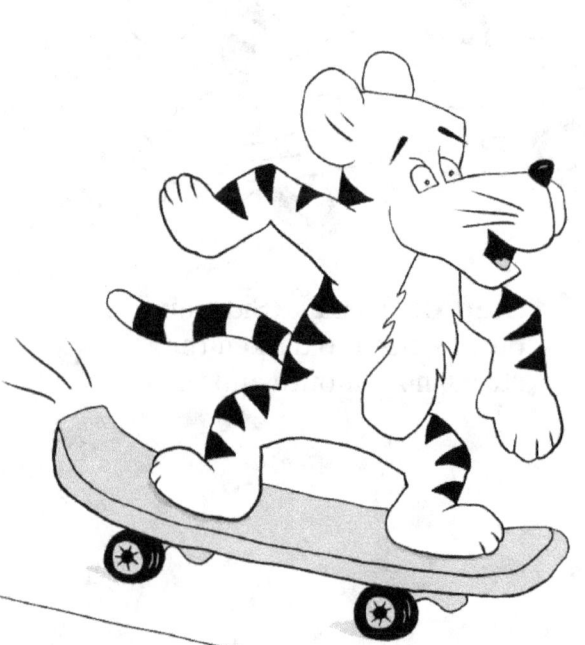

Step 16: It's all in the details. Add whiskers, lines for fingers and toes, spokes on the wheels, shade under the tires, and a line for the ground. Oh, and don't forget the motion lines behind the skateboard. Sid is going places. Congratulations! You did it.

Fang

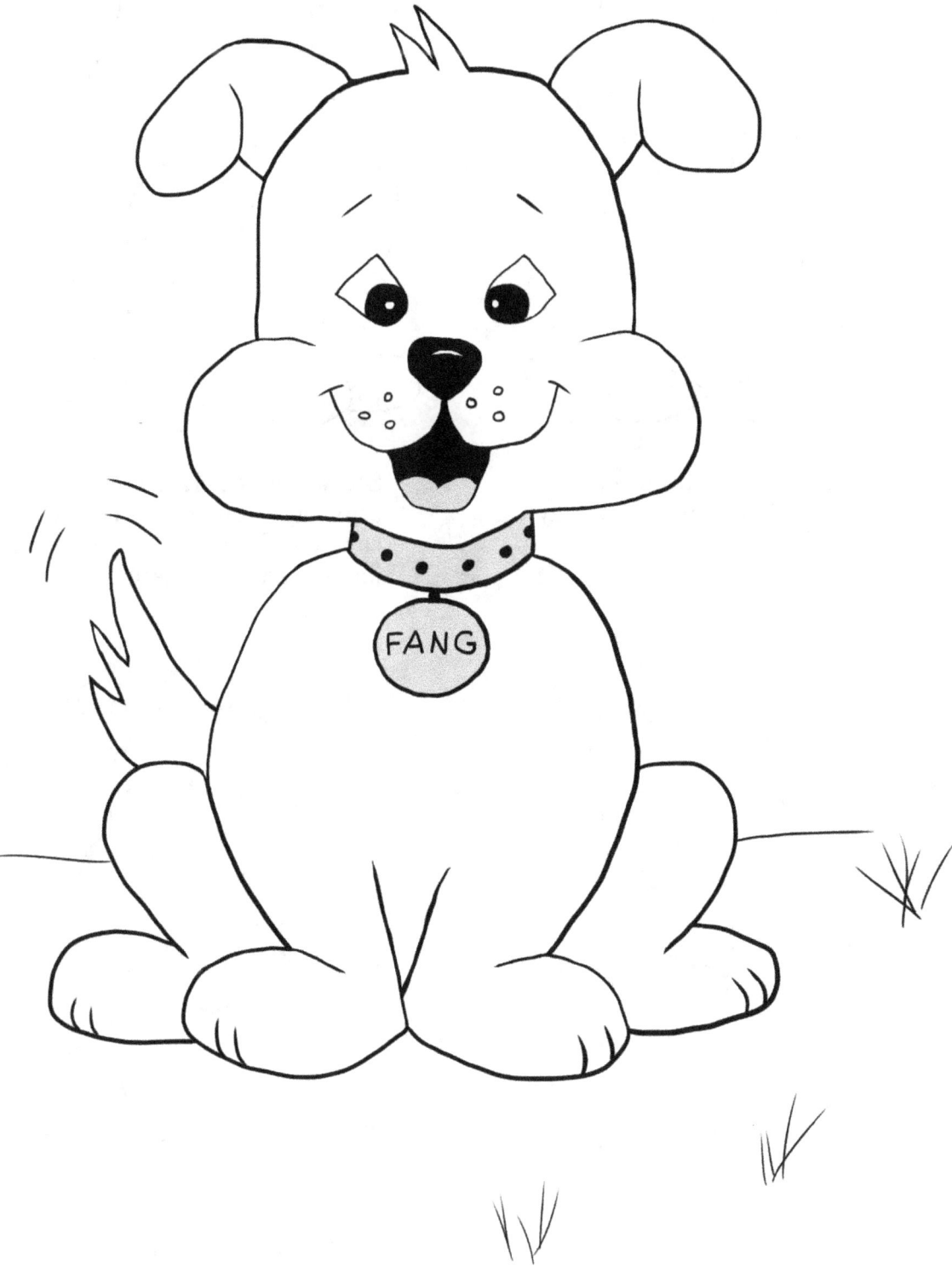

Turn Simple Shapes into Cool Cartoons

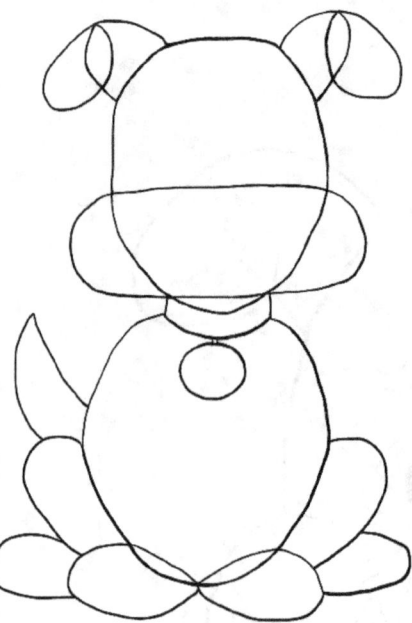

Step 1: Lightly draw the outline shapes of Fang's body.

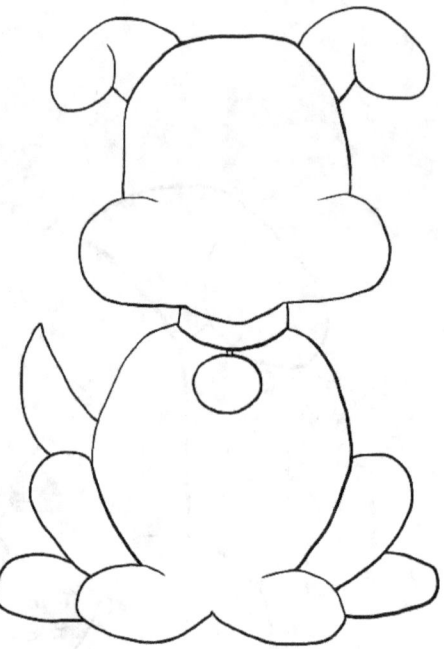

Step 2: Next, erase the unwanted pencil lines on the ears, cheeks, and paws. This will join the shapes together.

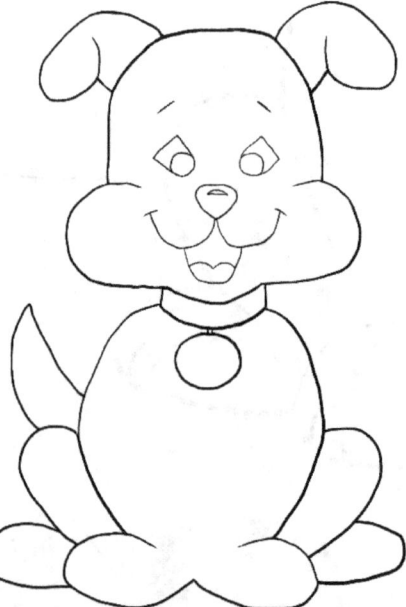

Step 3: Time to give Fang some eyes, a nose, and a mouth.

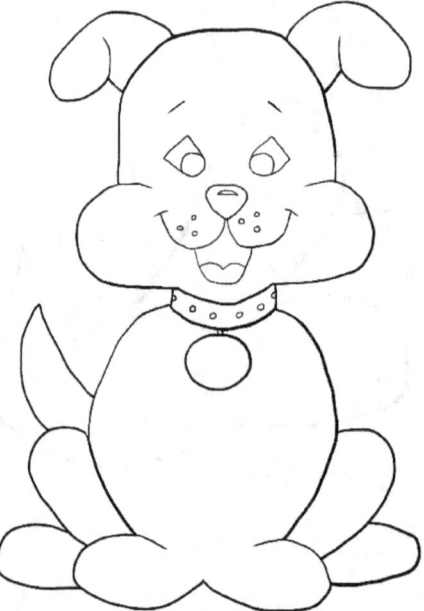

Step 4: Draw small circles on Fangs muzzle and collar.

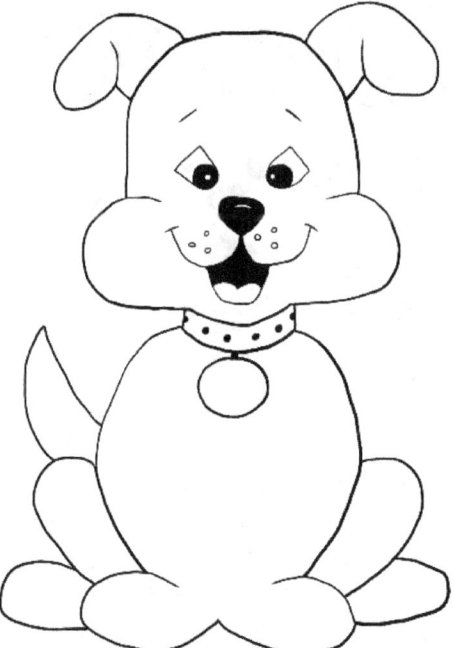

Step 5: Darken Fang's eyes, nose, and mouth. This will make his face pop right off the page.

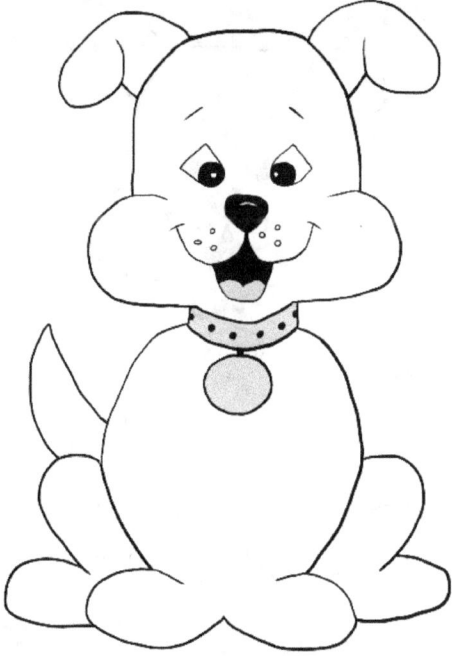

Step 6: Shade his tongue, collar, and dog tag with gray.

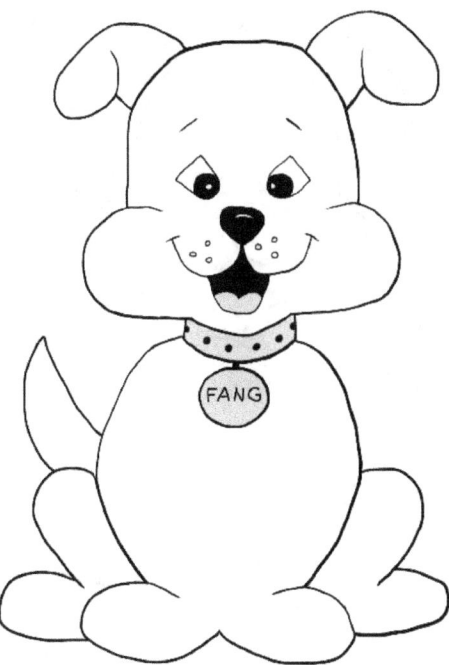

Step 7: Add Fang's name to his dog tag.

Turn Simple Shapes into Cool Cartoons

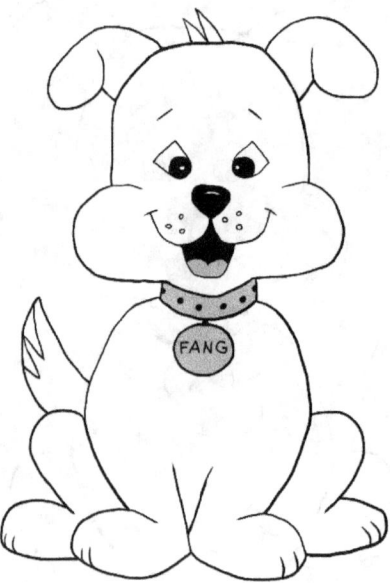

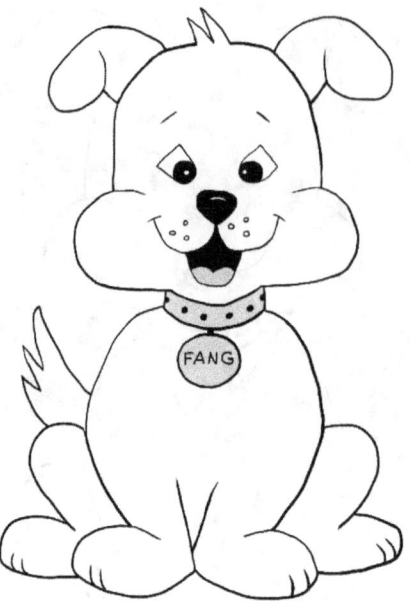

Step 8: Now draw detail lines for his toes and for the fur on his head and tail.

Step 9: To shape the fur, erase the unwanted pencil lines around the clumps of fur on head and tail.

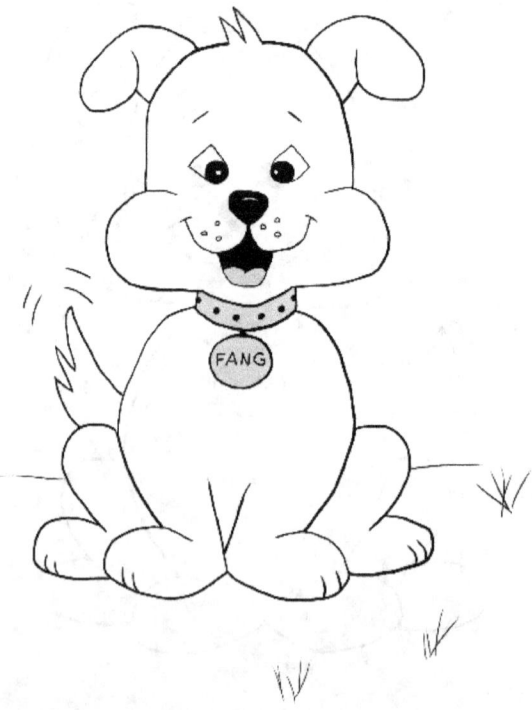

Step 10: Give Fang a horizon line behind him, grass to sit in, and "tail wagging" lines. You're done. He wants a snack.

Turn Simple Shapes into Cool Cartoons

Crime Fighting Cat

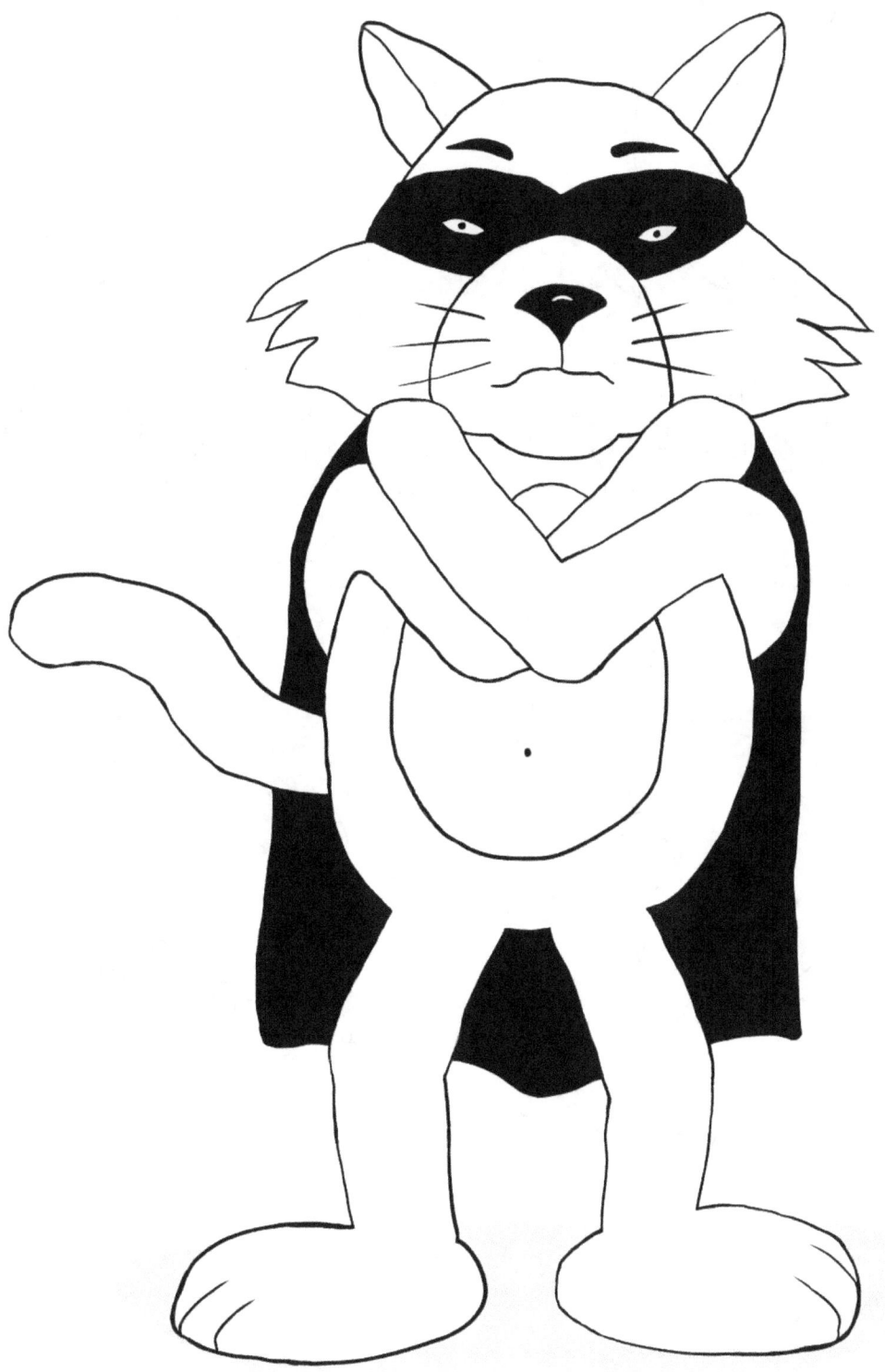

Turn Simple Shapes into Cool Cartoons

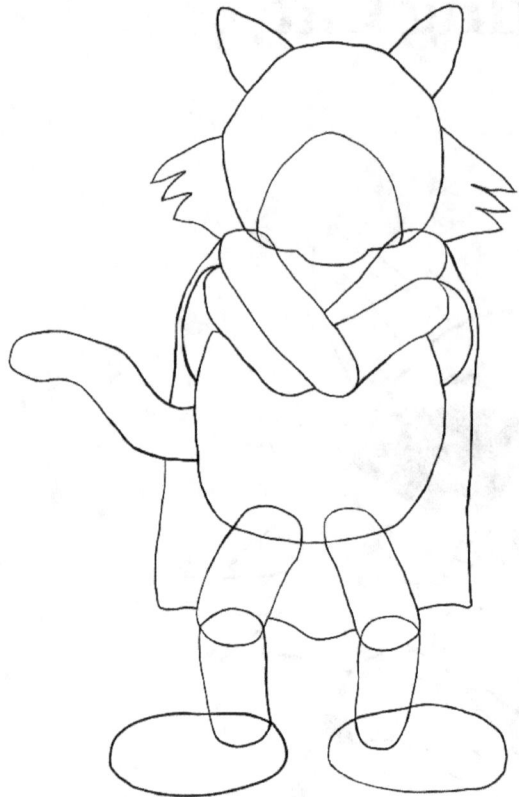

Step 1: Lightly draw the basic shapes.

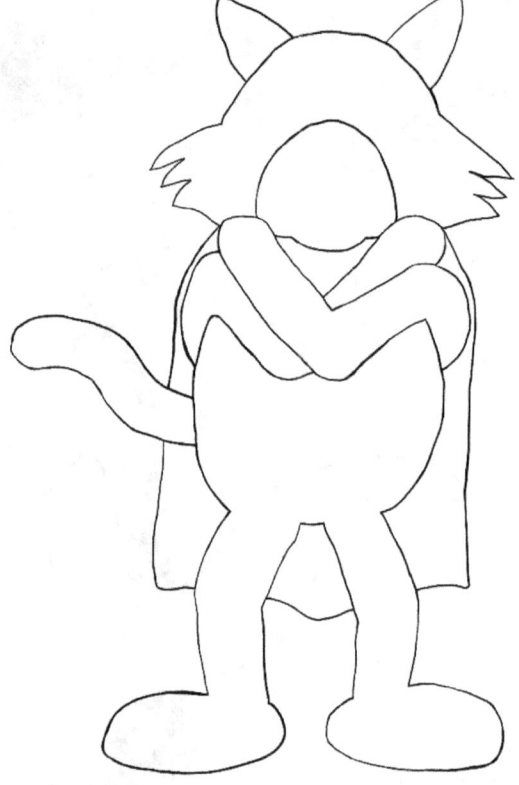

Step 2: Clean up all the unwanted pencil marks. These include where the joints, cheeks, and chin meet the cat's body.

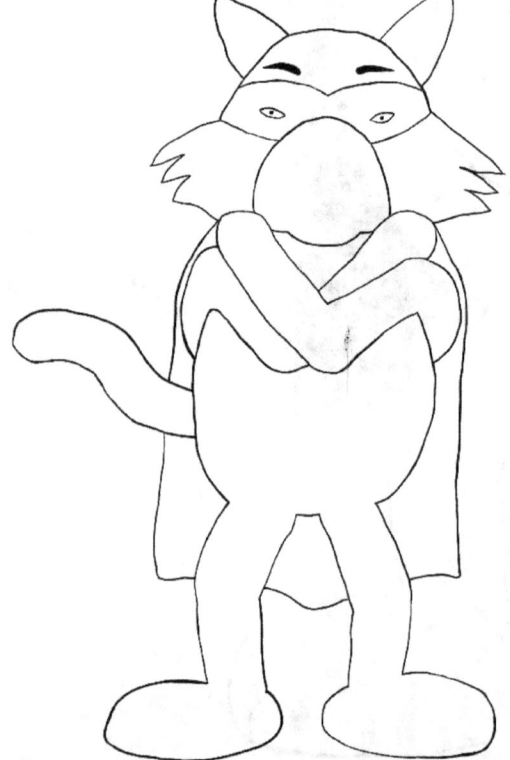

Step 3: Add the eyes, eyebrows, and mask.

Turn Simple Shapes into Cool Cartoons

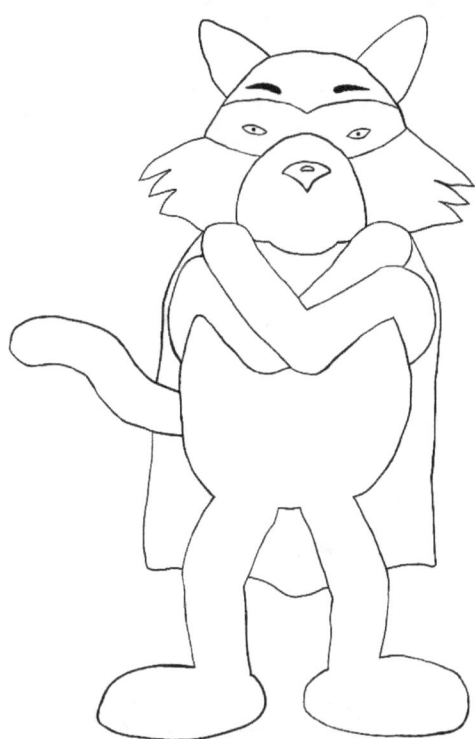

Step 4: "Crime Fighting Cat" can smell crime from a mile away. So, let's not forget to give him a nose.

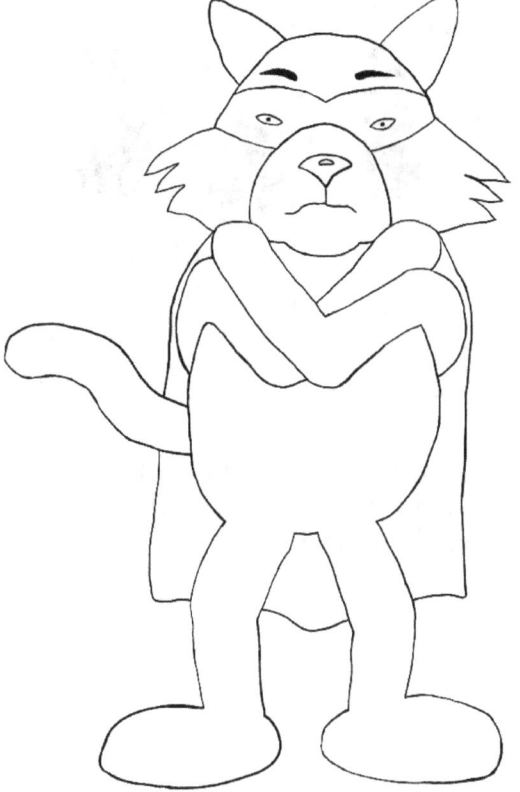

Step 5: Then, draw an expressive mouth.

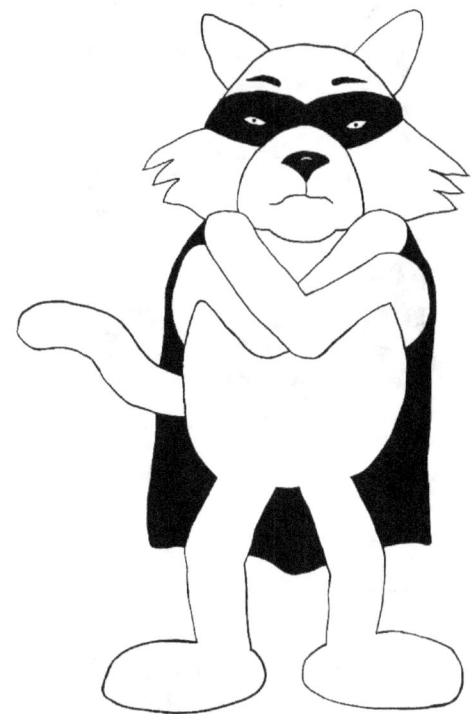

Step 6: Darken his nose, mask, and cape. "Crime Fighting Cat" is looking good.

Turn Simple Shapes into Cool Cartoons

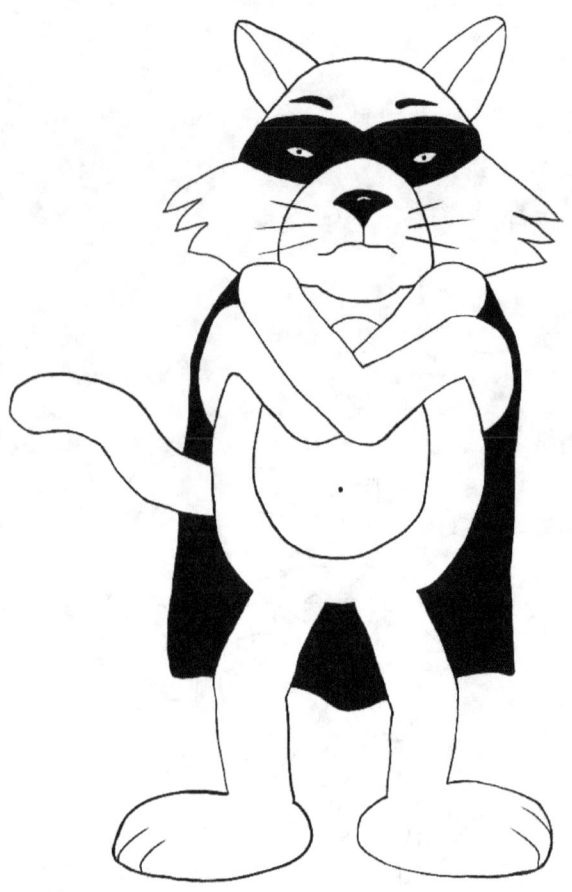

Step 7: Now, add details like whiskers, toes, and a belly button.

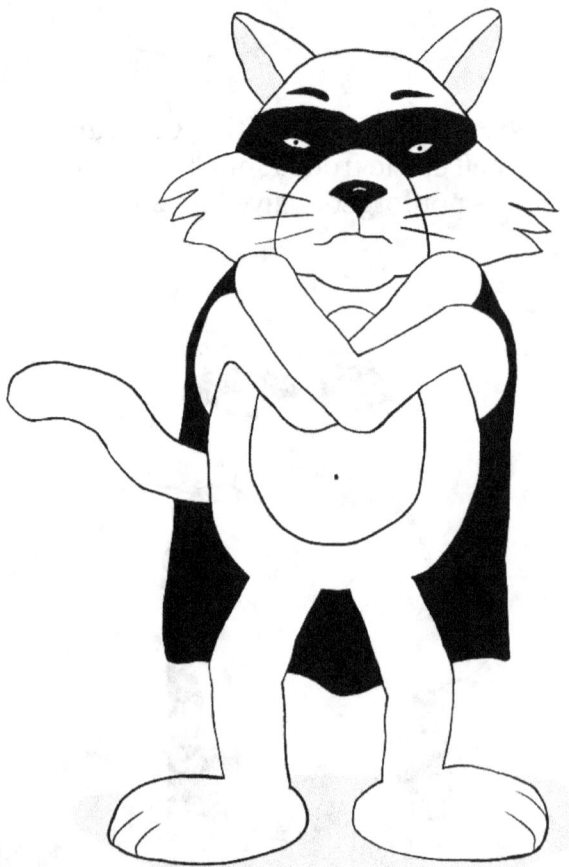

Step 8: Shade his ears and add some ground to stand on. You're done.

Dog Pooped

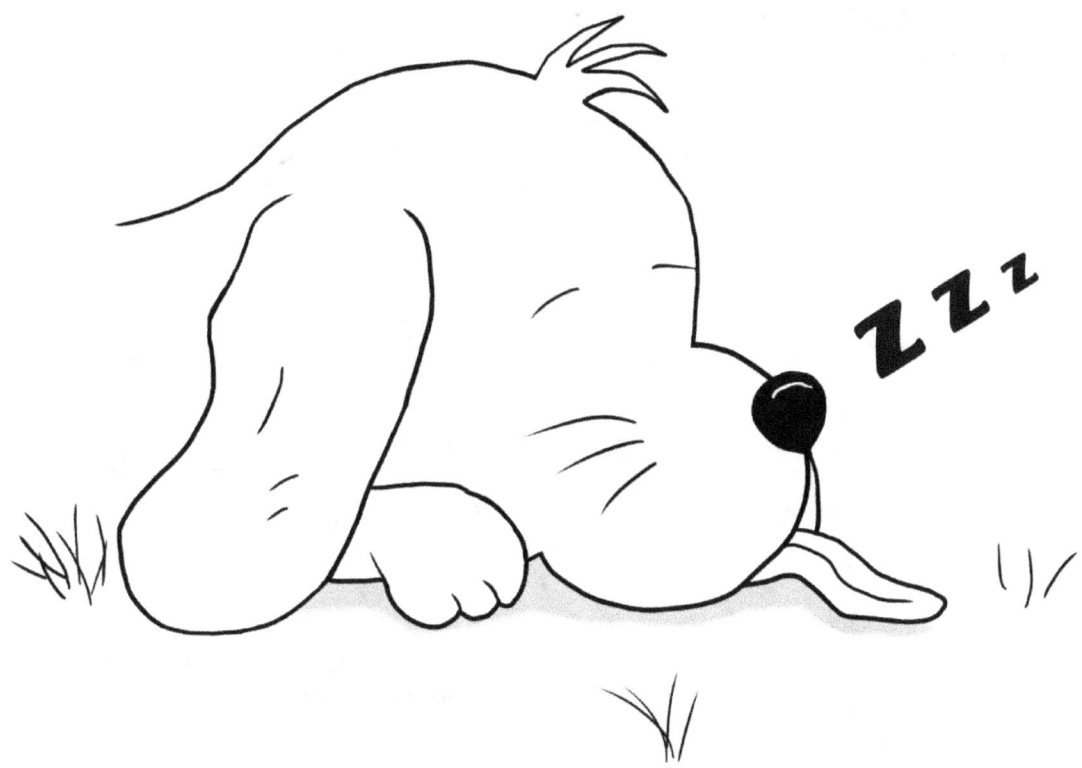

Turn Simple Shapes into Cool Cartoons

Step 1: Start by drawing the basic shapes of the dog.

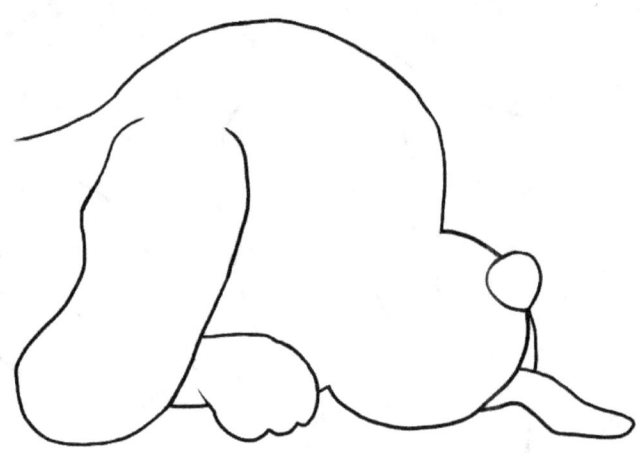

Step 2: Erase all the unwanted pencil marks.

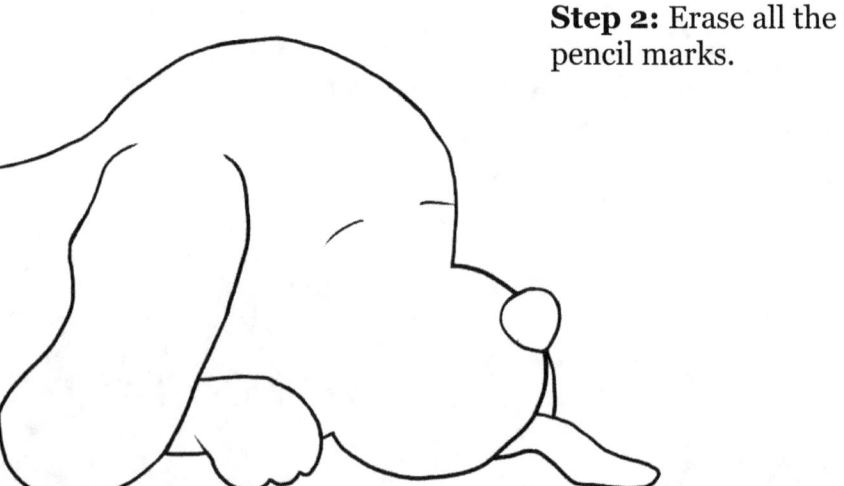

Step 3: Next, draw the eyes.

Turn Simple Shapes into Cool Cartoons

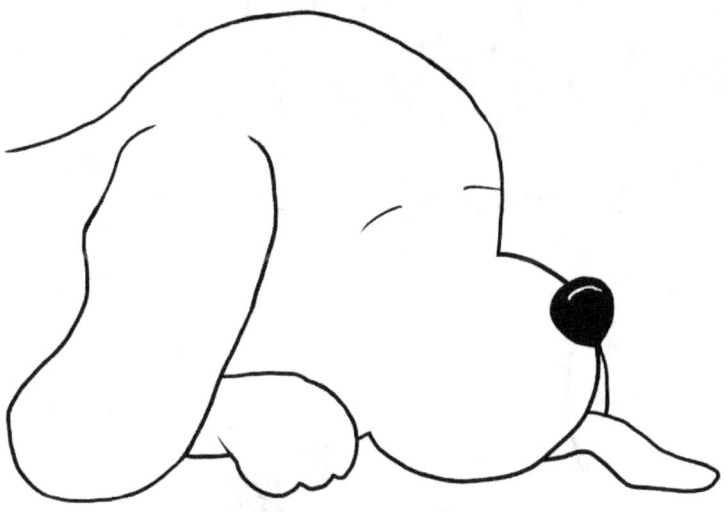

Step 4: Darken his nose. Don't forget to leave a white highlight on the dog's nose. This will make it look shiny and wet.

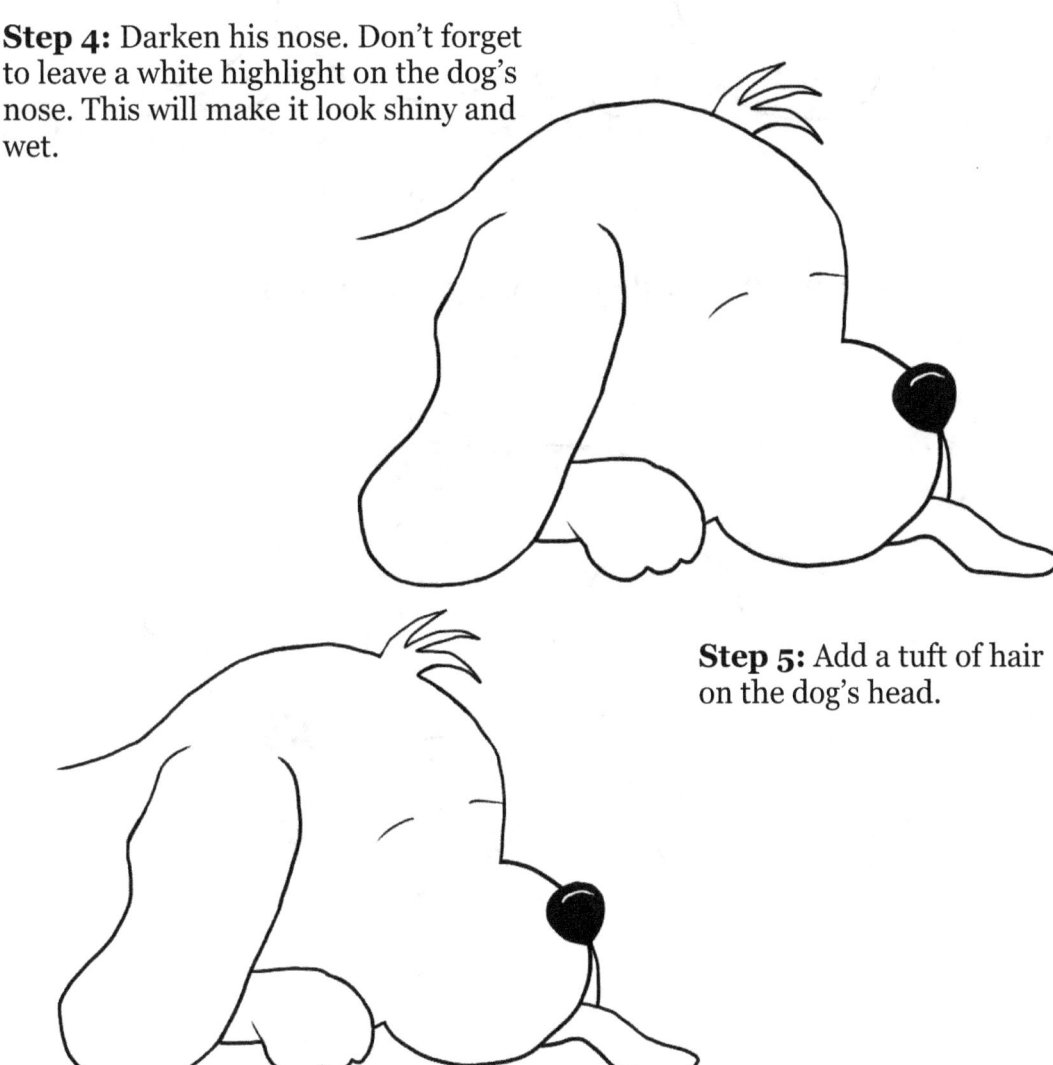

Step 5: Add a tuft of hair on the dog's head.

Step 6: Now, erase the unwanted pencil mark that separates the tuft of fur from the dog's head.

Turn Simple Shapes into Cool Cartoons

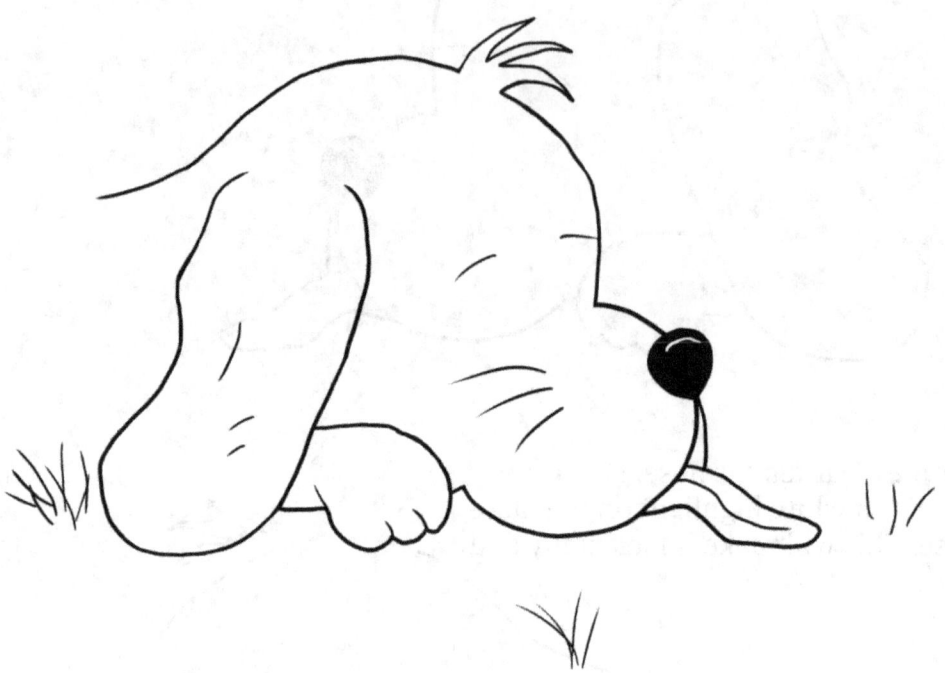

Step 7: Let's give the dog some grass to rest his tired head.

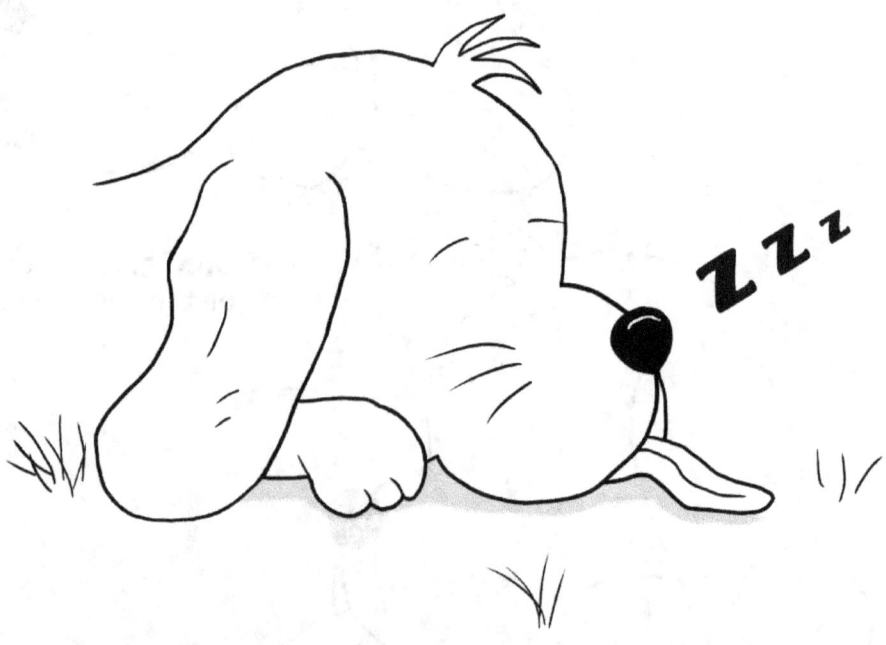

Step 8: Create shading underneath the dog. Add some Z's to show he's snoring, and you're done.

Paula the Waving Penguin

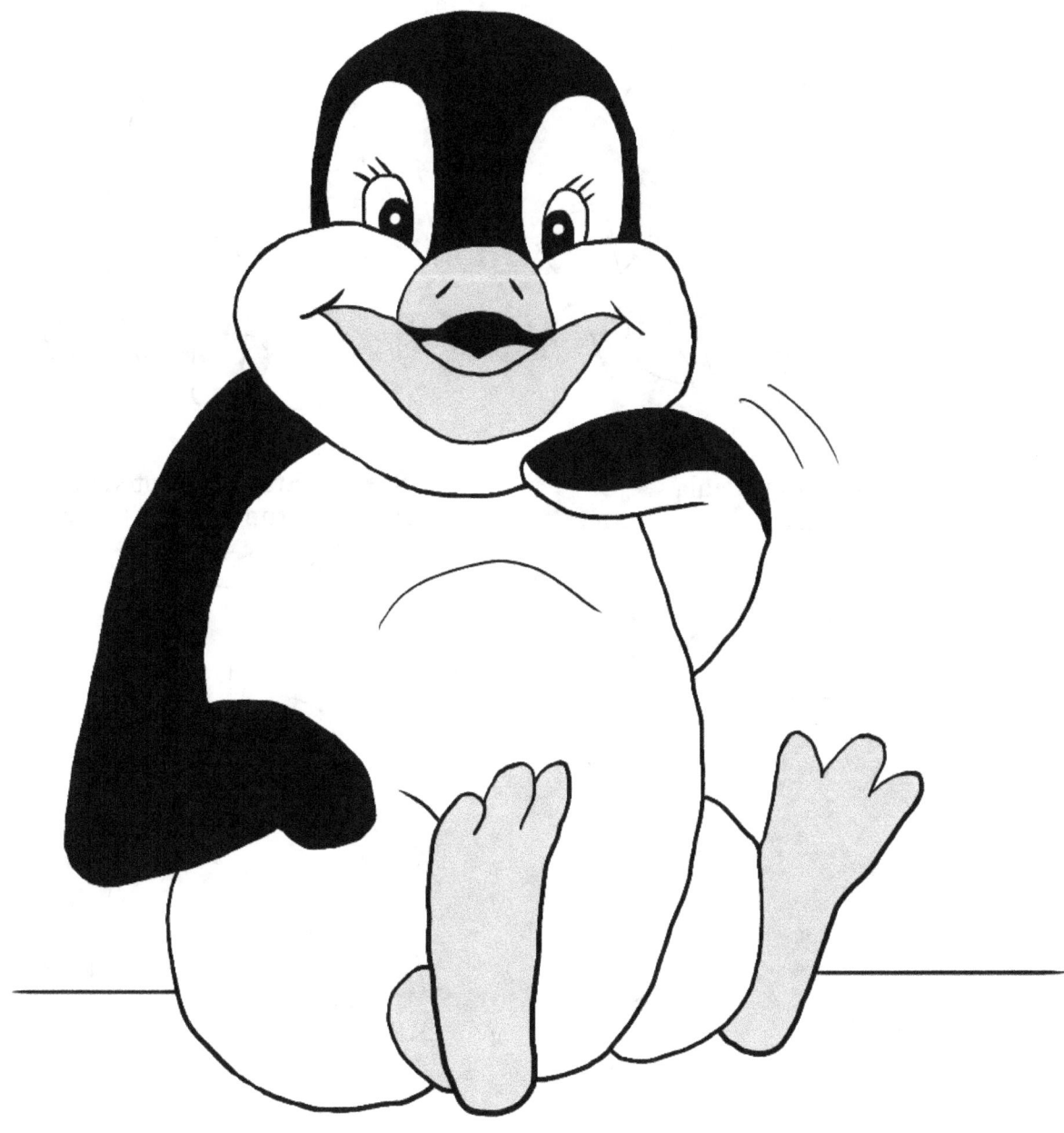

Turn Simple Shapes into Cool Cartoons

Step 1: Draw Paula's basic shapes.

Step 2: Erase unwanted pencil lines that run through her left and right flippers.

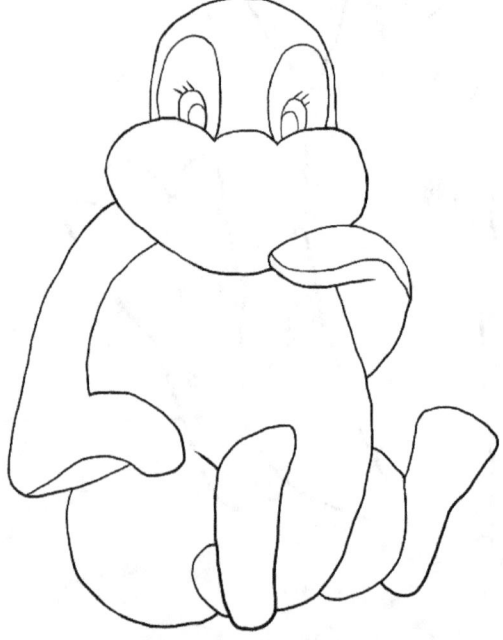

Step 3: Let's give Paula some big beautiful eyes. We'll add some eyelashes to show she's a girl.

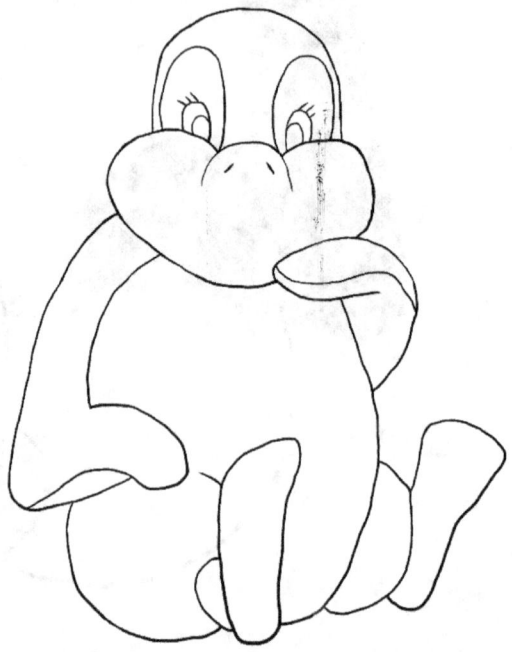

Step 4: Draw her nose. Include a few lines for her nostrils.

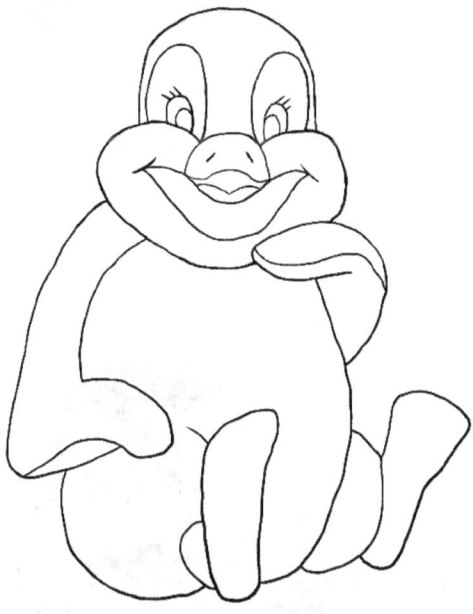

Step 5: Now draw a friendly smile.

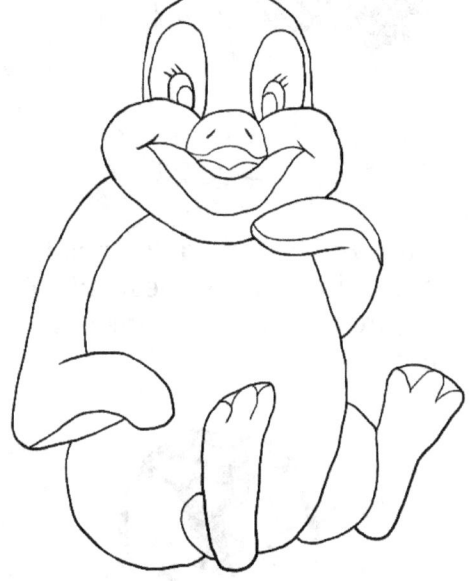

Step 6: Let's work on the toes by creating upside-down U shapes...three for each foot.

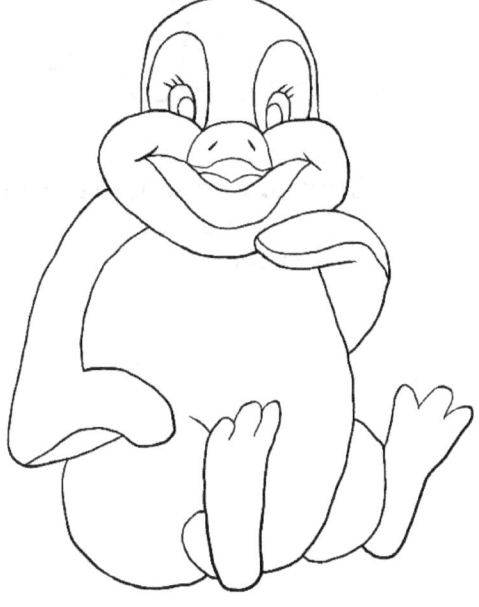

Step 7: Now erase the unwanted lines to separate the toes.

Turn Simple Shapes into Cool Cartoons

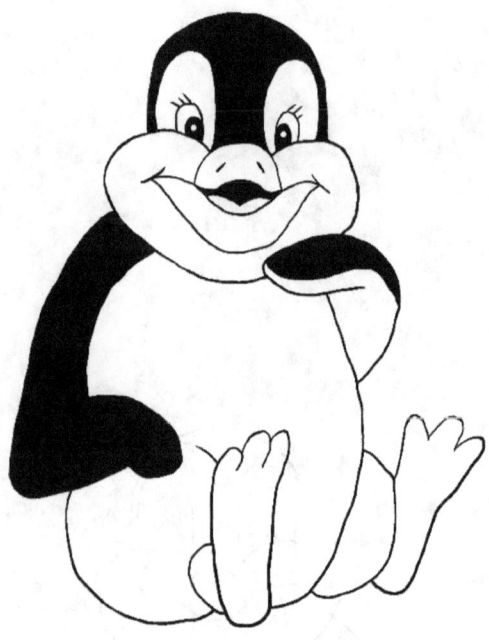

Step 8: Darken Paula's head, eyes, flippers, and the inside of her mouth. She's coming to life now.

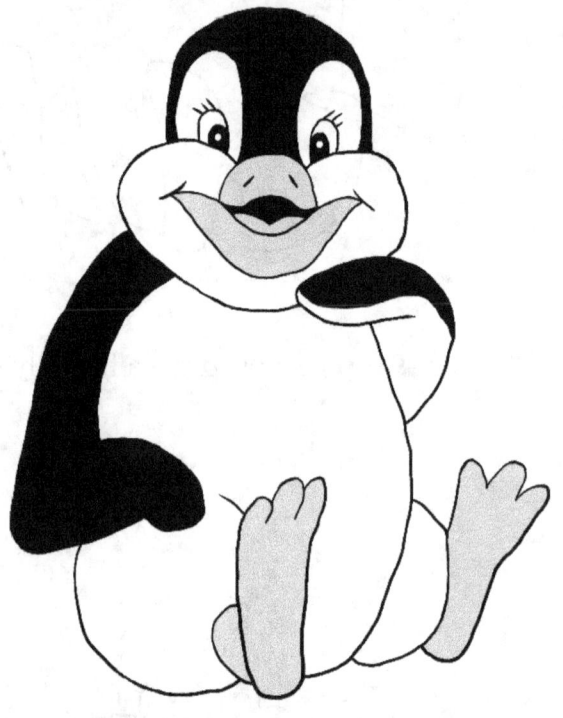

Step 9: Add shading to her nose, mouth, tongue, and feet. We're almost there.

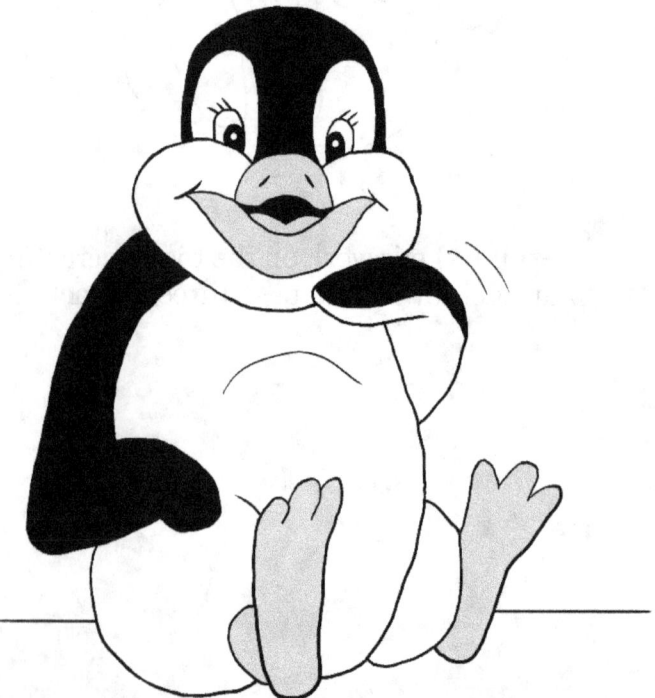

Step 10: All we need to do is draw a line behind her. This will give her some ground to sit on.

Turn Simple Shapes into Cool Cartoons

Art the Bear

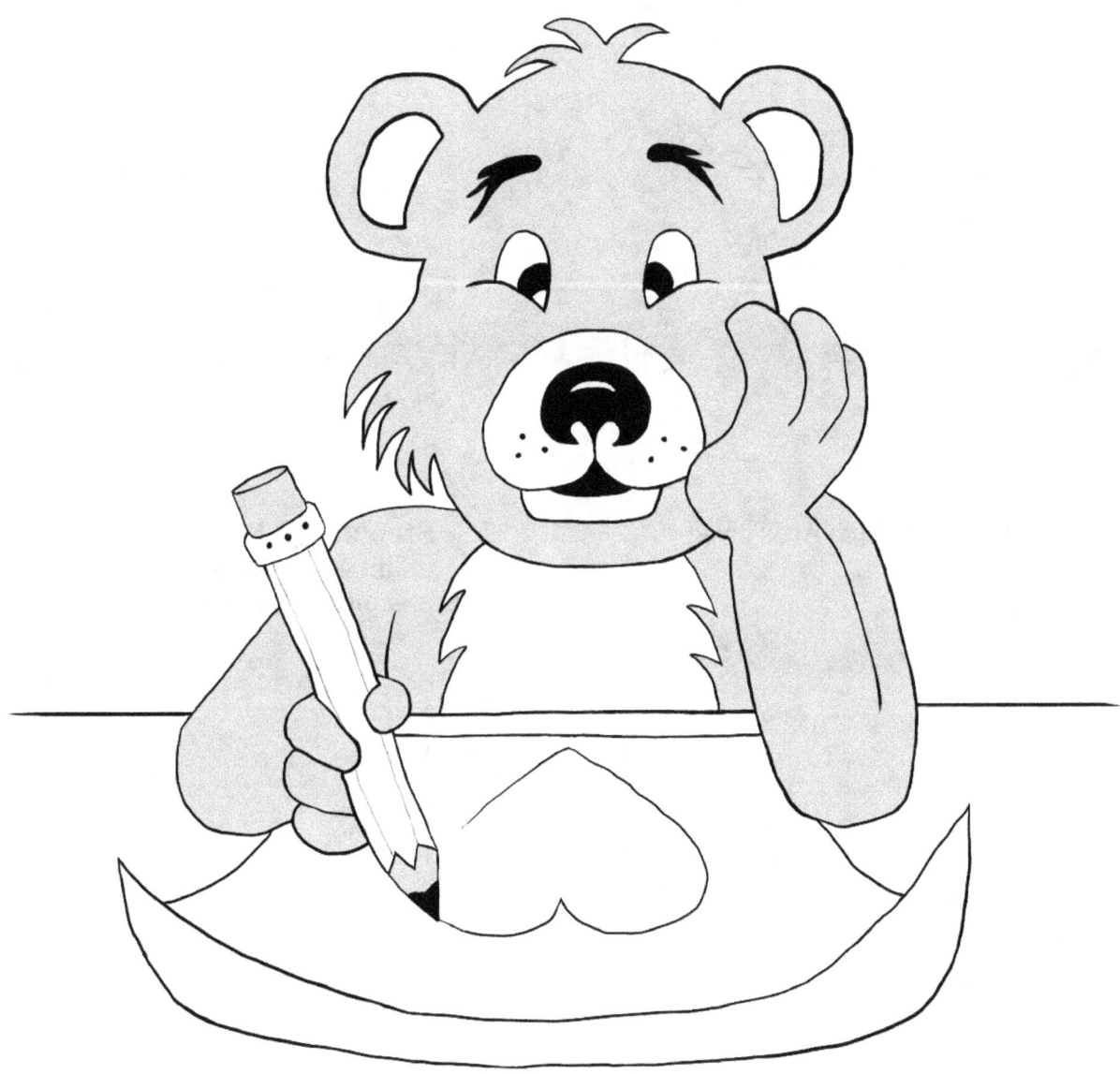

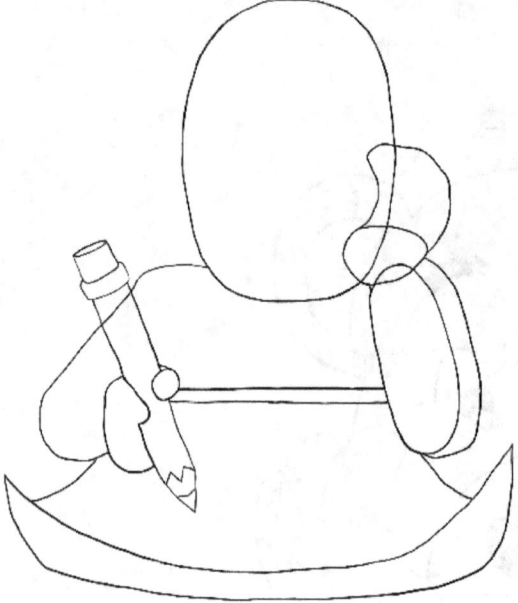

Step 1: Sketch Art's basic shapes.

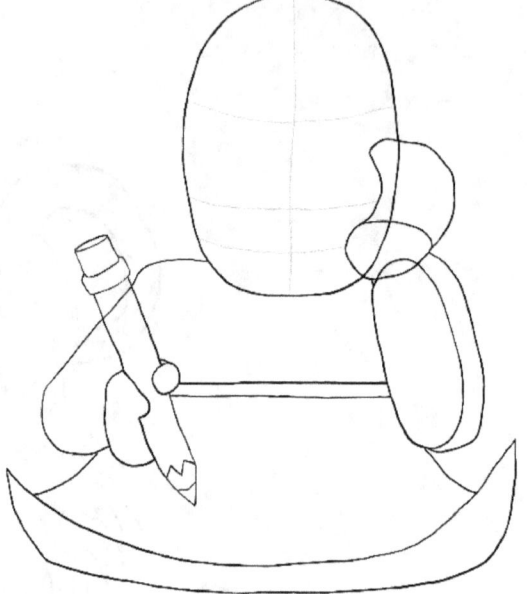

Step 2: Lightly draw guidelines on his face to show where the eyes nose and mouth will go.

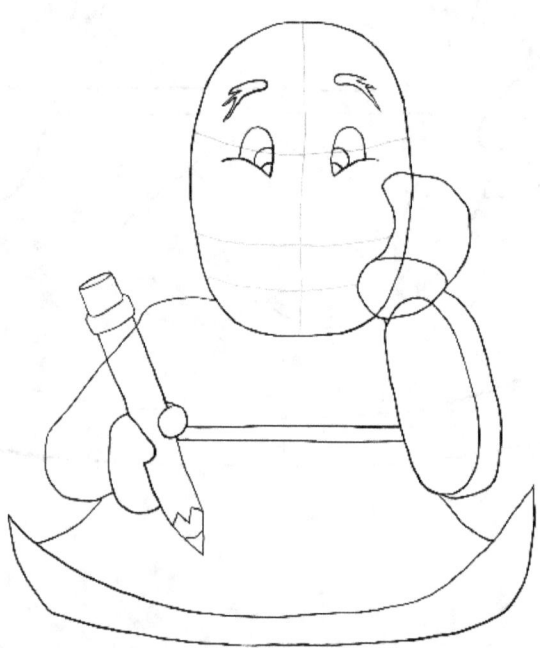

Step 3: Draw Arts eyes.

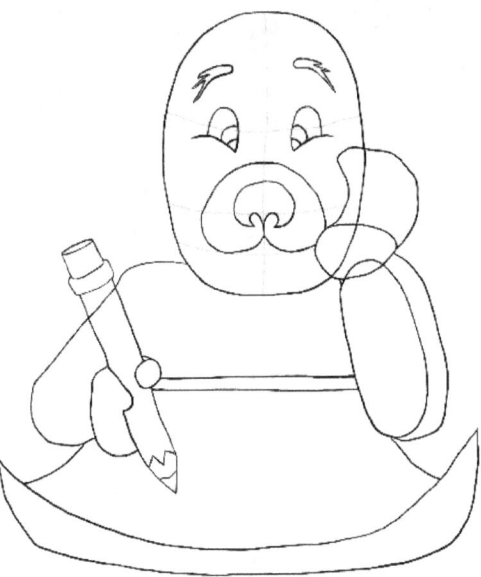

Step 4: Then, draw his nose.

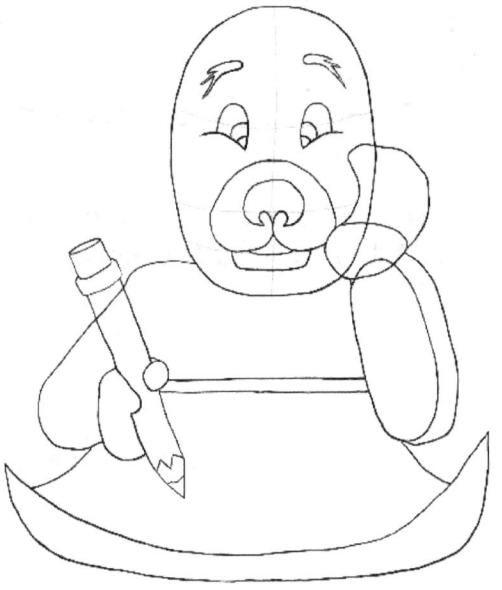

Step 5: Now sketch Art's mouth.

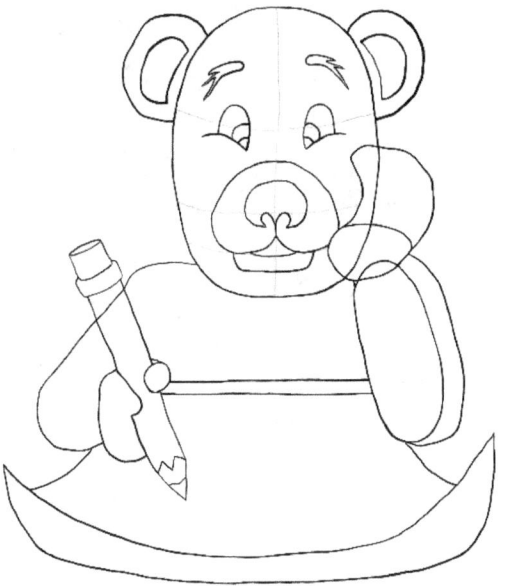

Step 6: Give him big ears.

Turn Simple Shapes into Cool Cartoons

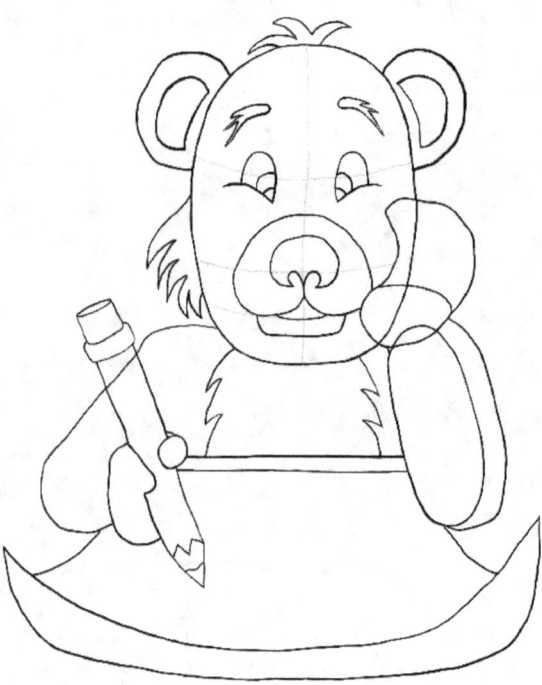

Step 7: Draw the fur on the top of Art's head, right cheek, and chest.

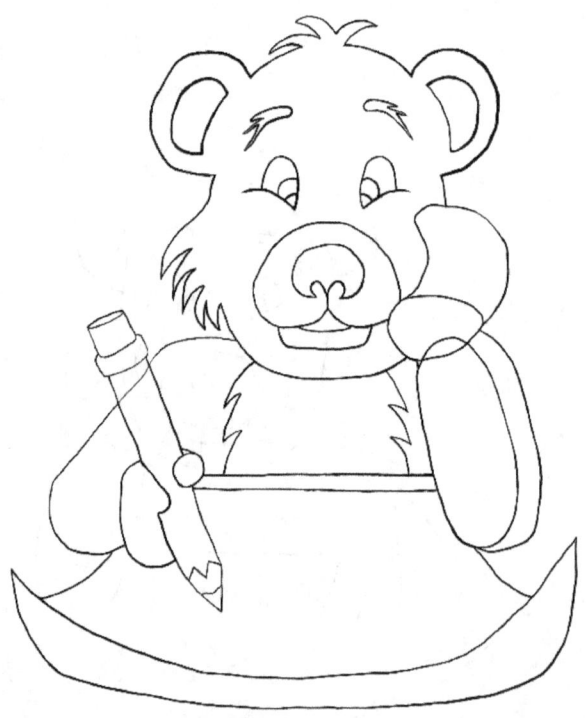

Step 8: Erase the guidelines, lines that separate his fur from his body, and the facial line that runs through his left hand.

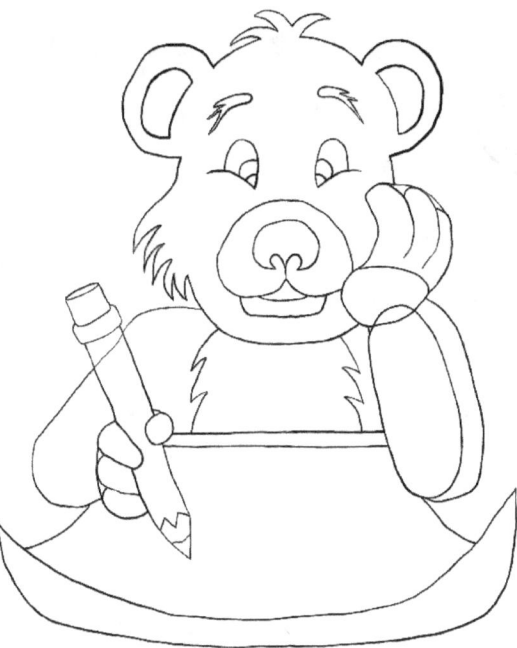

Step 9: Now draw his sausage-shaped fingers.

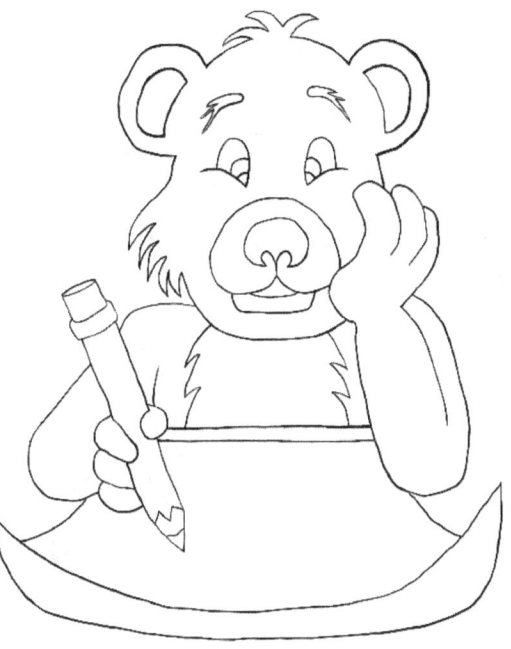

Step 10: Erase the unwanted pencil marks between the tips of his fingers, palm, and wrist.

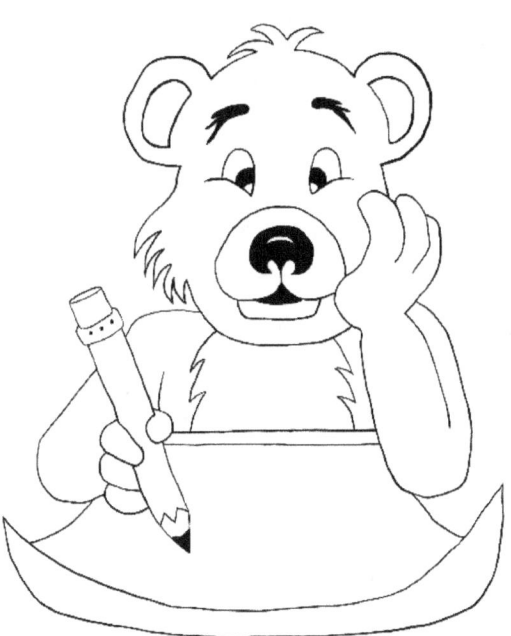

Step 11: Darken Art's eyes, mouth, and the tip of his pencil. Add three black dots to the metal rim under the eraser.

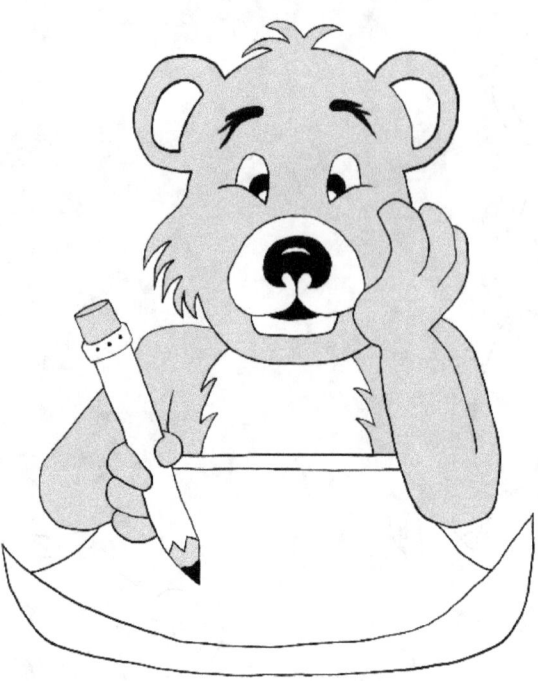

Step 12: Shade his body, the eraser, and wood above the lead of the pencil with grey.

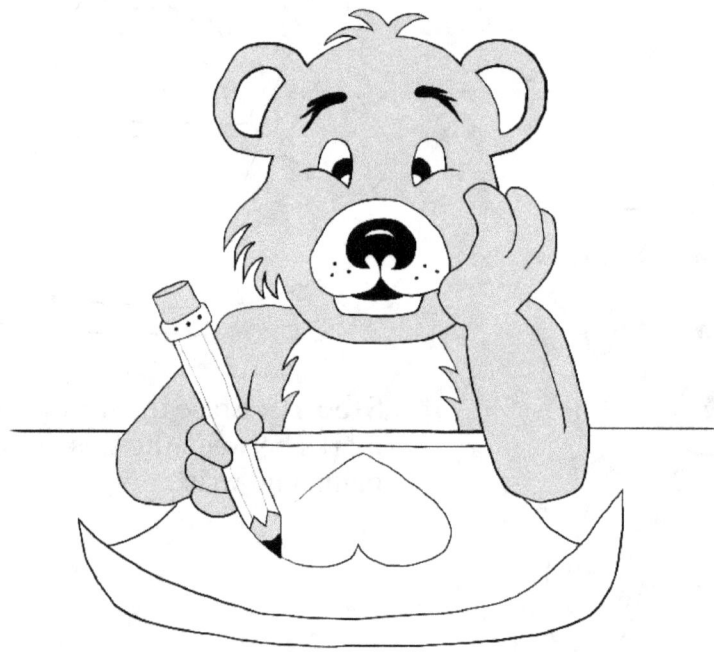

Step 13. Add details like dots on his muzzle. Give texture to the pencil by adding detail lines on the pencil casing.

Give Art something to draw on the paper. I've added a heart.

Ready for the next drawing?

Turn Simple Shapes into Cool Cartoons

Guilty Cat

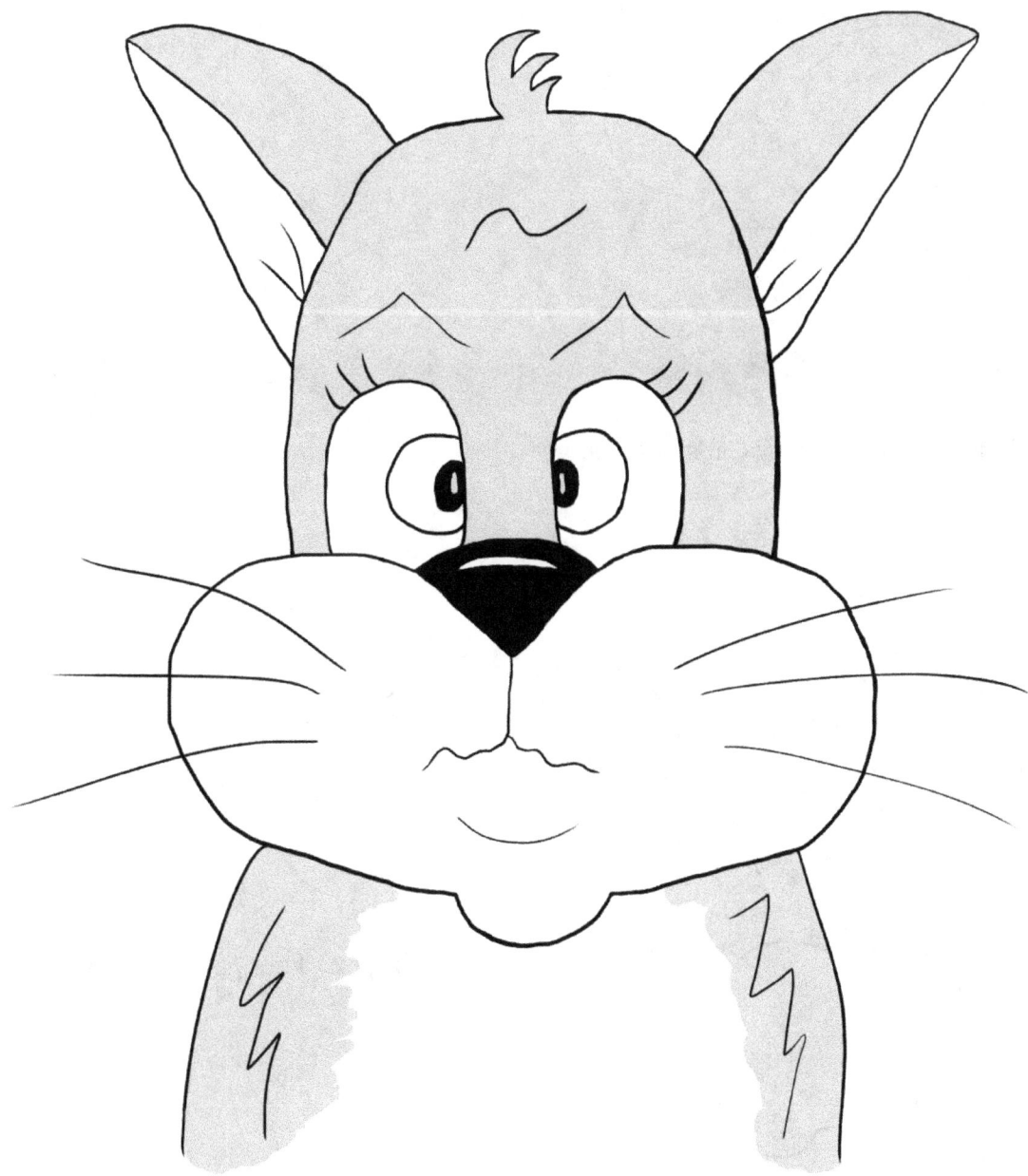

Turn Simple Shapes into Cool Cartoons

Step 1: Draw Guilty Cat's outline.

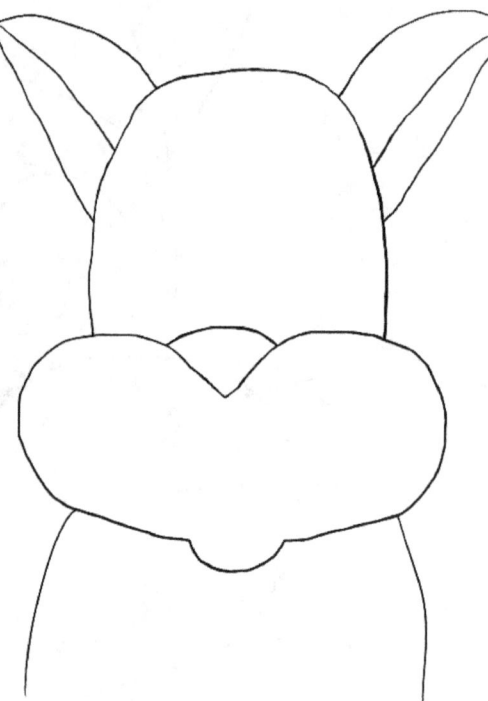

Step 2: Then, add triangle shaped ears.

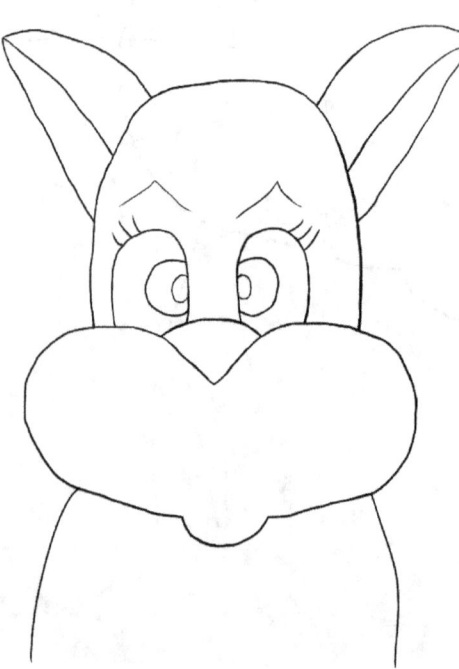

Step 3: Next, draw the eyes.

42

Turn Simple Shapes into Cool Cartoons

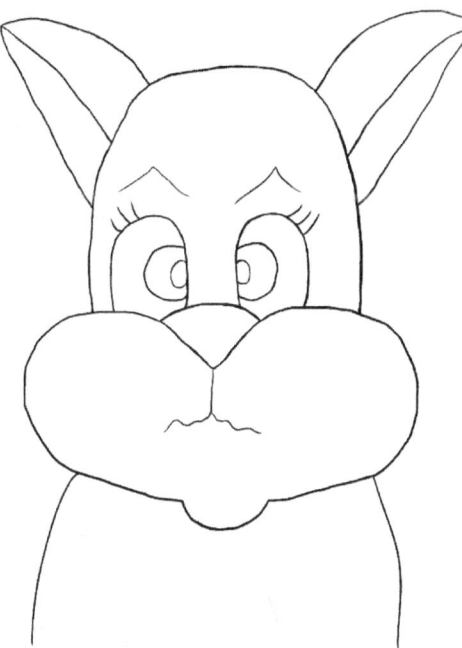

Step 4: This expressive mouth says it all.

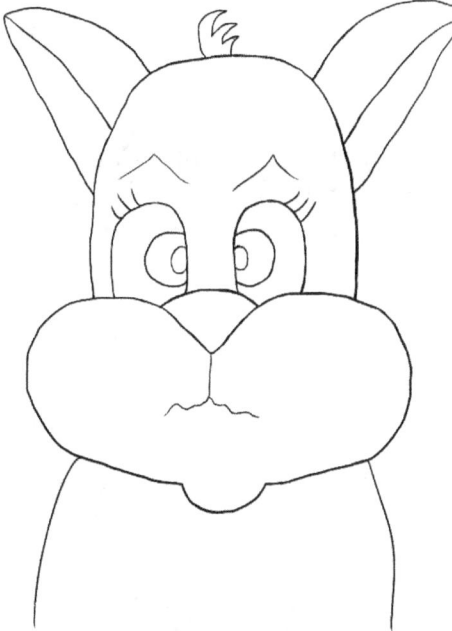

Step 5: Add a little fur on the forehead.

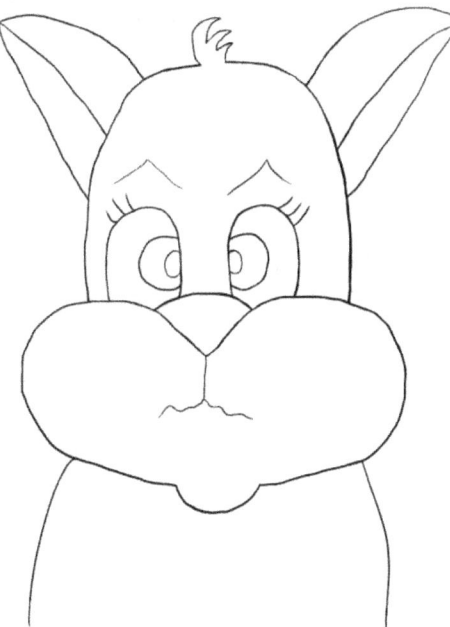

Step 6: Erase the line that separates the fur from his forehead.

43

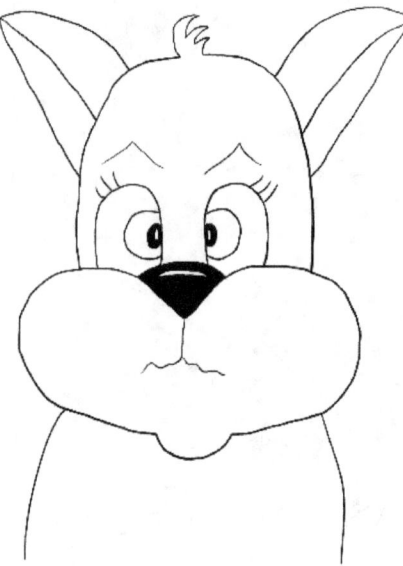

Step 7: Darken Guilty Cat's eyes and nose. Leave some white highlights to add sparkle to the eyes and shine to the nose.

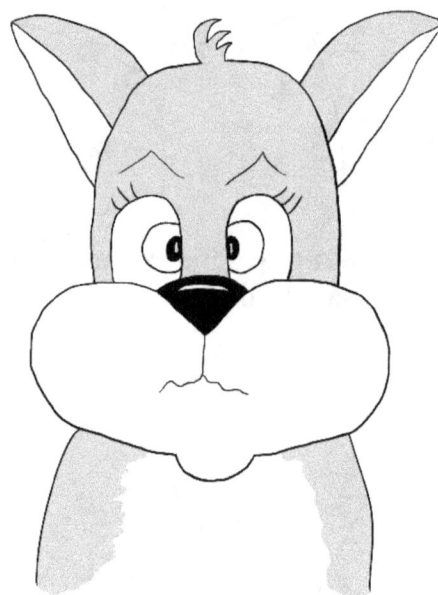

Step 8: Shade her face, ears, and part of the cat's body with grey.

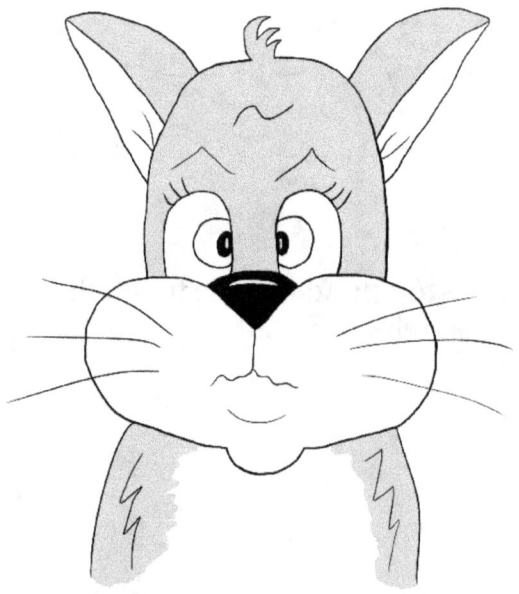

Step 9: Add whiskers on her cheeks and fur in the ears. Then, draw lines on the forehead, chin, and body. The look on her face makes me wonder what she did.

Turn Simple Shapes into Cool Cartoons

Monkey Business

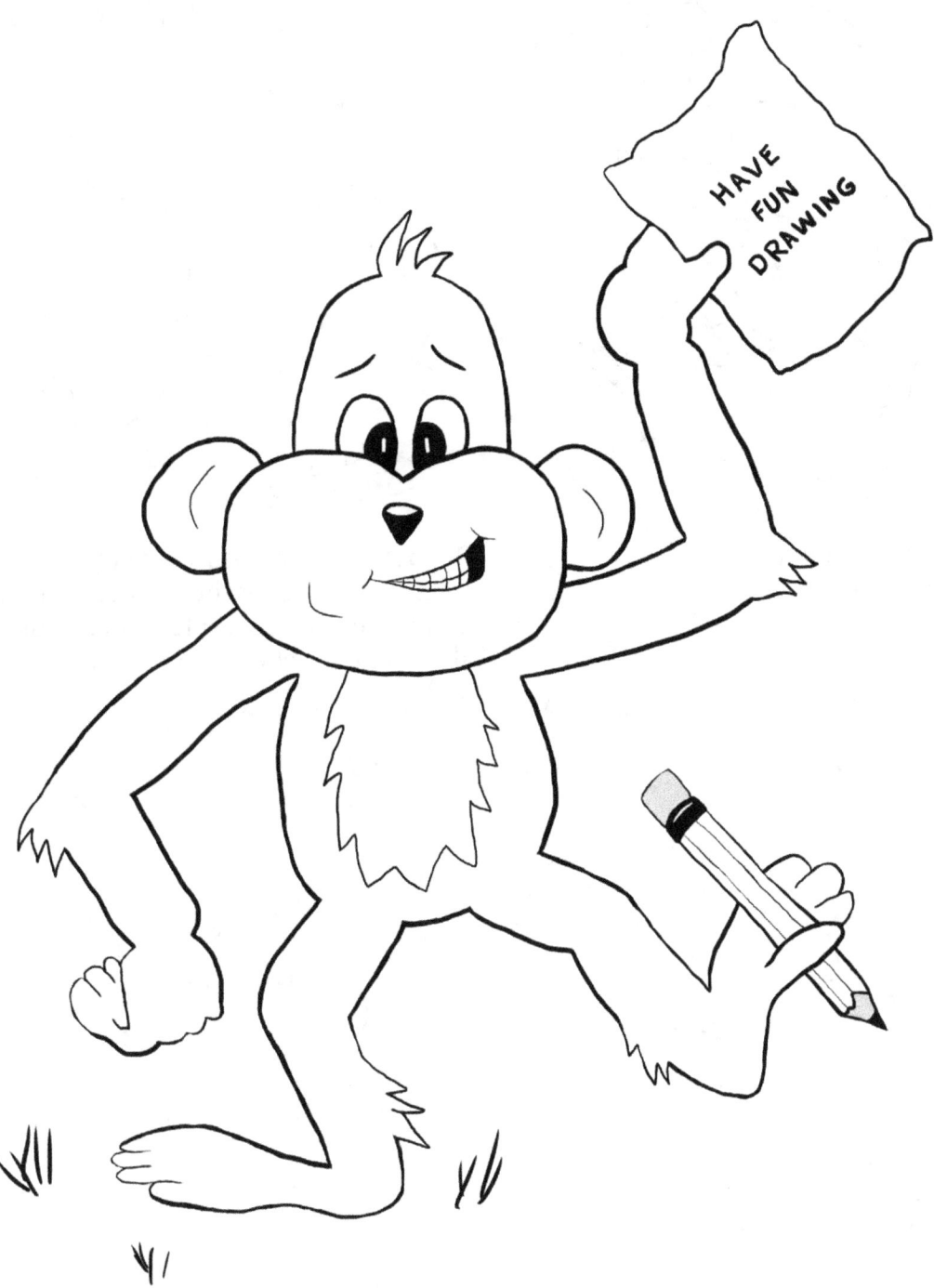

Turn Simple Shapes into Cool Cartoons

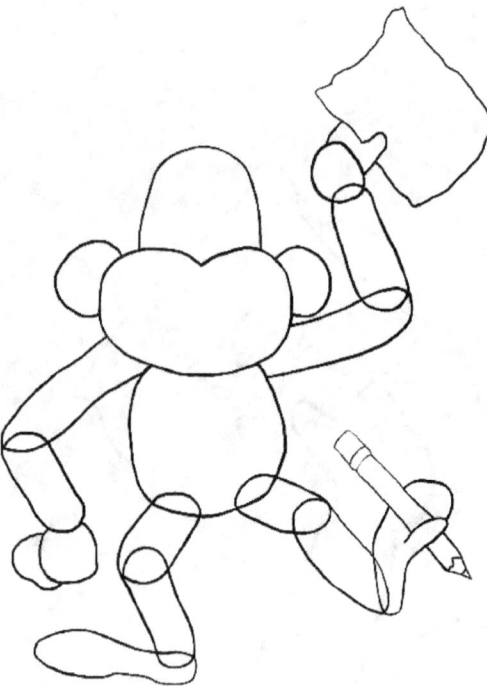

Step 1: Start with the basic shapes.

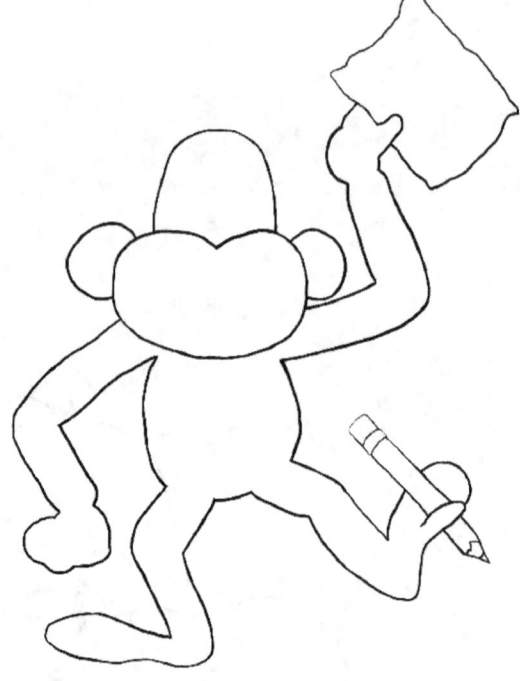

Step 2: Erase the unwanted pencil lines where the joints of the elbows, wrists, hands, knees, and ankles meet. This also includes where the legs join the body.

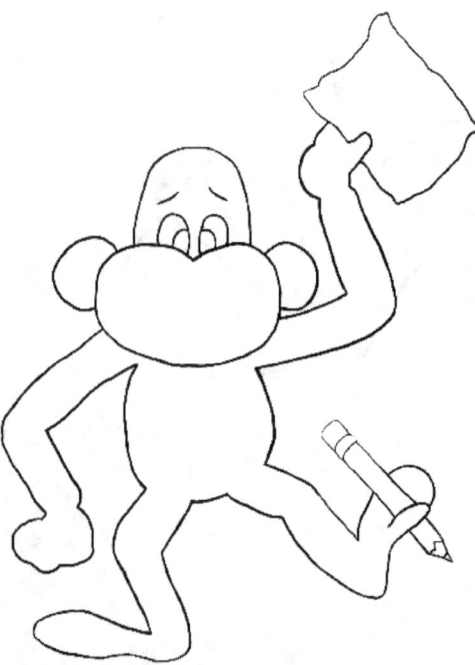

Step 3: Draw the eyes.

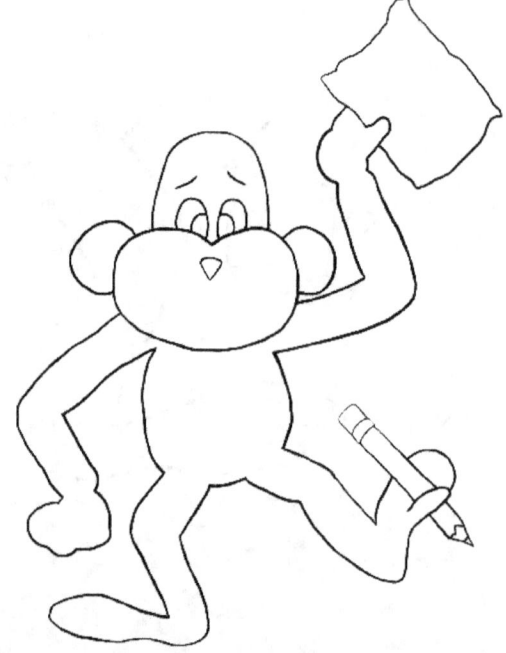

Step 4: Sketch in a nose.

Turn Simple Shapes into Cool Cartoons

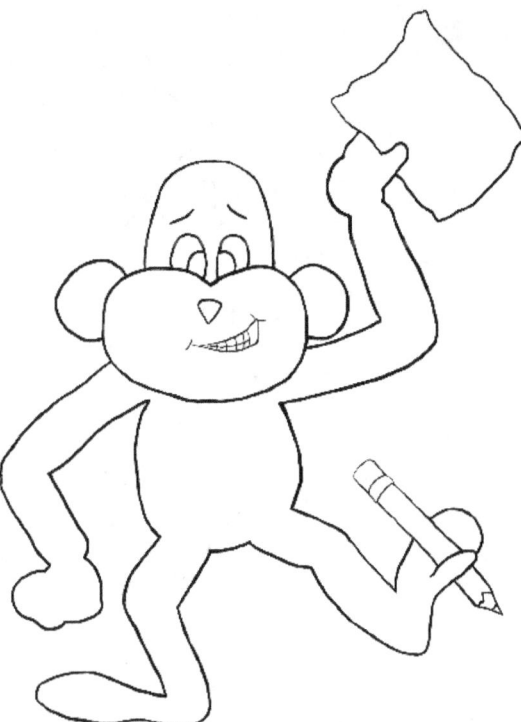

Step 5: Next, add the mouth and teeth.

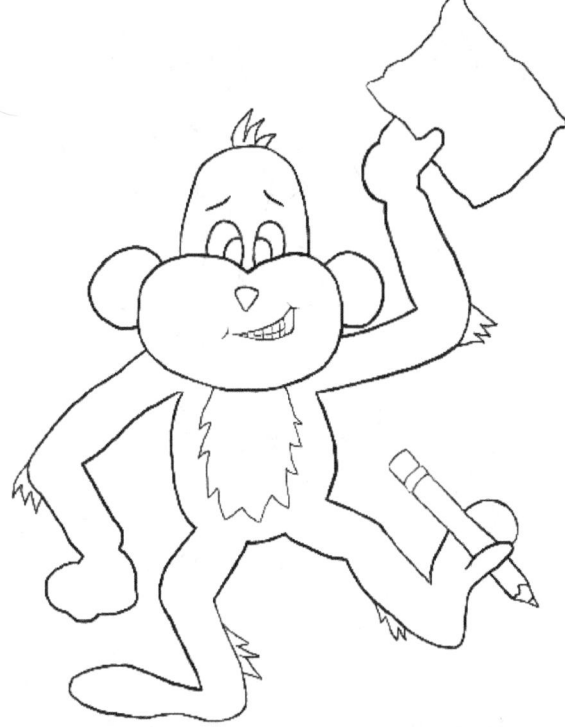

Step 6: Draw clumps of fur on his head, elbows, legs, and chest.

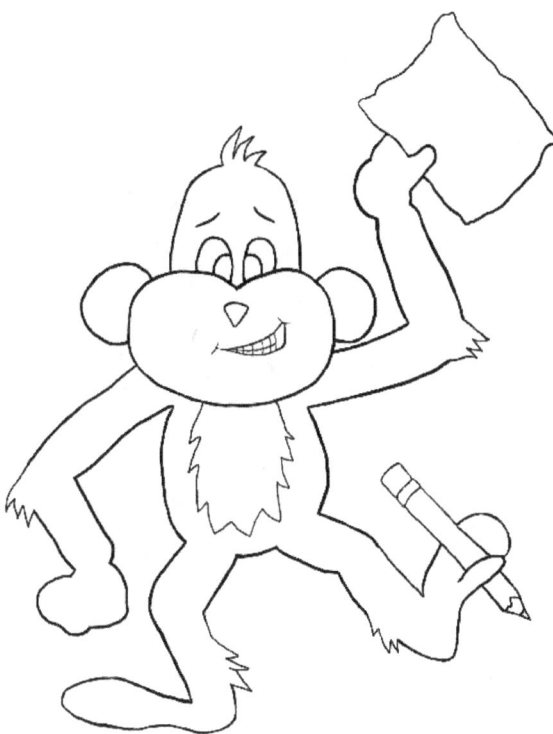

Step 7: Erase the lines that separate the fur from the body.

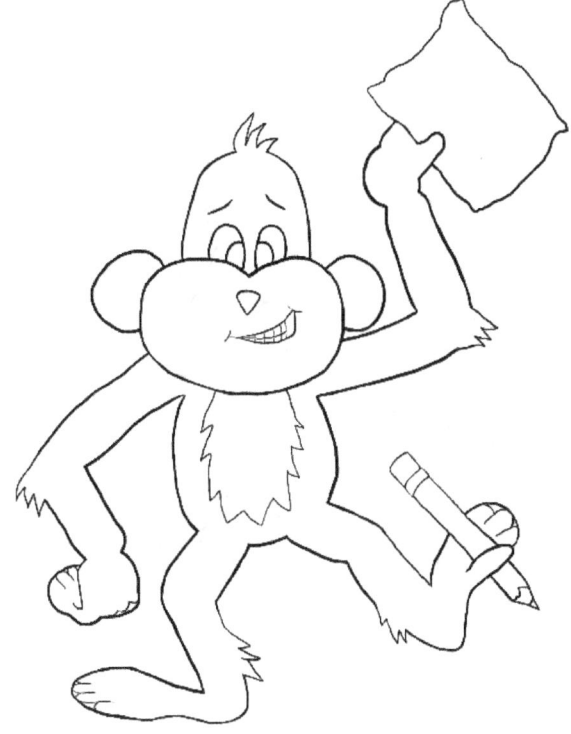

Step 8: Draw the toes, fingers, and knuckles.

Turn Simple Shapes into Cool Cartoons

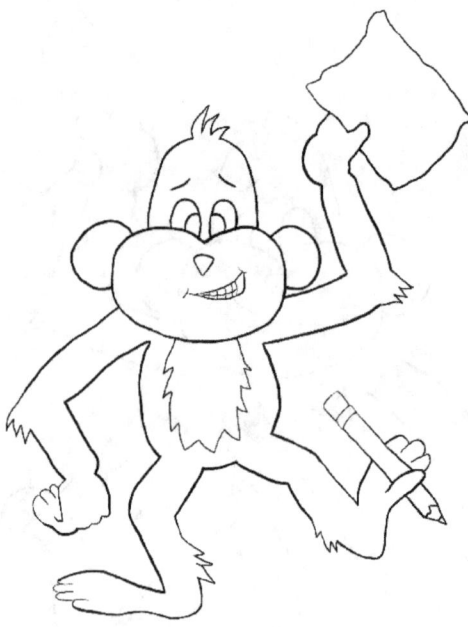

Step 9: Now erase the outside lines that run along the toes, fingers and knuckles. This will create space between each finger and toe.

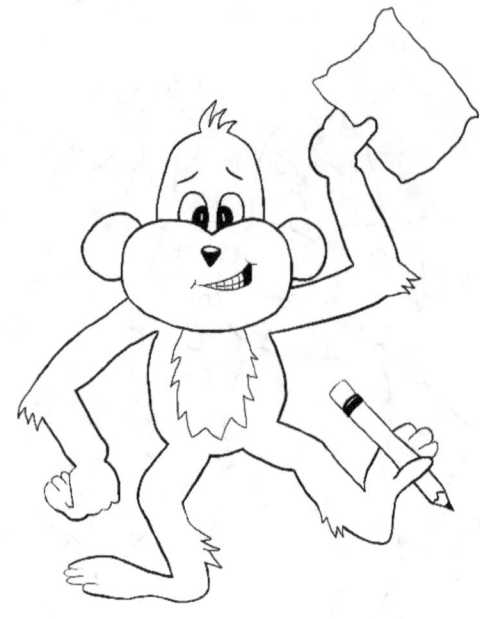

Step 10: Darken the eye, nose, mouth, and details on the pencil. Leaving white highlights will make the darks stand out.

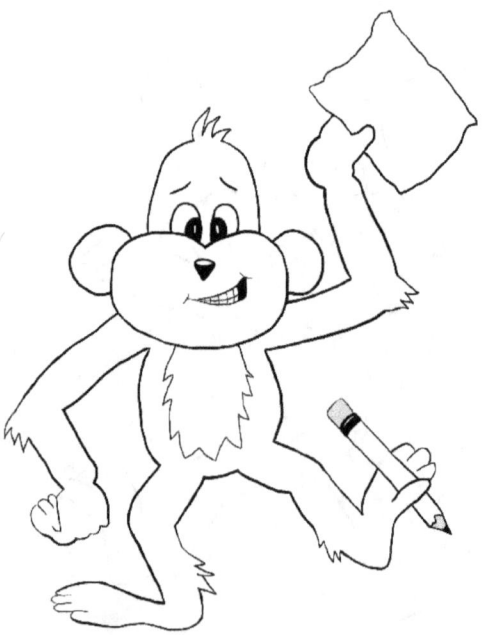

Step 11: Shade the eraser and the wooden tip of the pencil with grey.

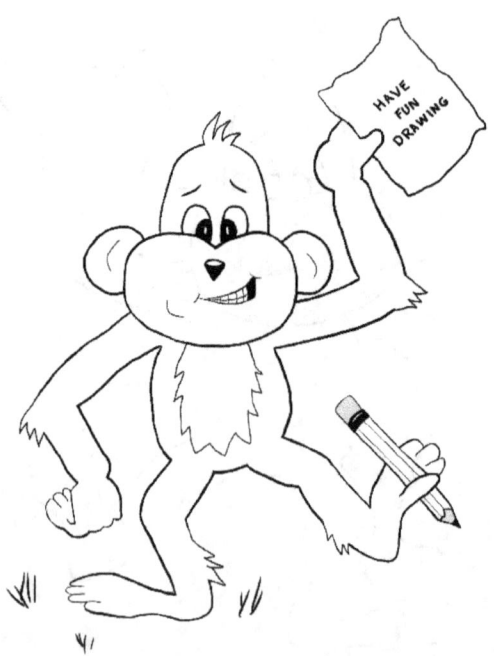

Step 12: The last step is to add detail lines on his ears, the writing on the paper, lines on the wooden pencil, and grass for the monkey to stand in.

Turn Simple Shapes into Cool Cartoons

Bella the Bunny

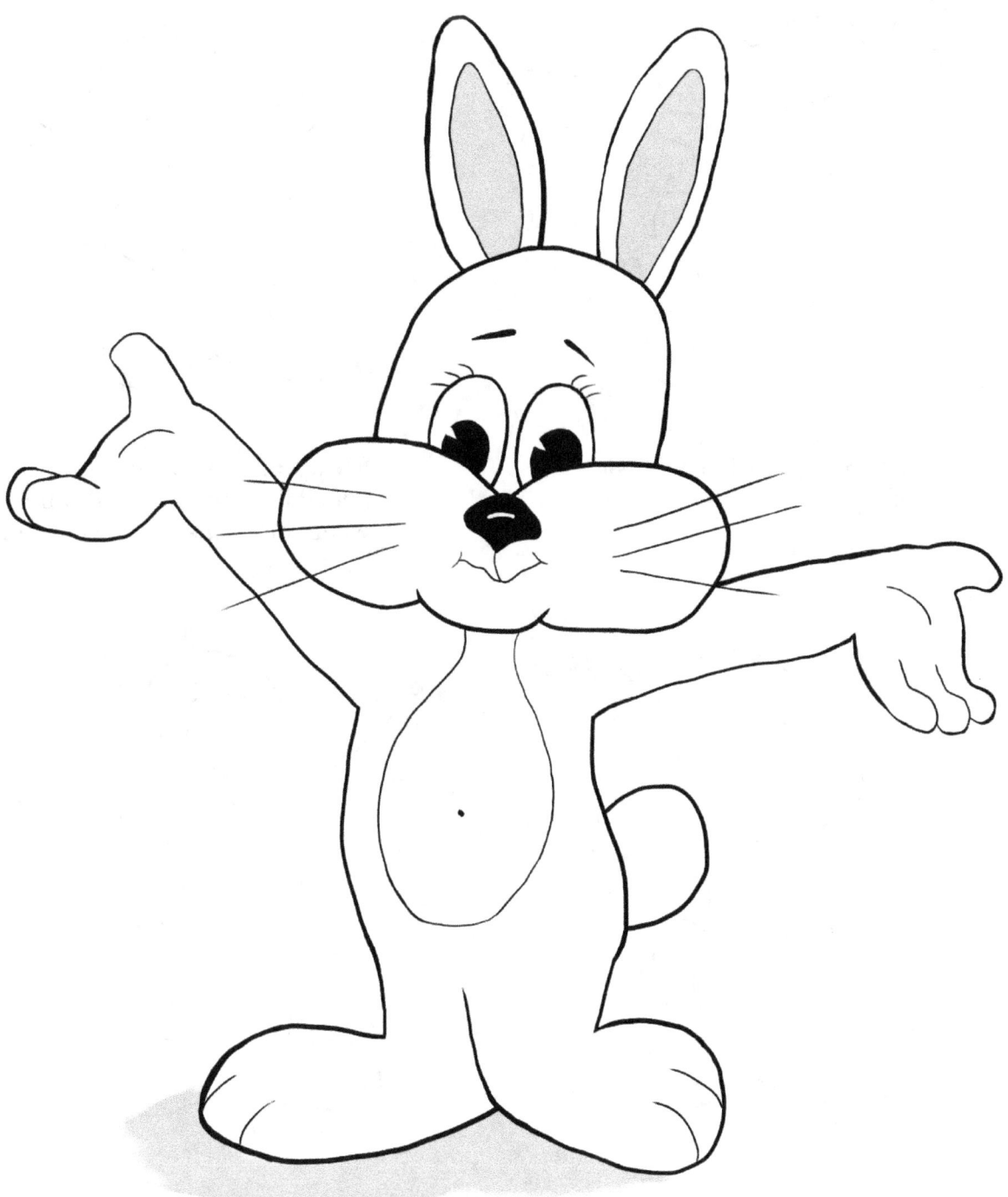

Turn Simple Shapes into Cool Cartoons

Step 1: Draw Bella's basic shapes.

Step 2: Erase the unwanted pencil lines on the hands and where her arms and legs meet her body.

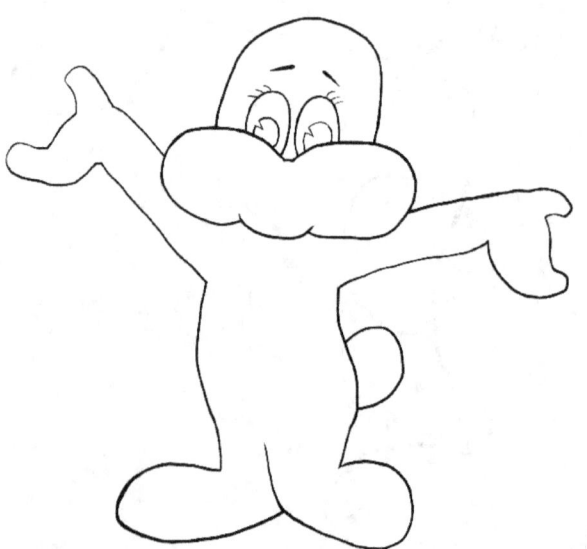

Step 3: Lets give Bella some big beautiful eyes.

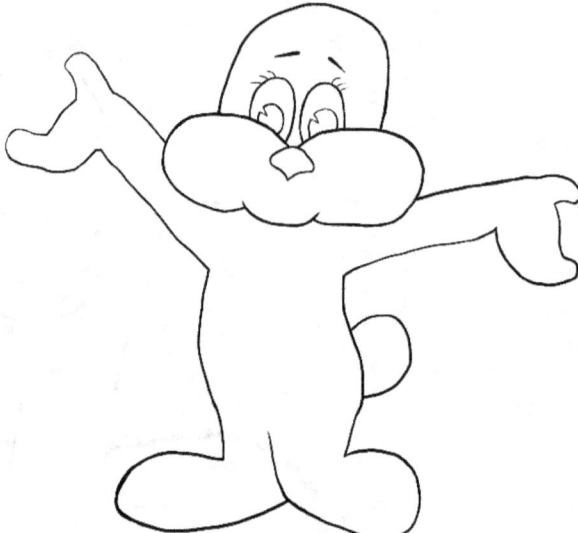

Step 4: Now draw her nose.

Turn Simple Shapes into Cool Cartoons

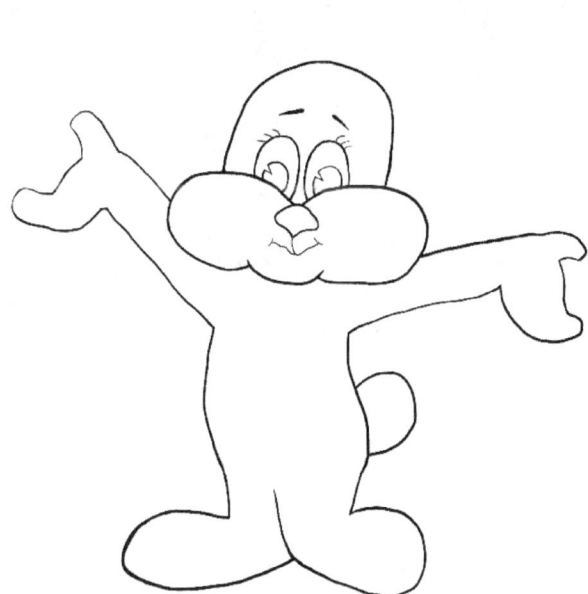

Step 5: Sketch Bella's mouth.

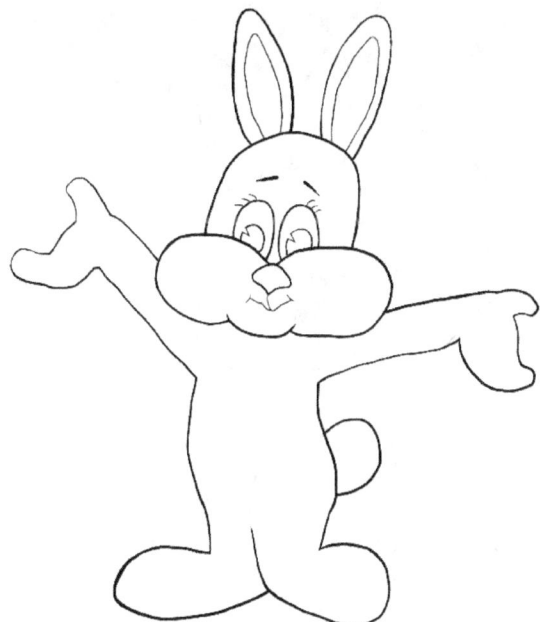

Step 6: Draw two big rabbit ears.

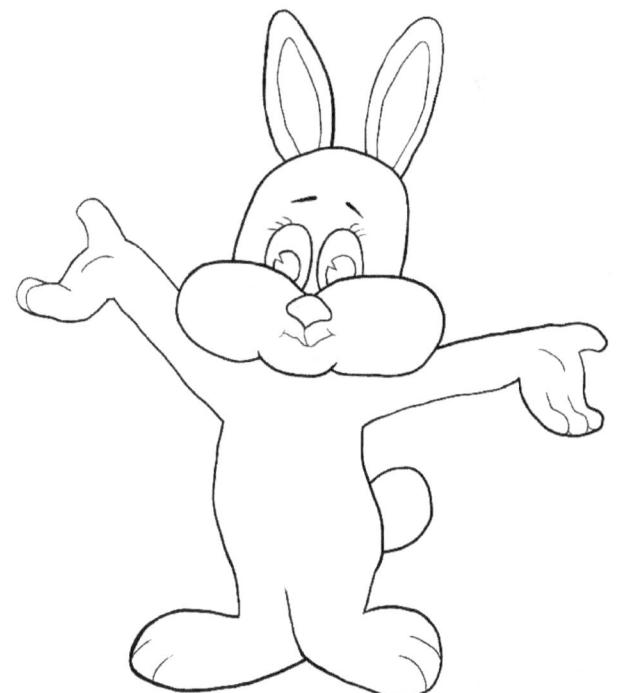

Step 7: Sketch the fingers and toes.

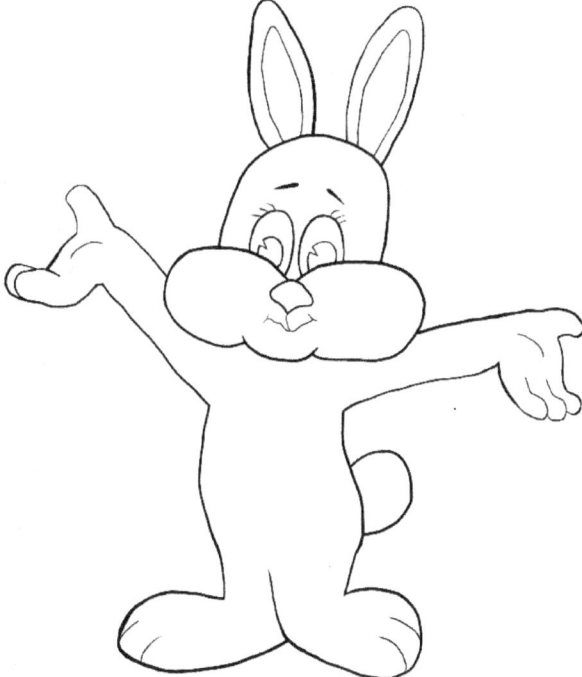

Step 8: Erase the unwanted lines between the fingers.

Turn Simple Shapes into Cool Cartoons

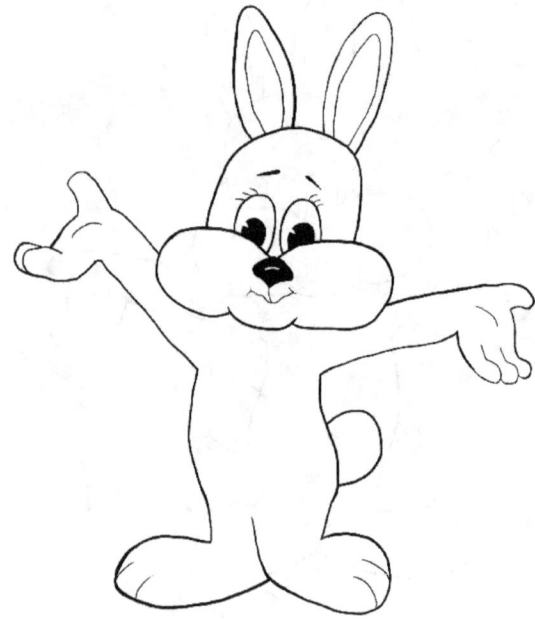

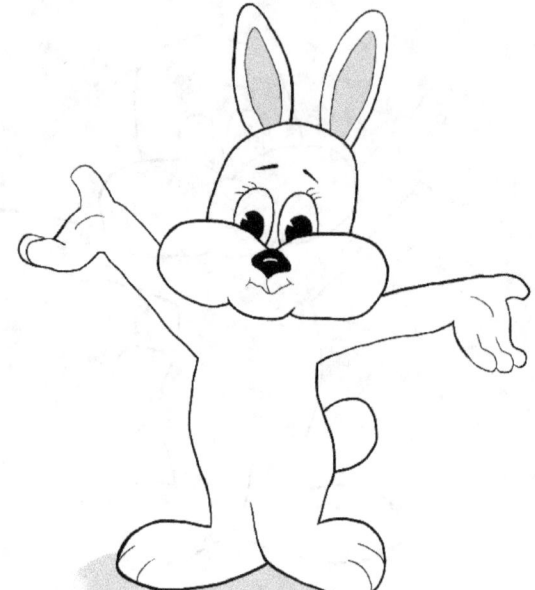

Step 9: Darken her eyes and nose - leaving white highlights.

Step 10: Shade Bella's ears and ground she's standing on with grey.

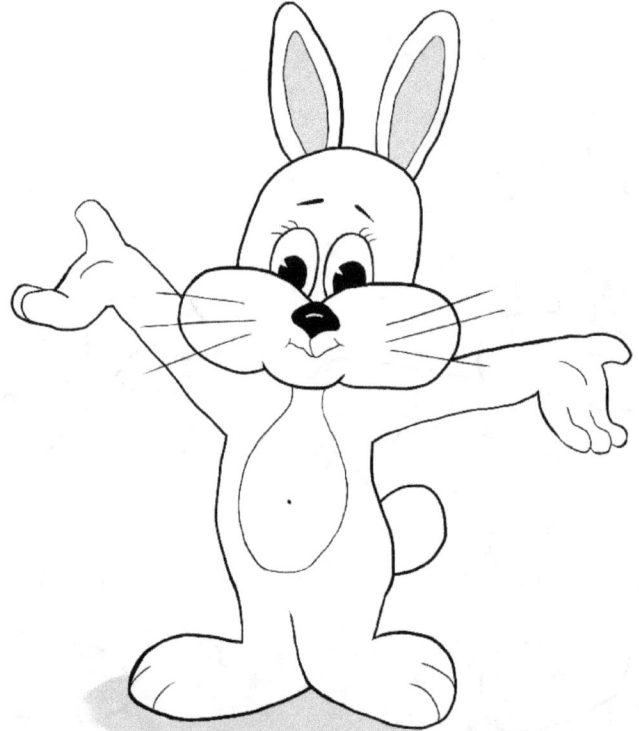

Step 11: Finish the drawing by adding details like whiskers and a belly button.

An Elephant and Her Peanut Butter

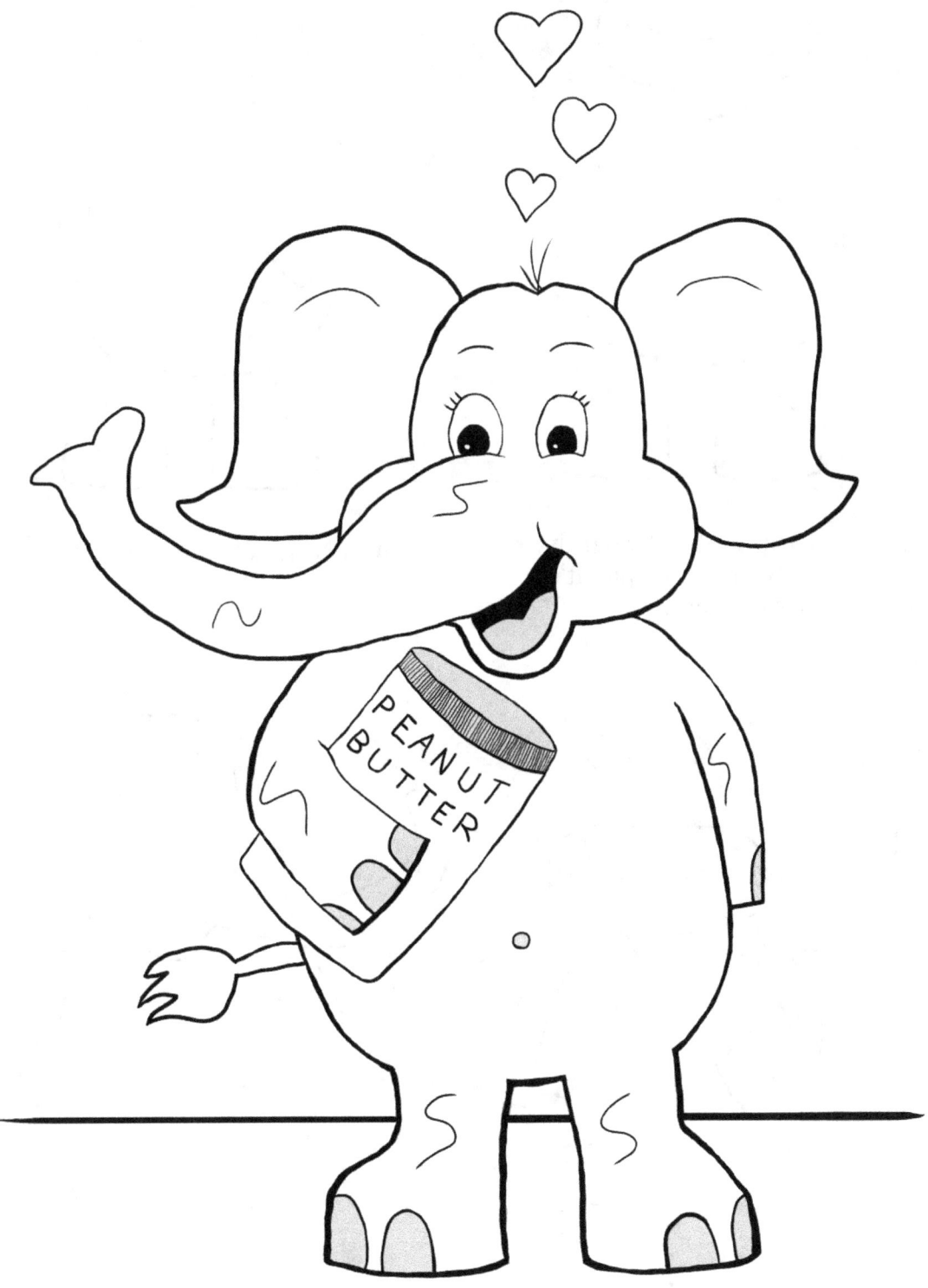

Step 1: Start by lightly drawing the elephant's basic shapes.

Step 2: Next, add the eyes.

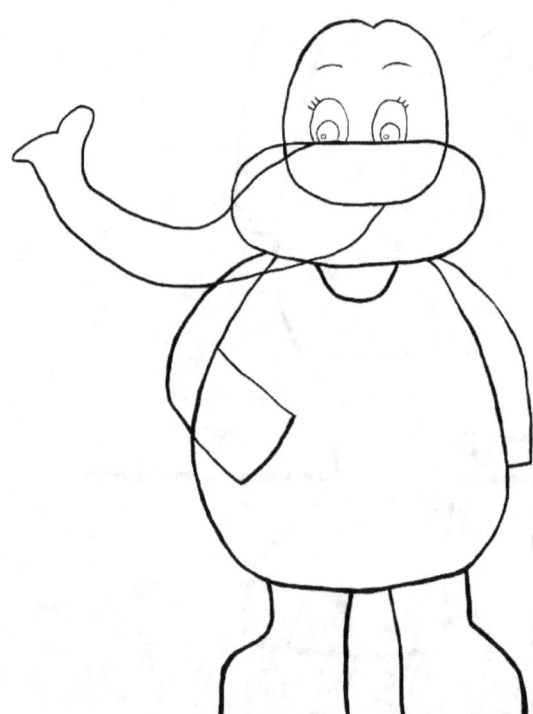

Step 3: Give the elephant a nice long trunk.

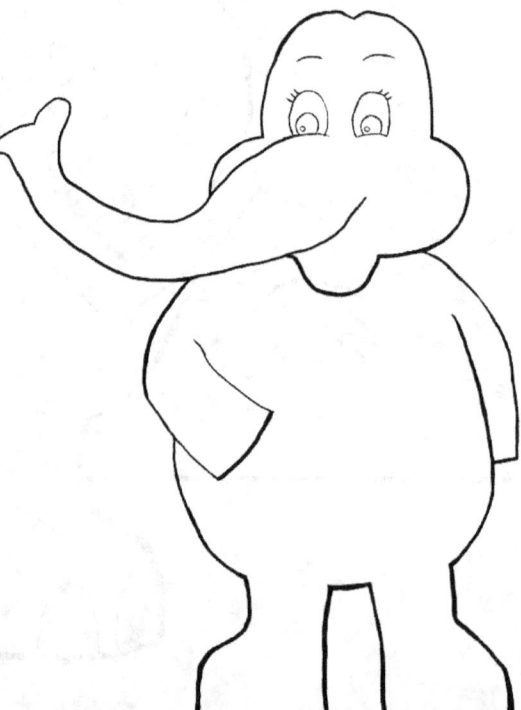

Step 4: Clean up the unwanted pencil lines along the chin, face, and shoulders.

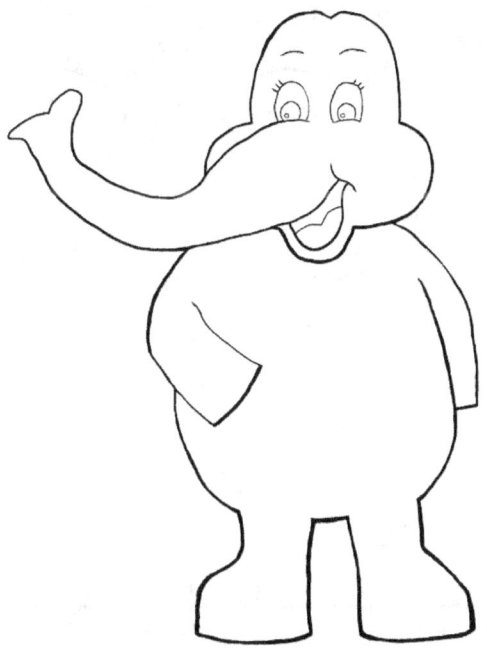

Step 5: Sketch the elephant's mouth and tongue.

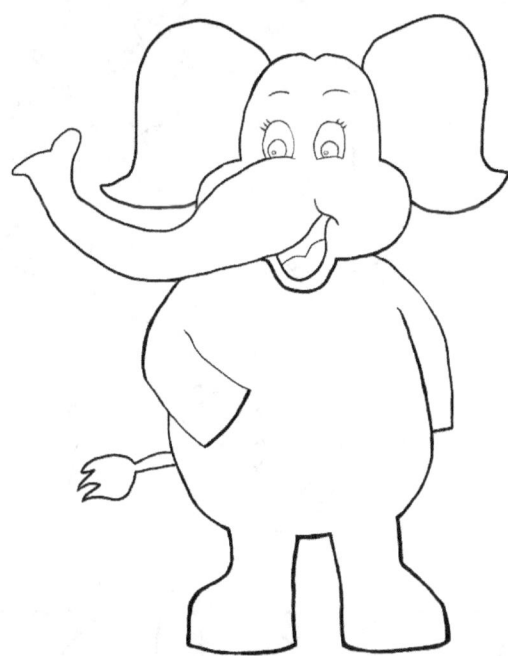

Step 6: Now add the tail.

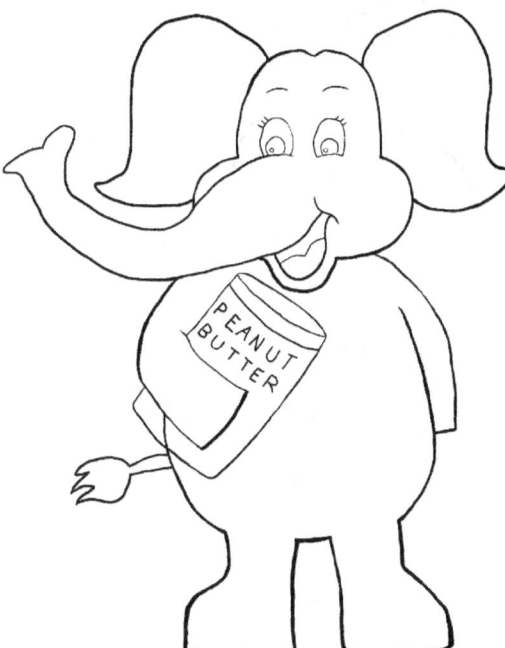

Step 7: Draw the peanut butter jar and add the words.

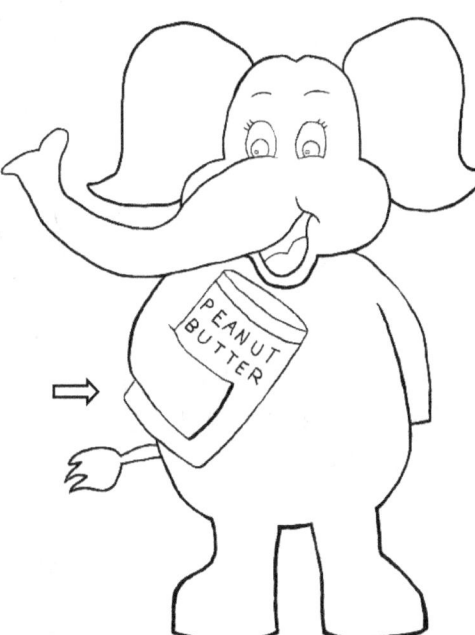

Step 8: Now erase the line underneath the elephant's right arm. The peanut butter jar should hide it.

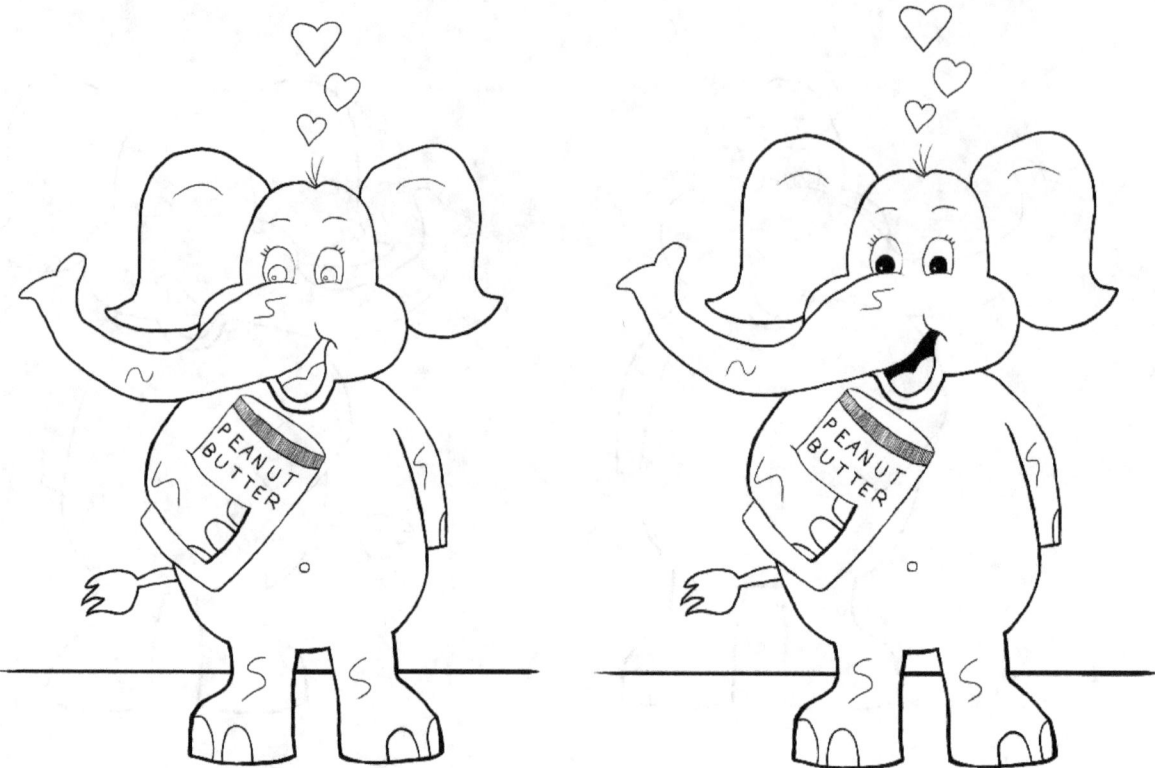

Step 9: Add detail lines to the lid of the jar and ears. Give the elephant wrinkles, toenails, a belly button, and a few strands of hair on top of her head. Then draw a horizontal line behind the elephant, and the hearts above her head.

Step 10: Darken the elephant's eyes and mouth.

Step 11: Shade the tongue, belly button, toenails, and jar lid with grey, and she's complete.

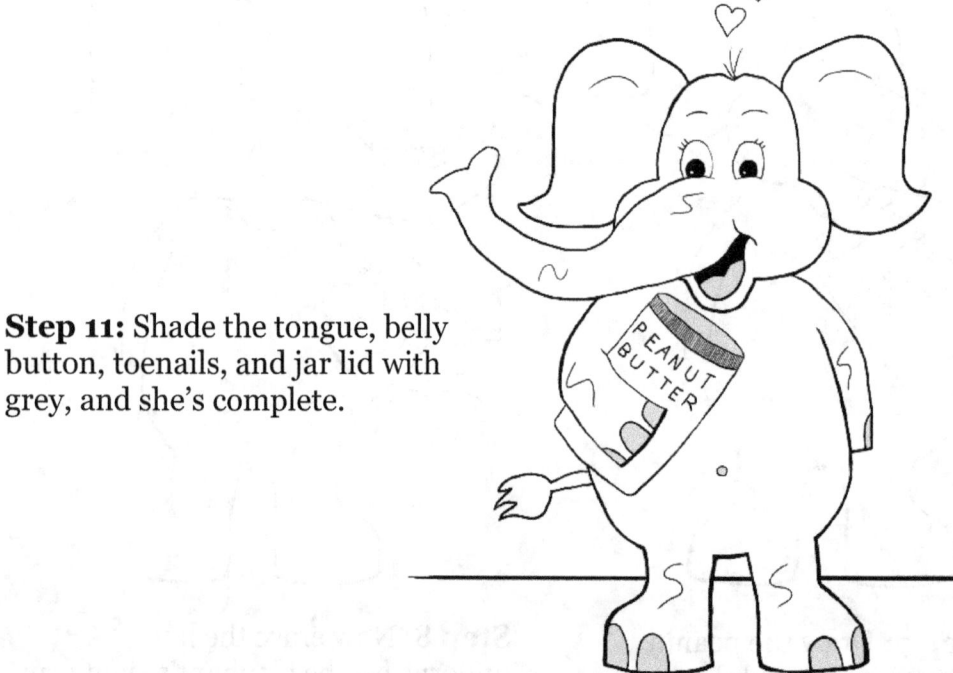

Turn Simple Shapes into Cool Cartoons

Buttercup the Cow

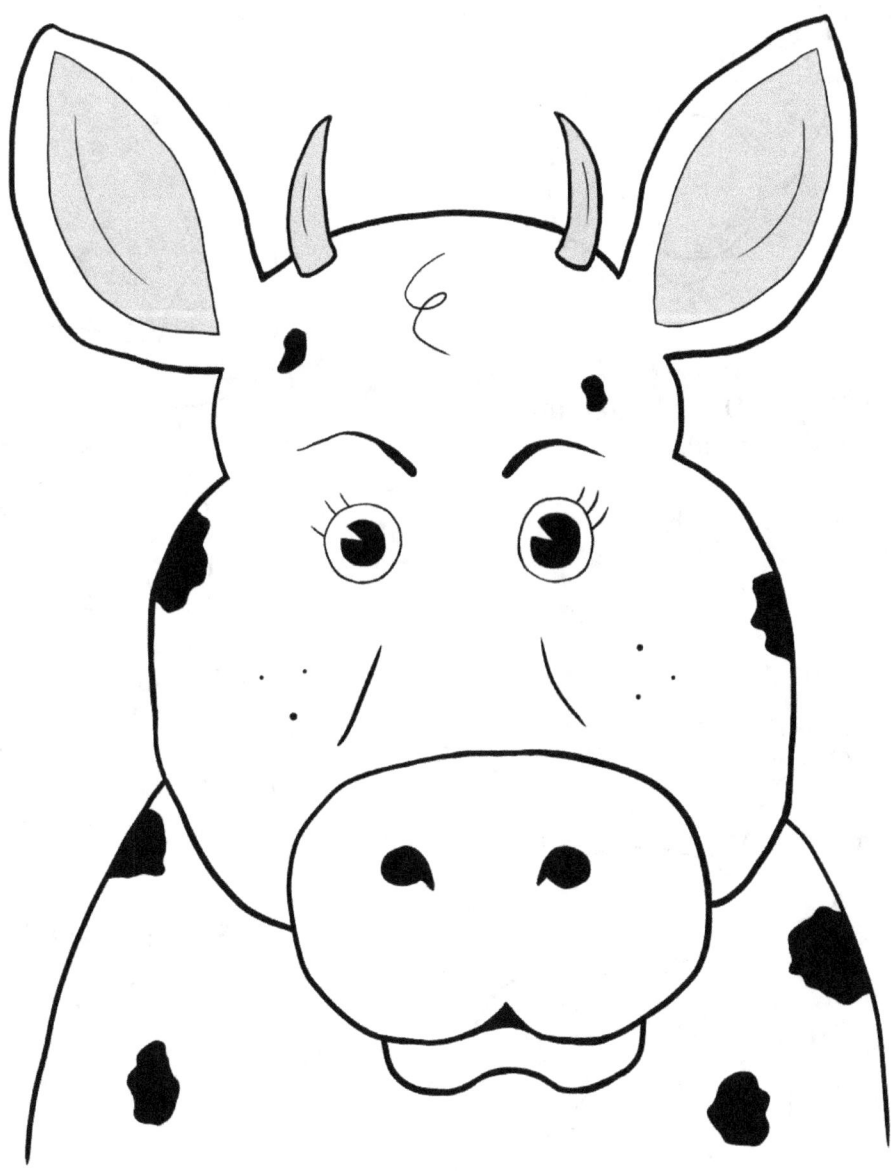

Turn Simple Shapes into Cool Cartoons

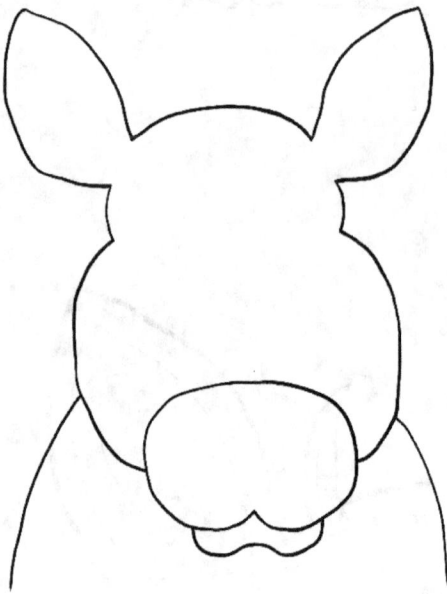

Step 1: Draw Buttercup's basic outline.

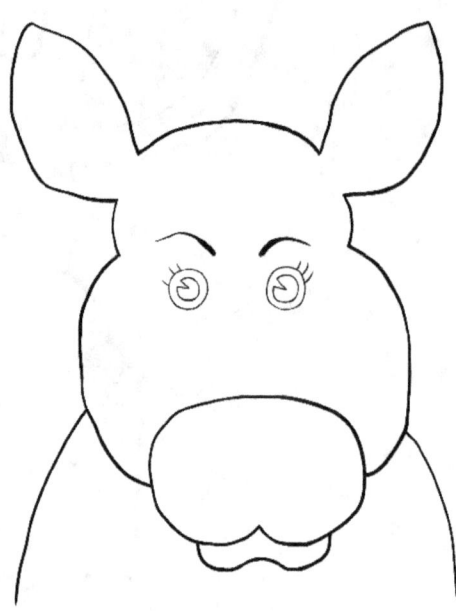

Step 2: Next draw the eyes.

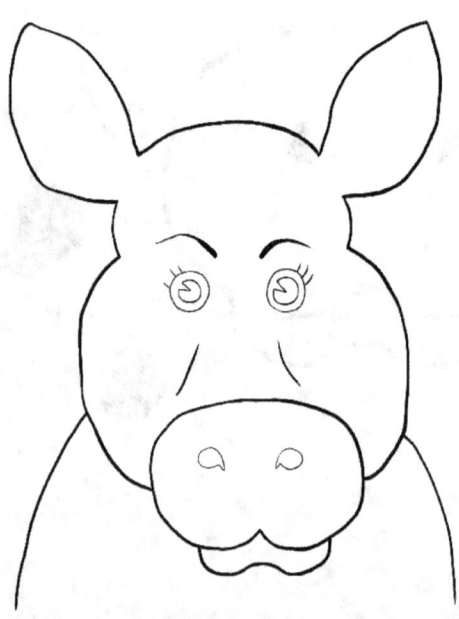

Step 3: Add nostrils and lines above the nose.

Turn Simple Shapes into Cool Cartoons

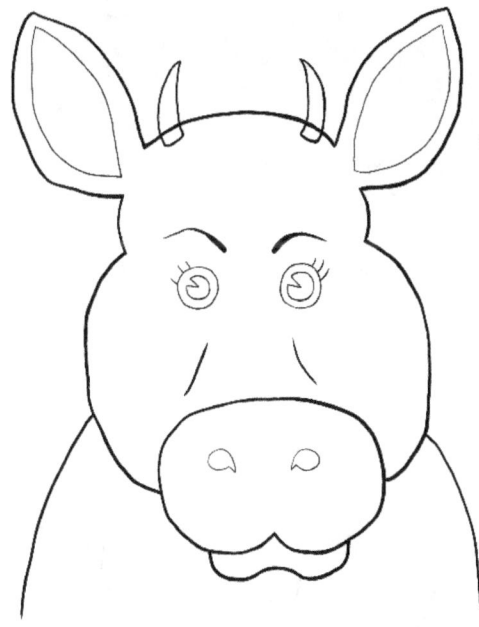

Step 4: Give her some small horns.

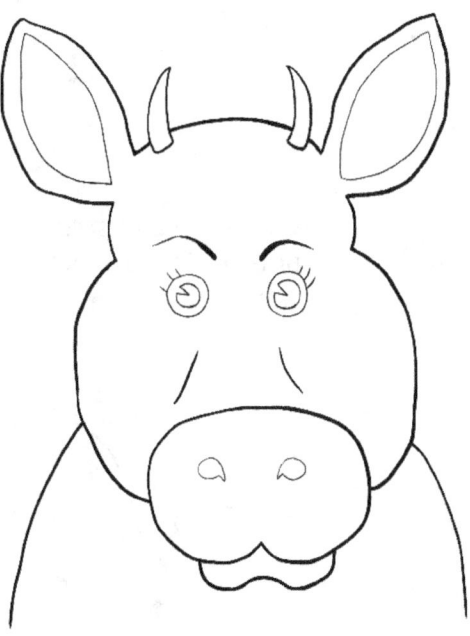

Step 5: Now erase the unwanted pencil marks that run across the horns.

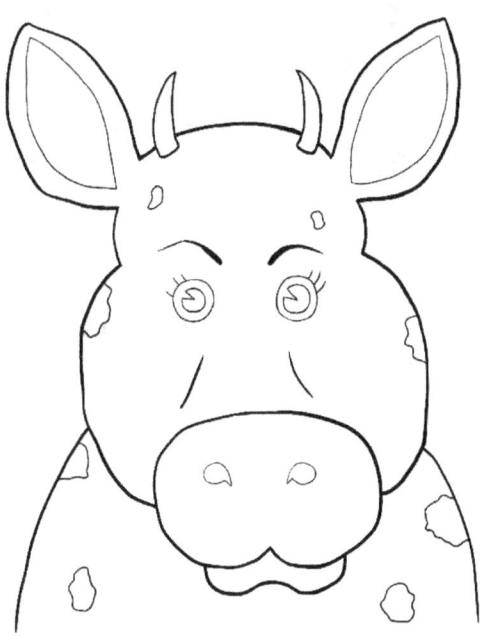

Step 6: Add different shaped spots on her body and face. Make some spots big and others small.

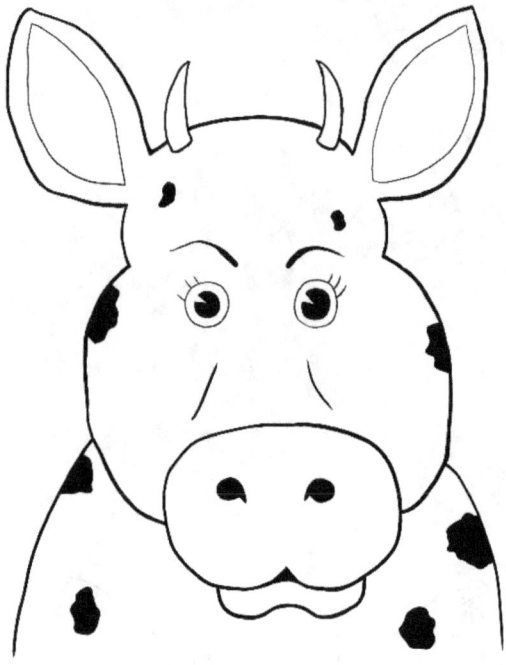

Step 7: Darken the eyes nostrils, mouth, and spots. Buttercup is beginning to stand out.

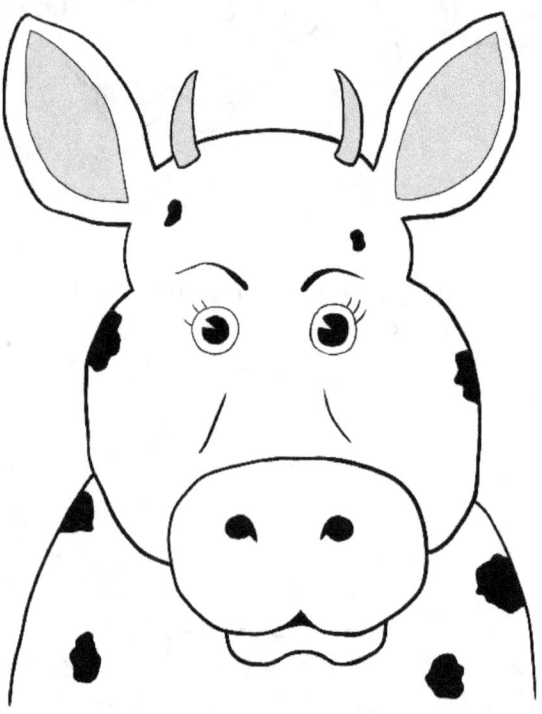

Step 8: Add grey shading to her ears and horns.

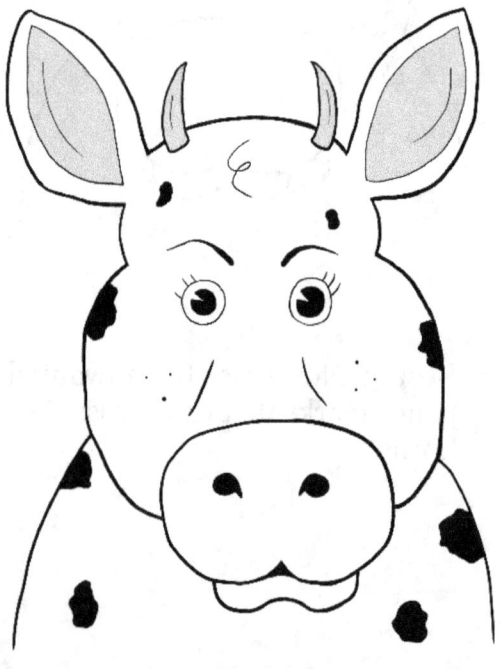

Step 9: Finally, give Buttercup freckles on her cheeks, a single swirl of hair on her forehead, accent lines on her ears, and horns. That's it.

Turn Simple Shapes into Cool Cartoons

Gary the Gator

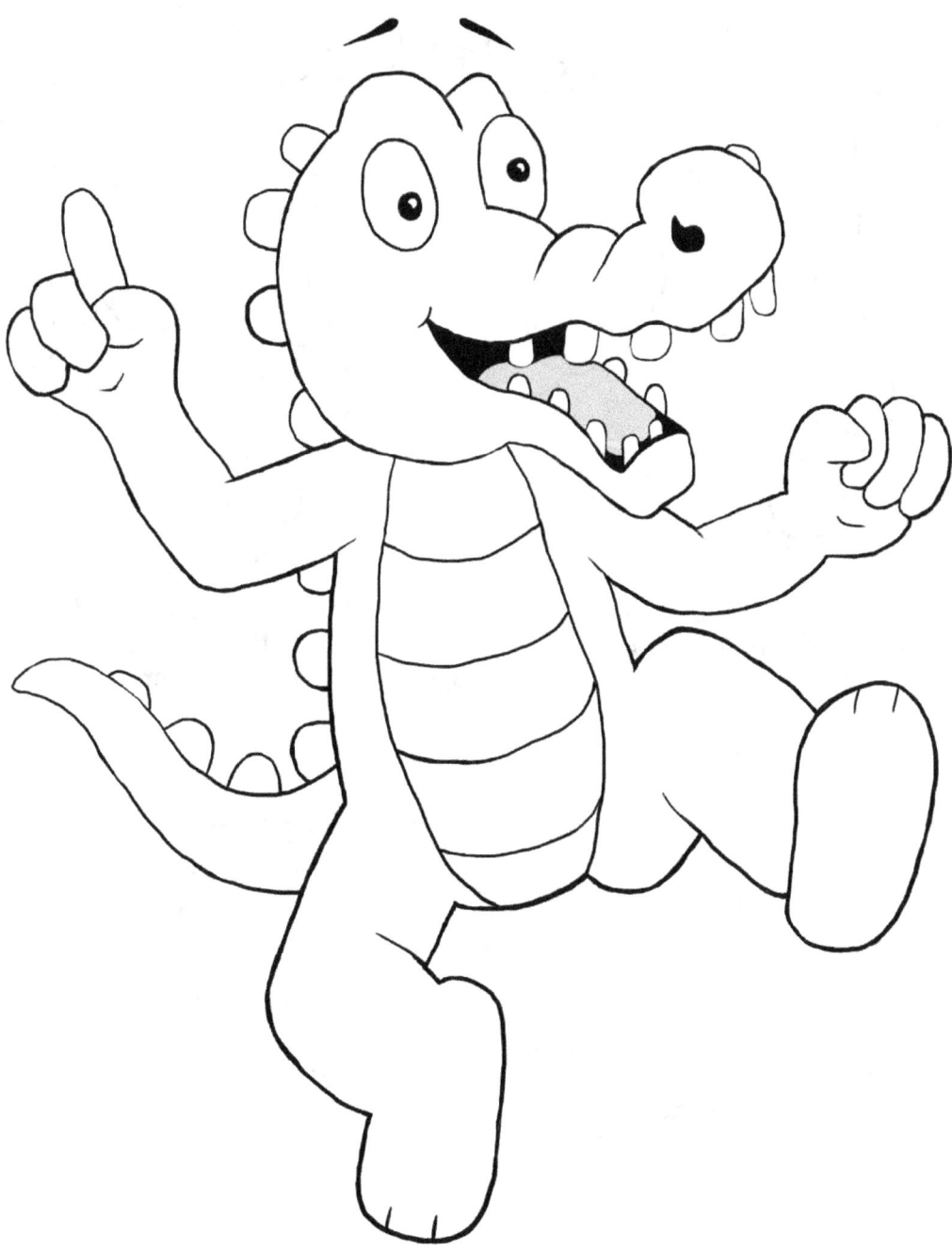

Turn Simple Shapes into Cool Cartoons

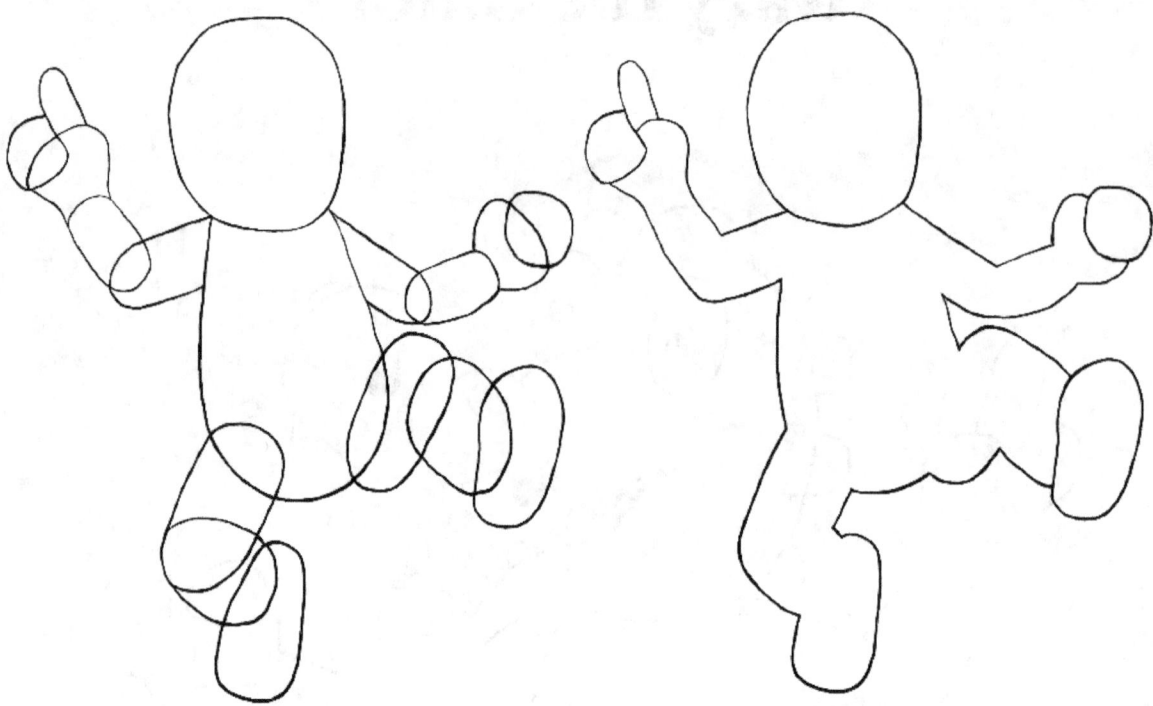

Step 1: Draw Gary the Gator in simple shapes.

Step 2: Now erase the unwanted lines where the shapes join in the ankles, knees, top of the legs, elbows, wrists, and hands.

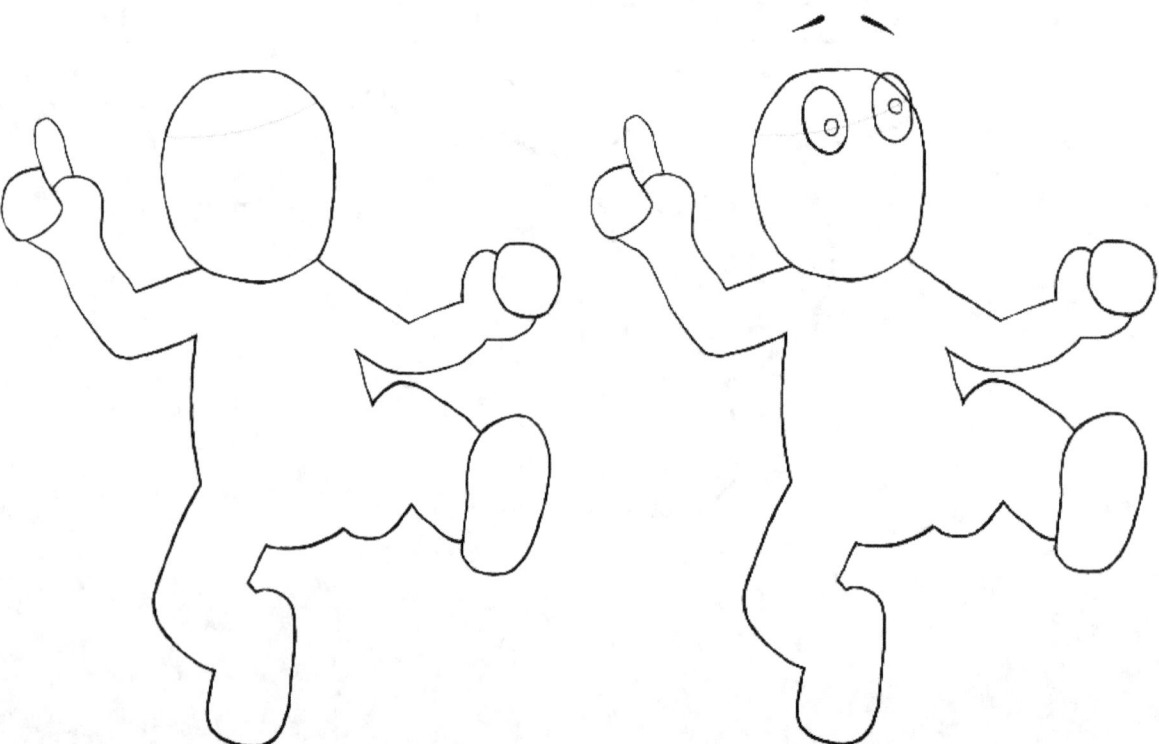

Step 3: Draw a light line where Gary's eyes will appear.

Step 4: Sketch his eyes.

Turn Simple Shapes into Cool Cartoons

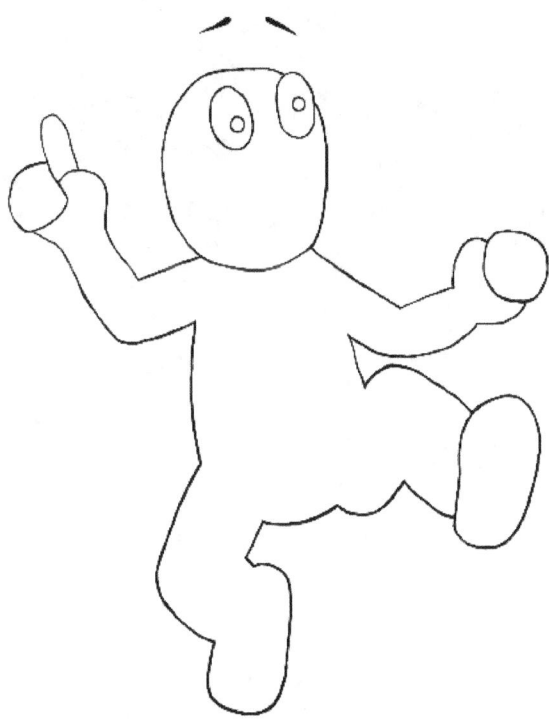

Step 5: Now erase the guideline and the line that runs through the top of his left eye.

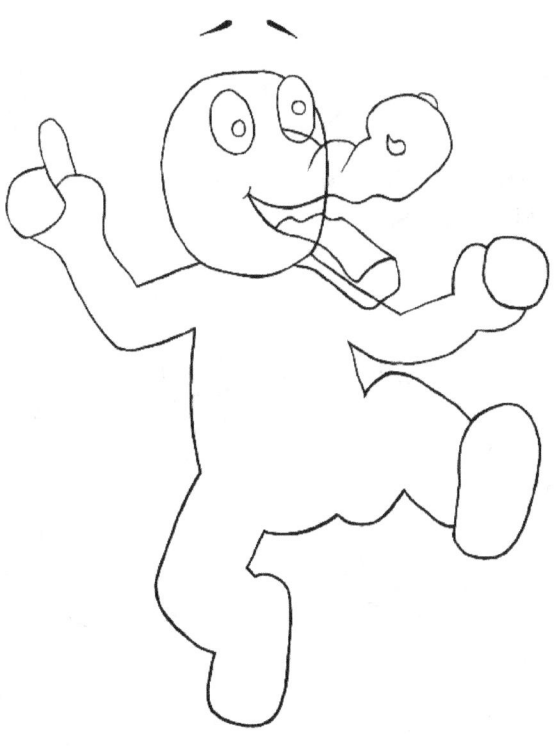

Step 6: Draw his nose, mouth, and tongue.

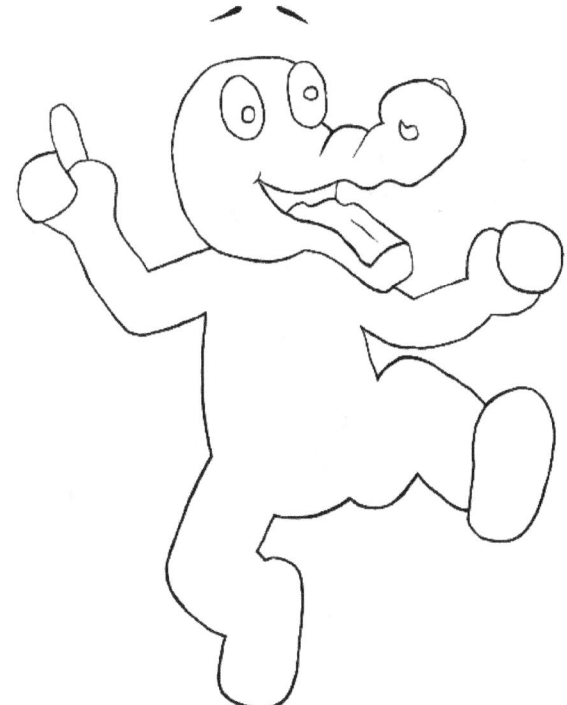

Step 7: Clean up his face by erasing the unwanted lines that run through his nose, mouth, and the bottom of his left eye.

Turn Simple Shapes into Cool Cartoons

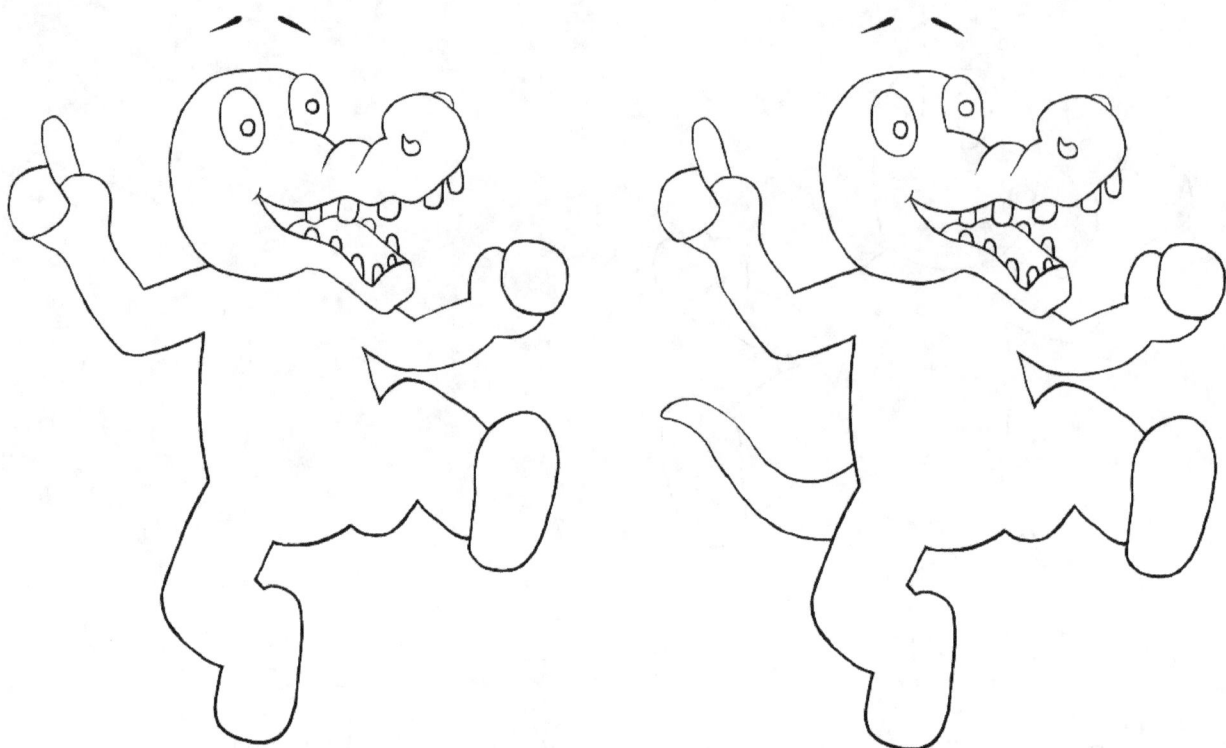

Step 8: Now draw the teeth and clean up any stray lines.

Step 9: Sketch Gary's tail.

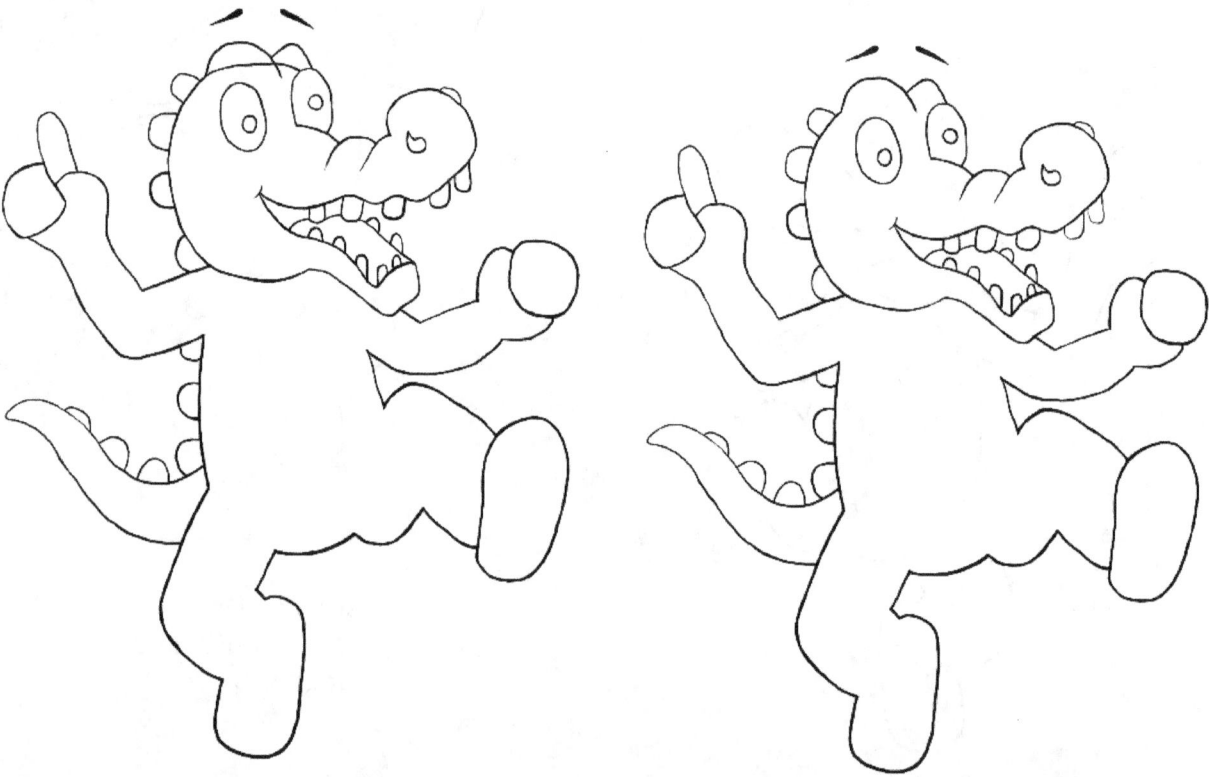

Step 10: Draw Gary's scales and bumps over his eyes.

Step 11: Now erase the stray lines that separate his head from the bumps on top of his head.

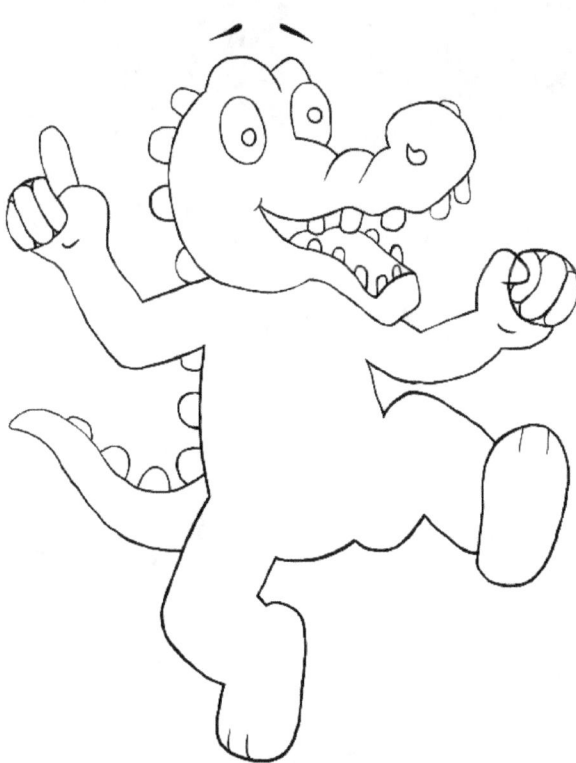

Step 12: Draw Gary's fingers and toes.

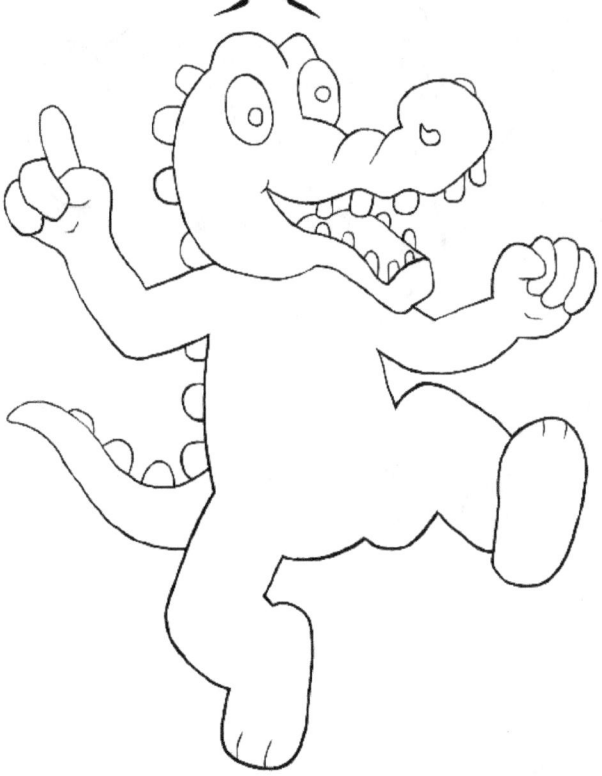

Step 13: Erase any stray marks around the knuckles and fingertips.

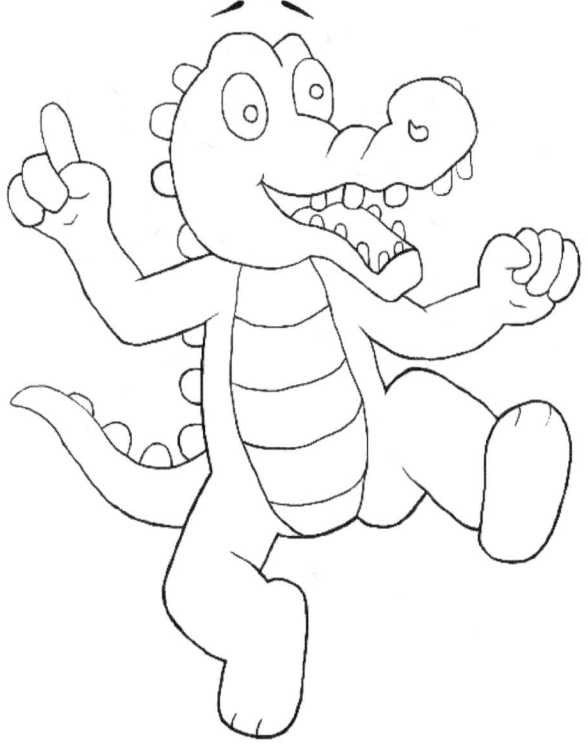

Step 14: Time to add detail to his chest. Give Gary's legs some crease marks behind his knees and elbows.

Turn Simple Shapes into Cool Cartoons

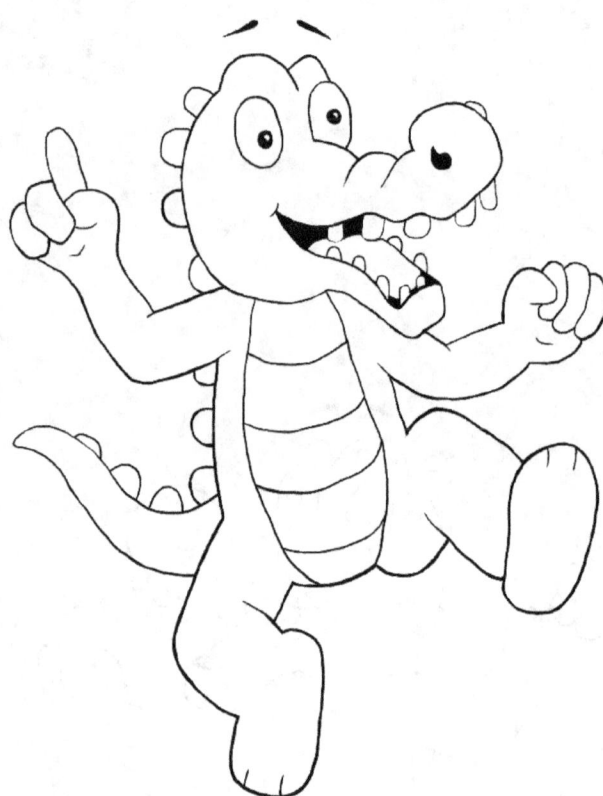

Step 15: Darken his eyes nostrils and mouth.

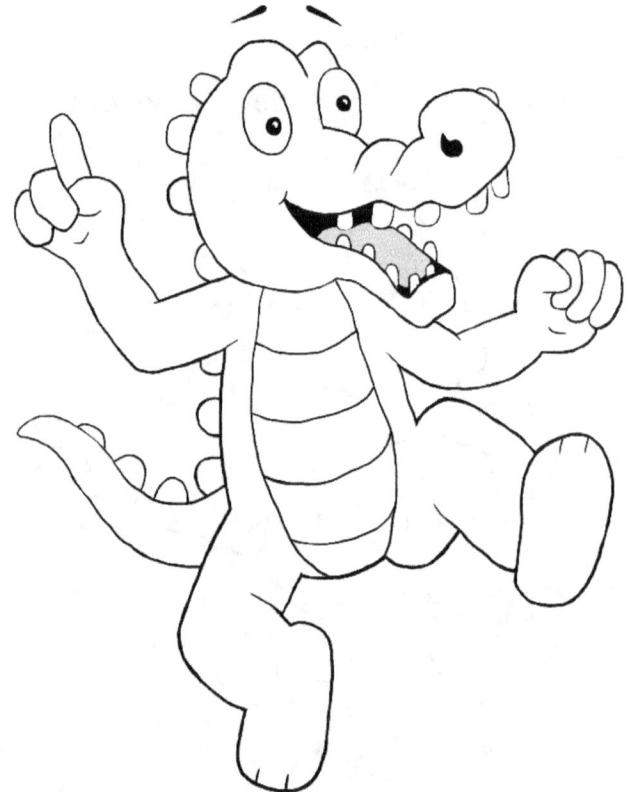

Step 16: Shade Gary's tongue and a patch of ground in gray. Now that's one happy gator.

Turn Simple Shapes into Cool Cartoons

Max the Mouse

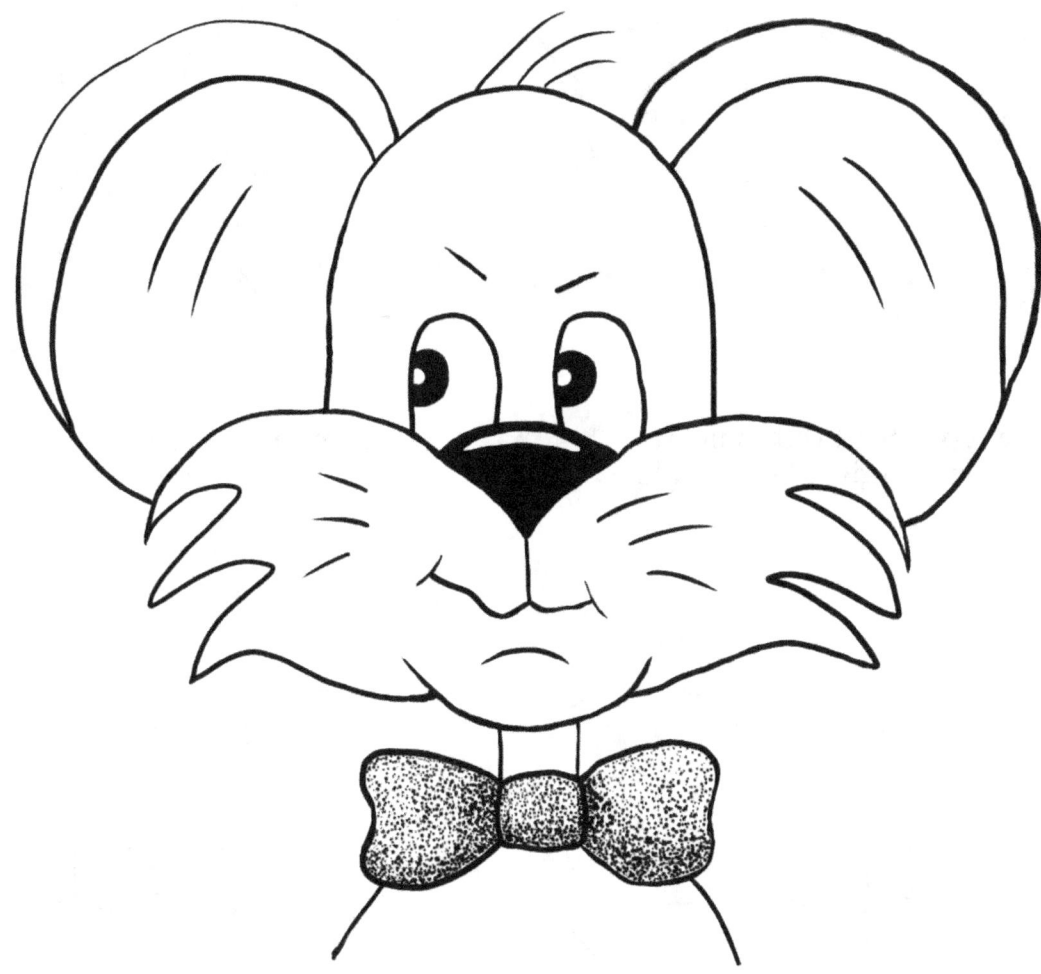

Turn Simple Shapes into Cool Cartoons

Step 1: Start with simple shapes to give Max an outline.

Step 2: Now erase all the unwanted pencil lines between his cheeks and jaws.

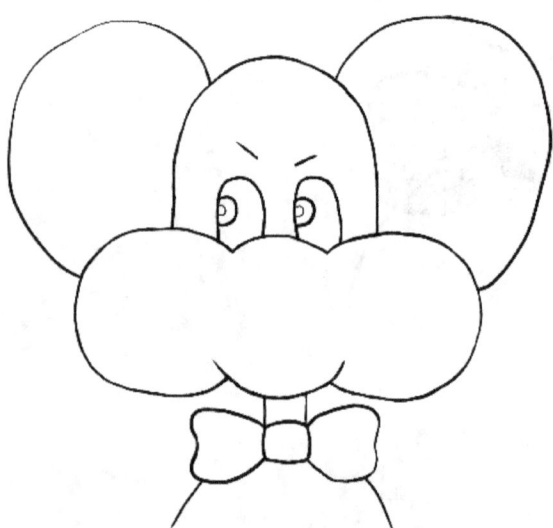

Step 3: Let's give Max expressive eyes.

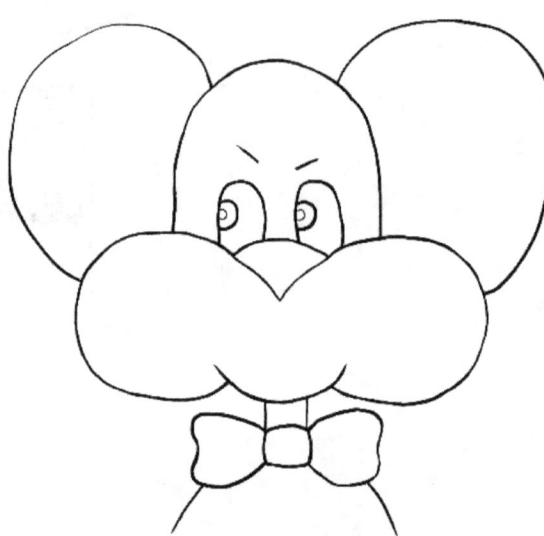

Step 4: Time to add the nose.

Turn Simple Shapes into Cool Cartoons

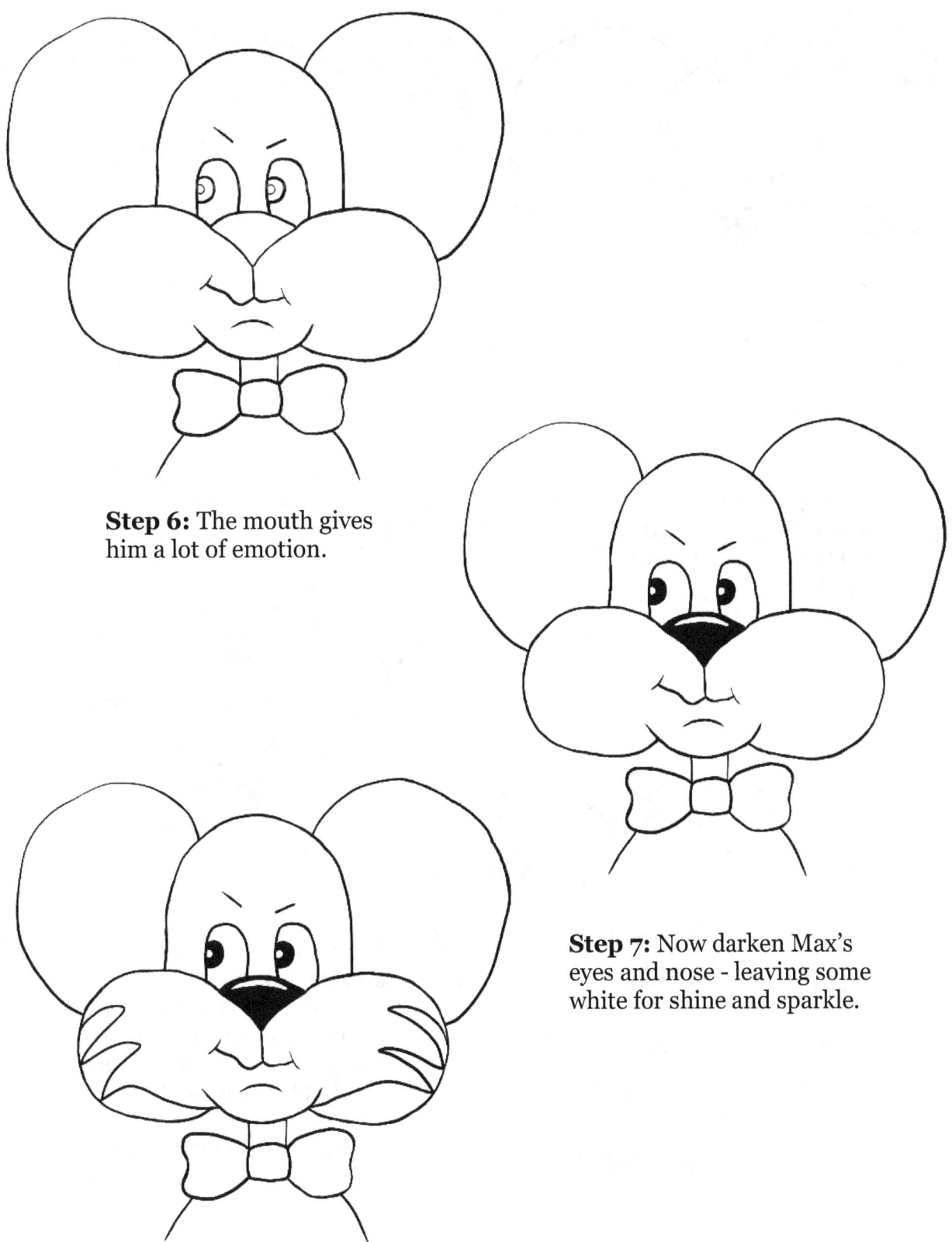

Step 6: The mouth gives him a lot of emotion.

Step 7: Now darken Max's eyes and nose - leaving some white for shine and sparkle.

Step 8: We can add fur by drawing zig-zag shapes along his cheeks.

Turn Simple Shapes into Cool Cartoons

Step 9: Now erase the unwanted pencil marks along the outside of his cheeks.

Step 10: Create details on the bow tie. All you need to do is tap the paper with the point of your pencil - leaving a round dot. Continue to do so until you've filled in the bow tie. For the darker areas, the dots are close together. For lighter areas, the dots are further apart from each other.

Step 11: Add details like whiskers, strands of hair on his head, and accent lines on the ears. You've just drawn a mouse with an attitude.

Turn Simple Shapes into Cool Cartoons

Moe the Lion

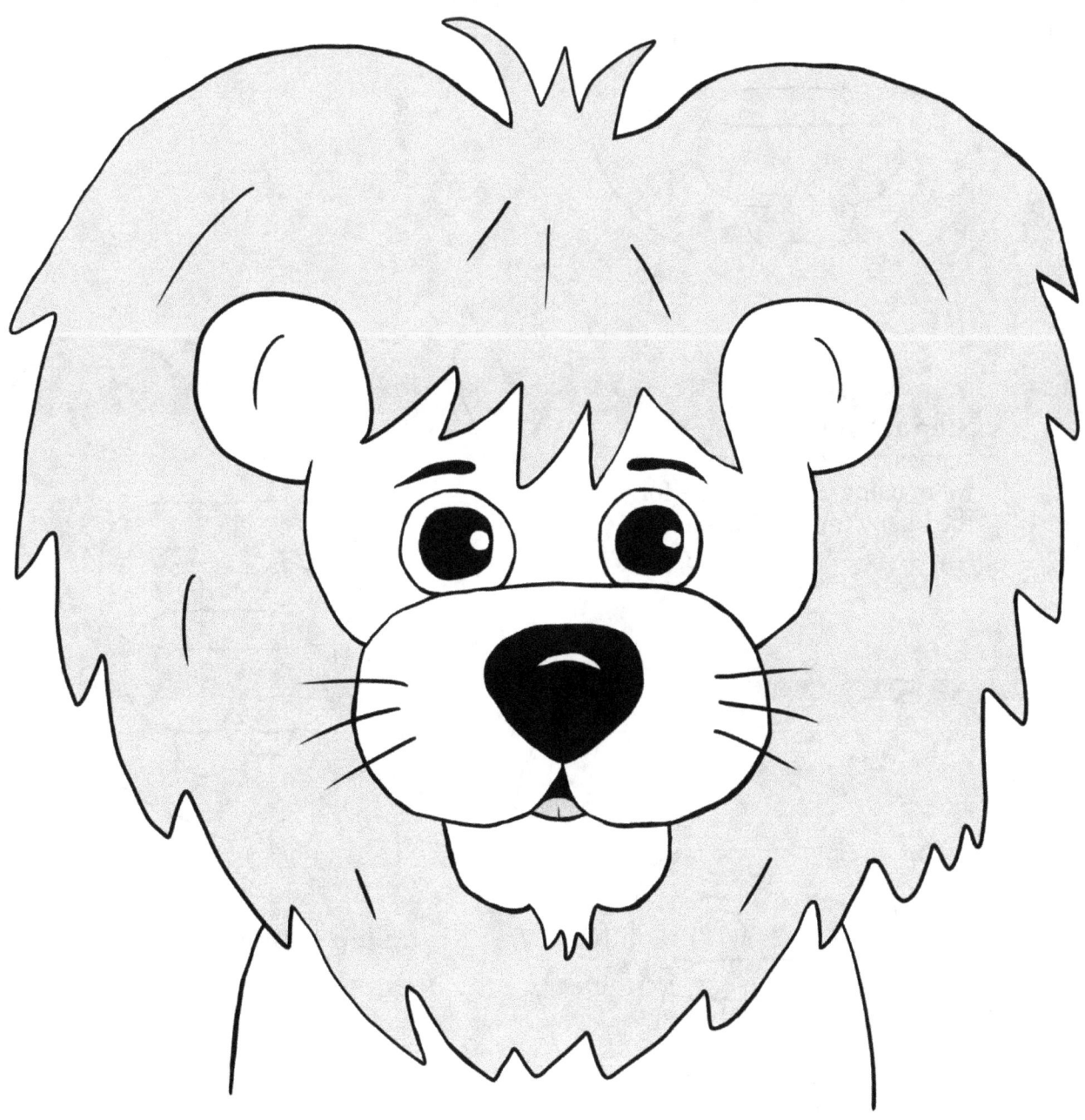

Turn Simple Shapes into Cool Cartoons

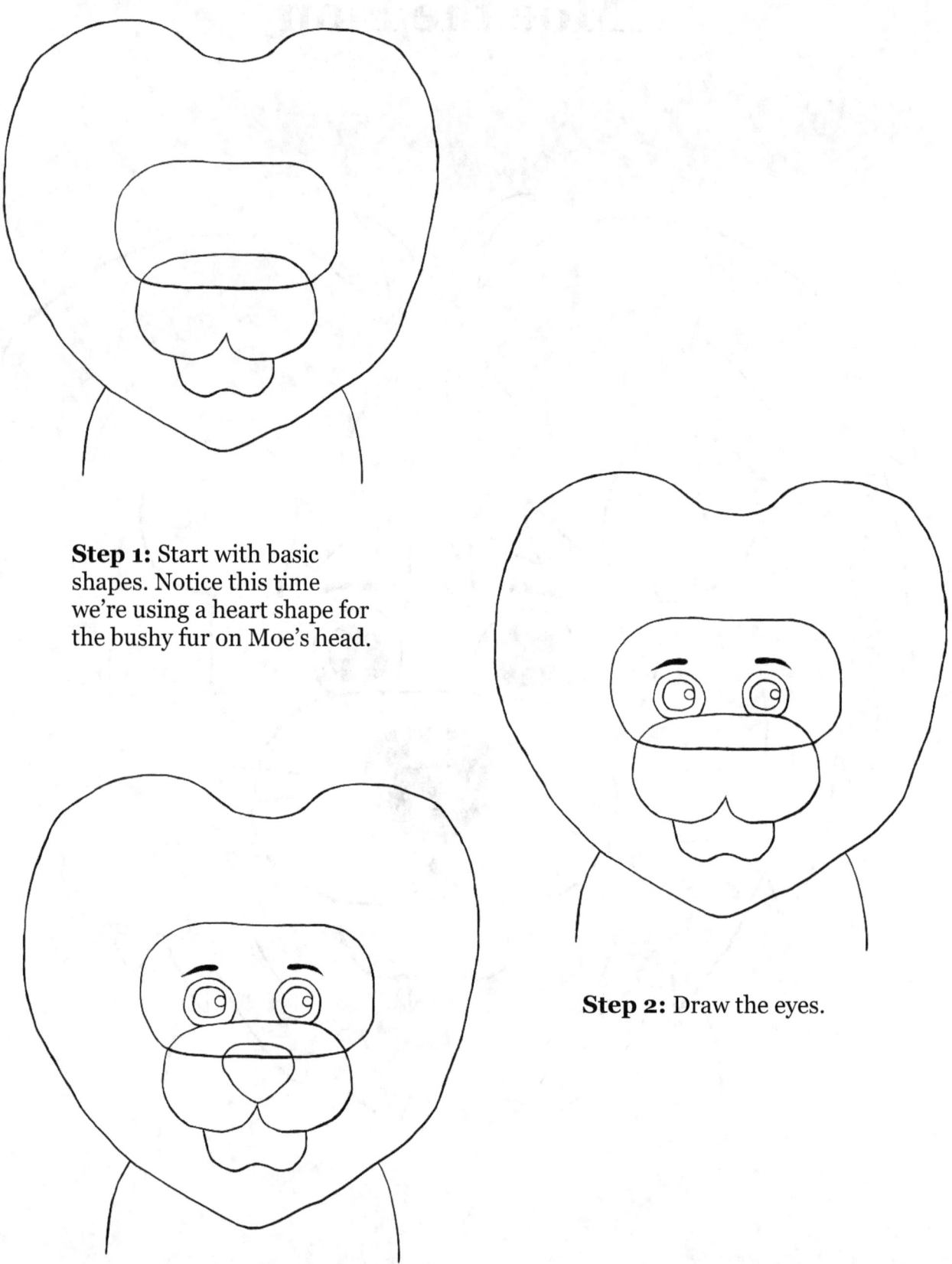

Step 1: Start with basic shapes. Notice this time we're using a heart shape for the bushy fur on Moe's head.

Step 2: Draw the eyes.

Step 3: Give him a large nose.

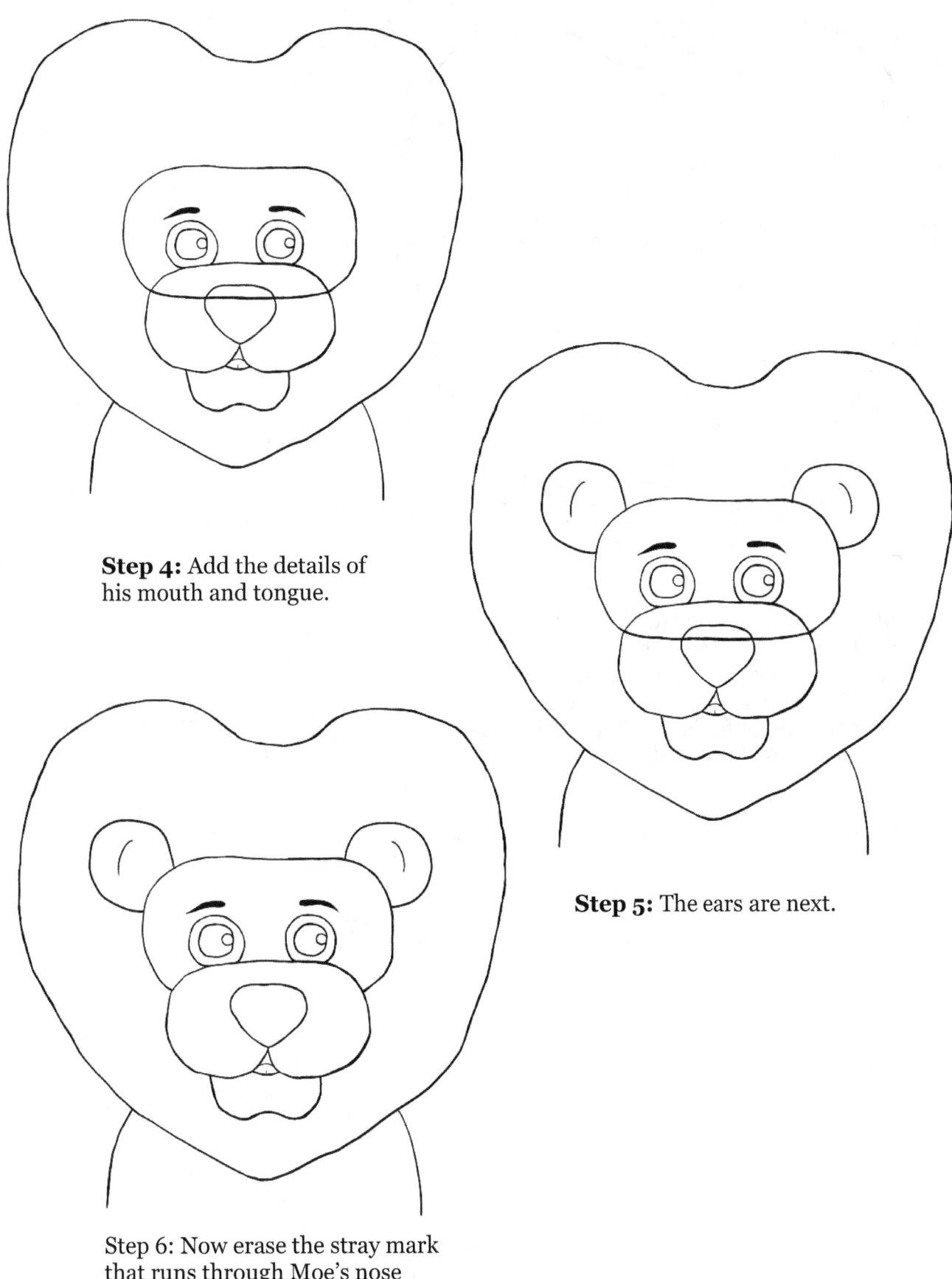

Step 4: Add the details of his mouth and tongue.

Step 5: The ears are next.

Step 6: Now erase the stray mark that runs through Moe's nose and muzzle. He's shaping up.

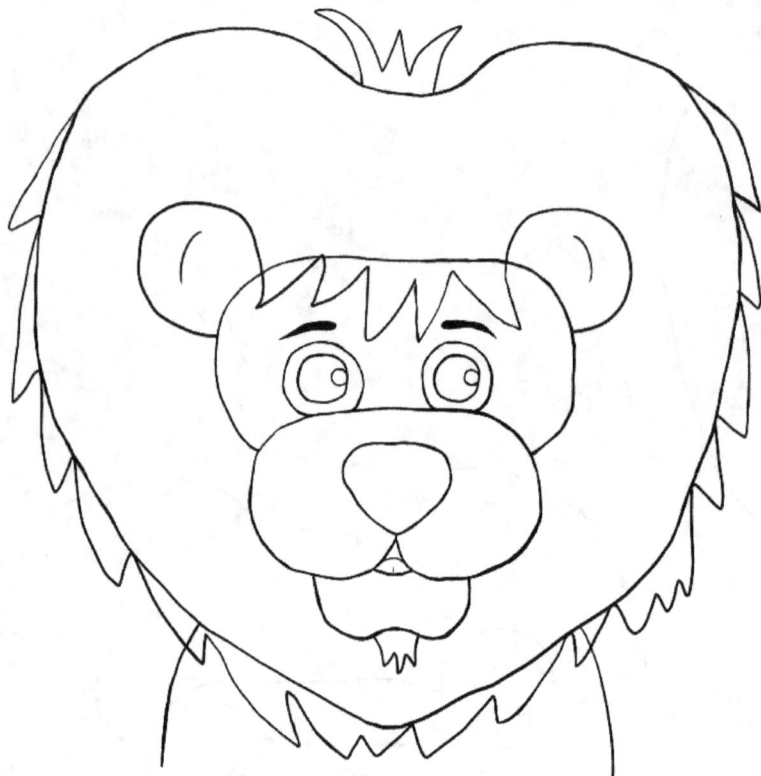

Step 7: Let's draw the fur. We can do this by creating zig-zag lines around his head, forehead, chin. Moe is king of the jungle. So, let's include a tuft of fur in the shape of a crown on top of his head.

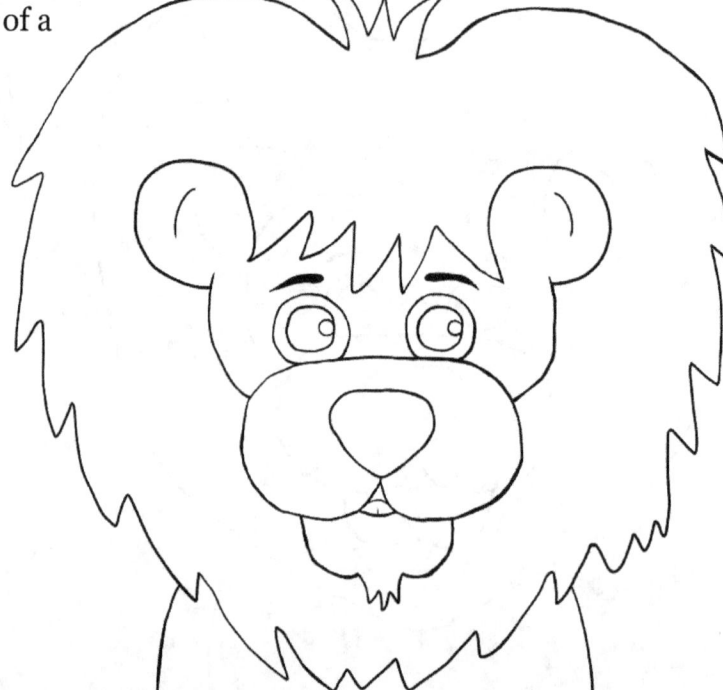

Step 8: Erase all the unneeded lines that separate the fur from his body.

Turn Simple Shapes into Cool Cartoons

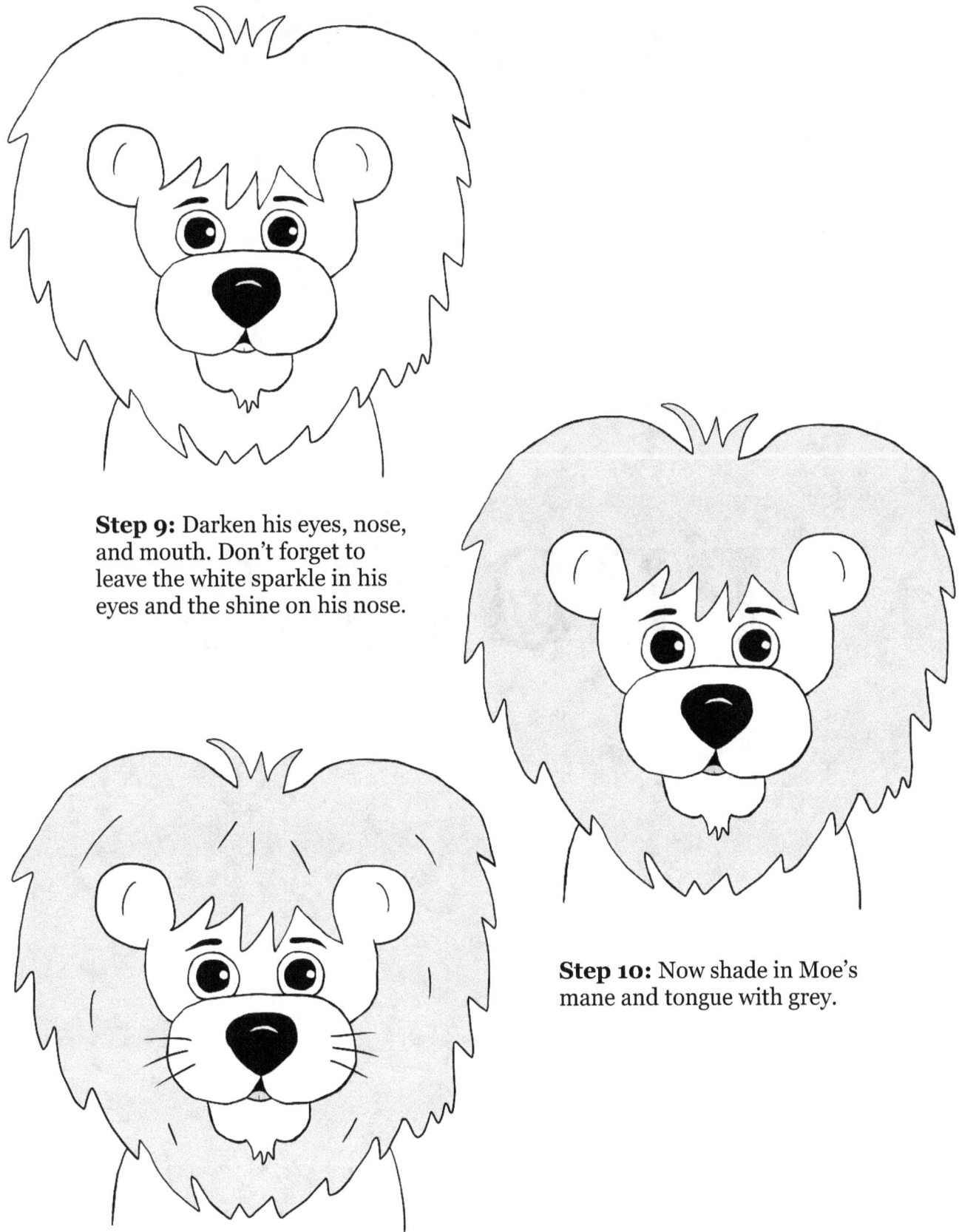

Step 9: Darken his eyes, nose, and mouth. Don't forget to leave the white sparkle in his eyes and the shine on his nose.

Step 10: Now shade in Moe's mane and tongue with grey.

Step 11: Add stray lines and detail to the mane and whiskers. Long live the king.

PEOPLE

Turn Simple Shapes into Cool Cartoons

Nervous Nick

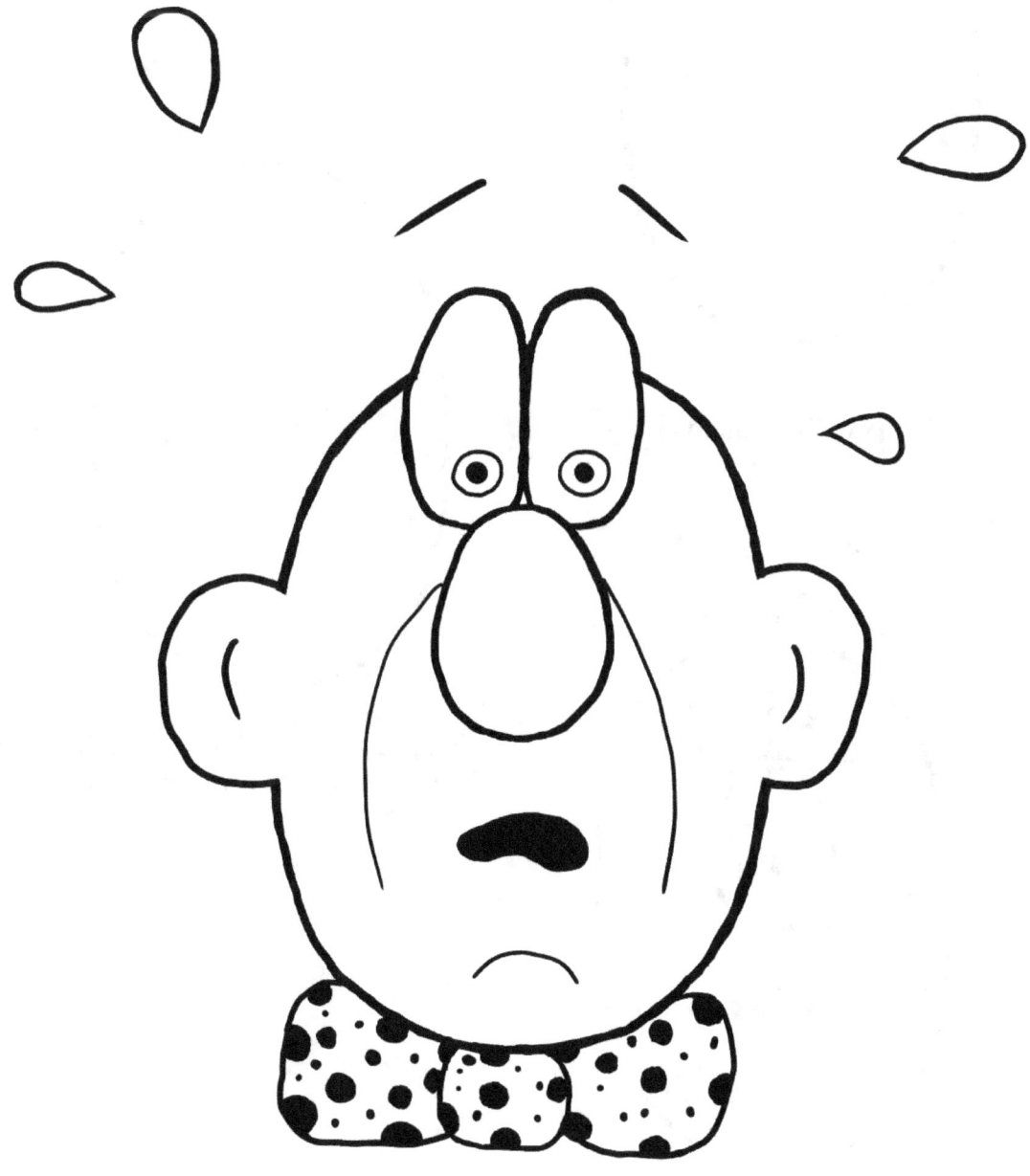

Turn Simple Shapes into Cool Cartoons

Step 1: Draw an oval.

Step 2: Lightly sketch guidelines to show where the eyes, nose, and mouth will go.

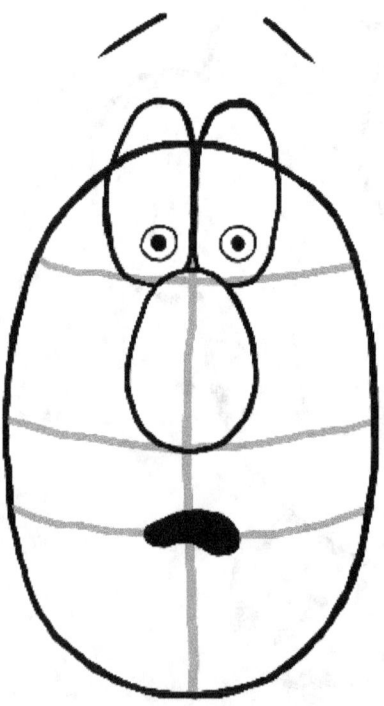

Step 3: Then draw Nick's eyes, nose, and mouth. Don't forget his raised eyebrows. They help exaggerate Nick's nervousness.

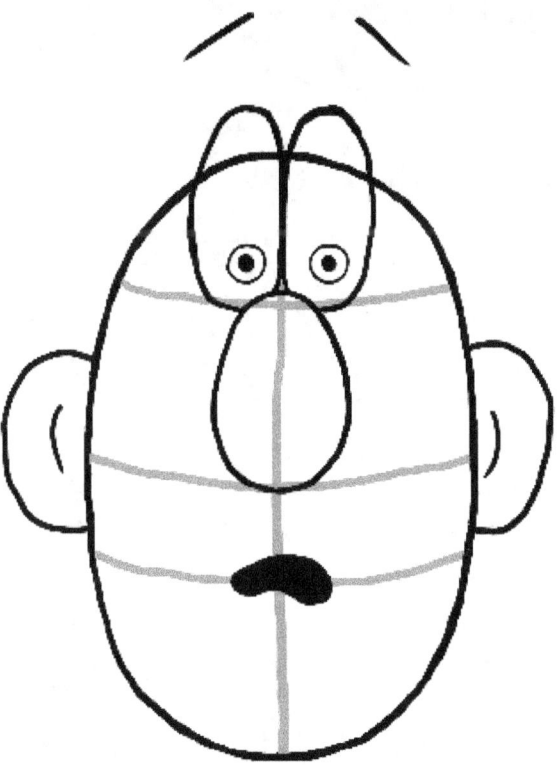

Step 4: Now it's time to give him some ears.

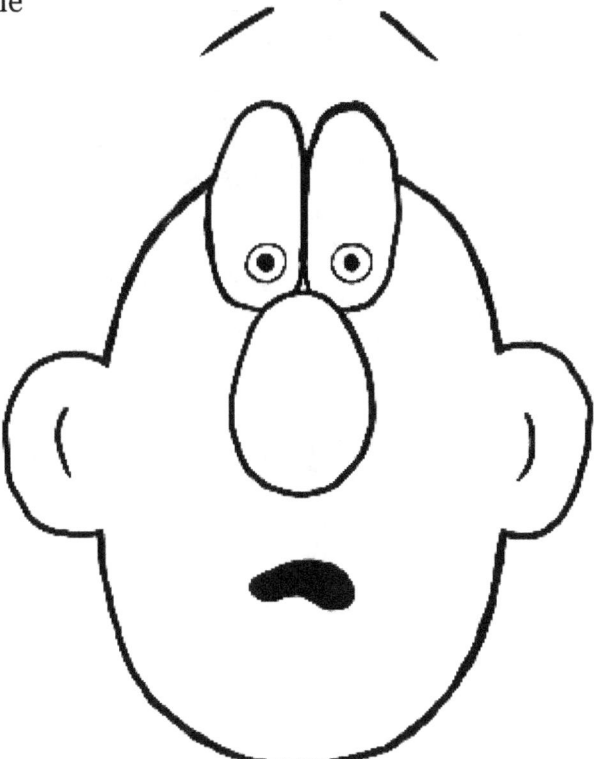

Step 5: Carefully erase the guidelines.

Turn Simple Shapes into Cool Cartoons

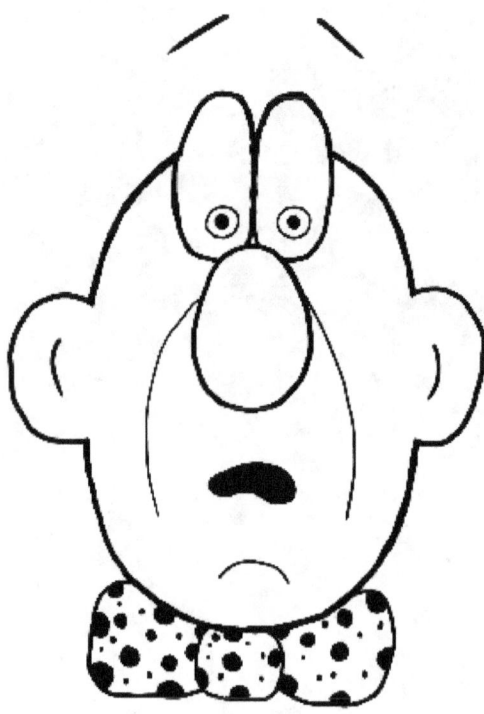

Step 6: Now add the detail lines to Nick's cheeks and give him a bow tie.

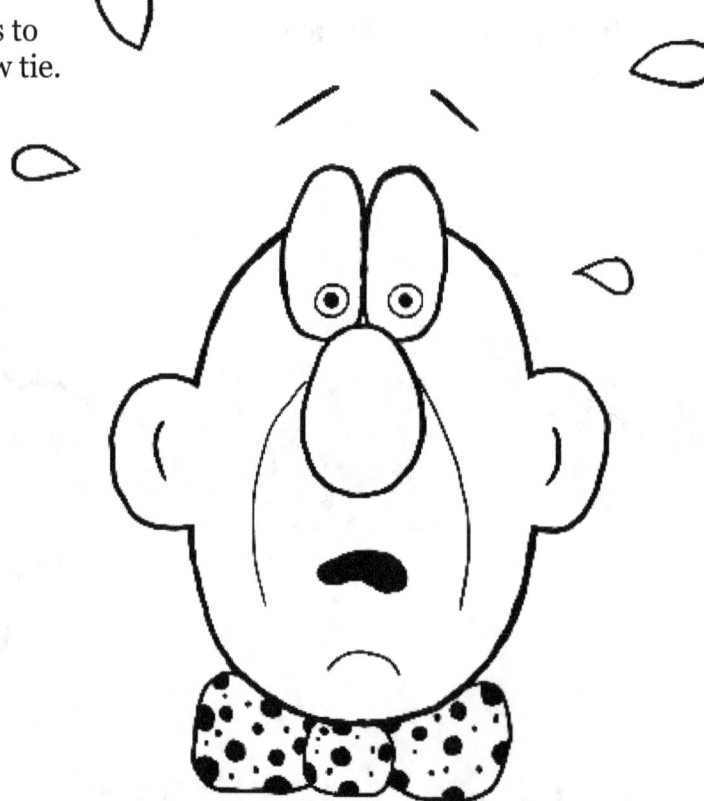

Step 7: Your almost done. The only thing left to do is add sweat drops coming from his forehead.

Fred

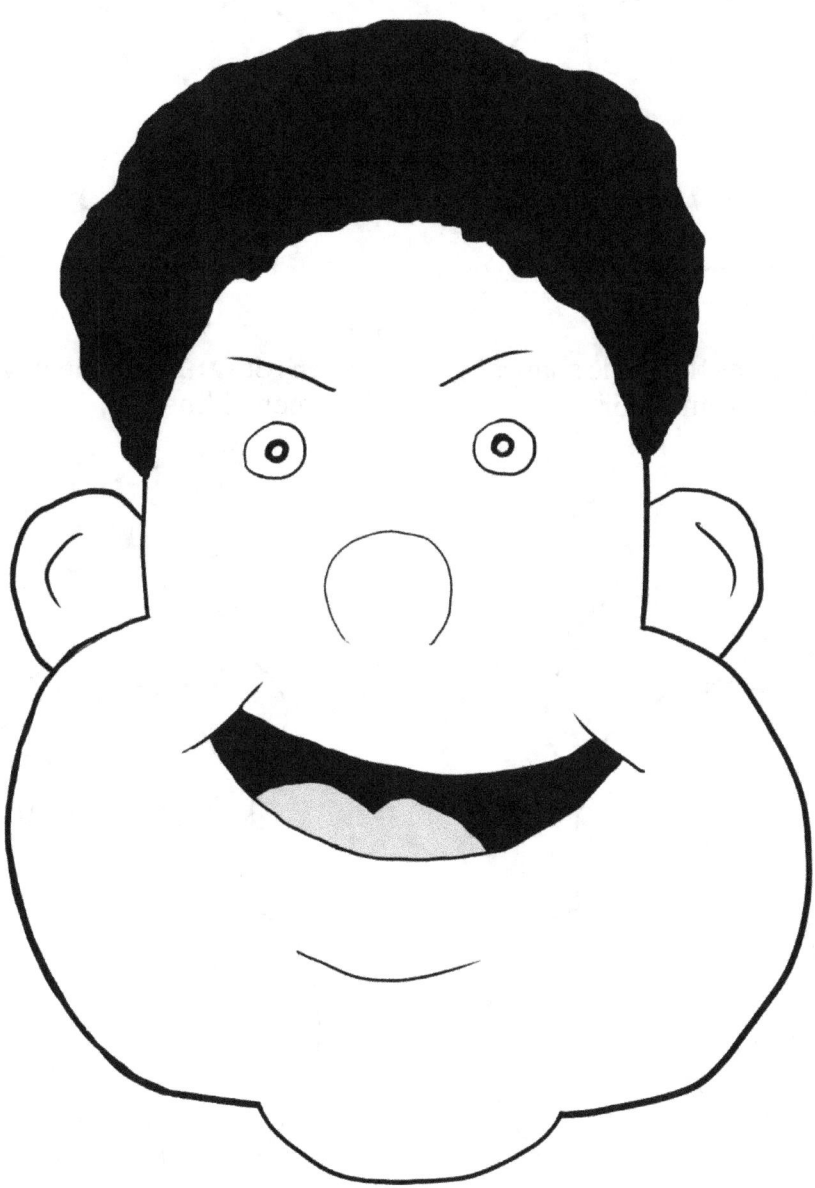

Turn Simple Shapes into Cool Cartoons

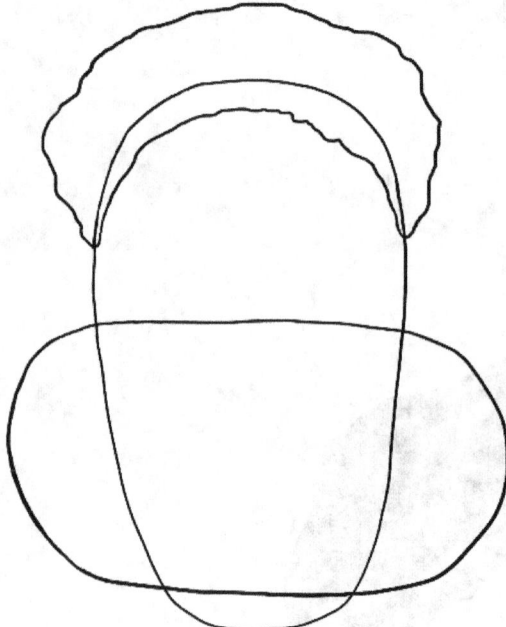

Step 1: Draw the basic shapes of Fred's face and hair.

Step 2: Erase the unwanted pencil lines.

Step 3: Lightly draw the guidelines for Fred's eyes, nose, and mouth. This will help you line them up better.

Step 4: Next draw Fred's eyes.

Turn Simple Shapes into Cool Cartoons

Step 5: Let's give him a turned-up nose.

Step 6: Fred needs a great big smile.

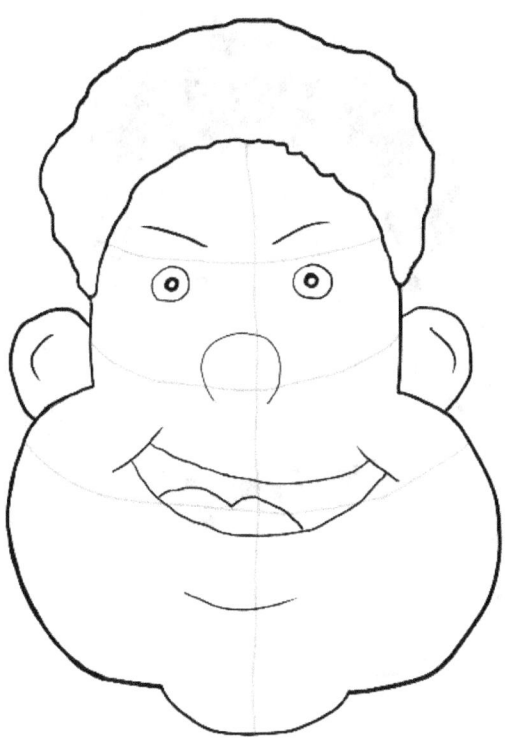

Step 7: Now draw his ears.

Turn Simple Shapes into Cool Cartoons

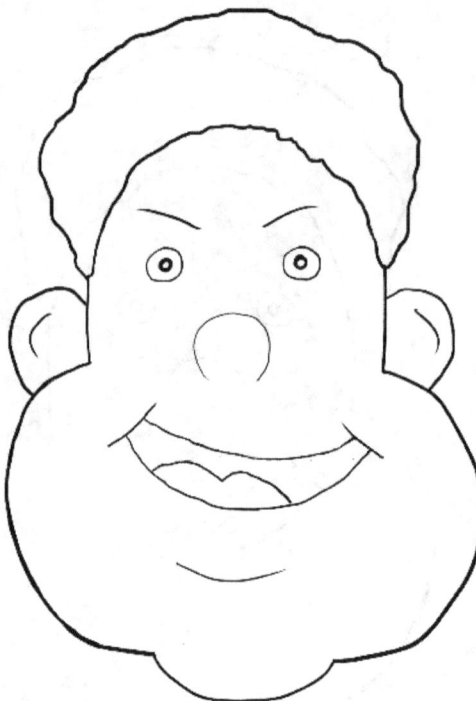

Step 8: Carefully erase the guidelines.

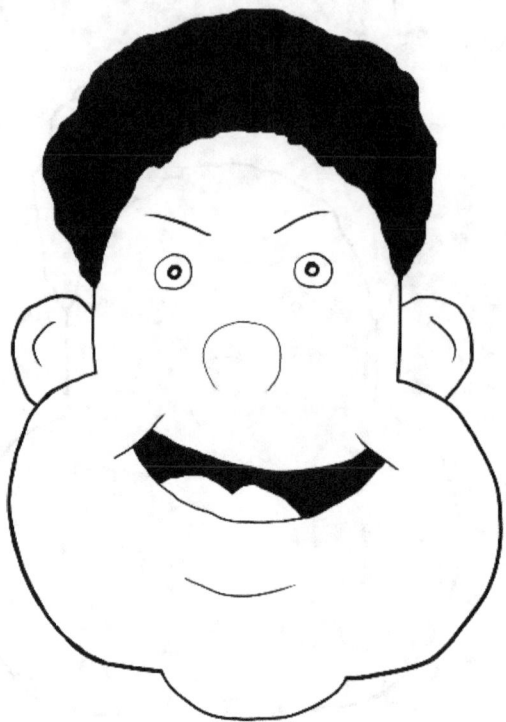

Step 9: Color in Fred's hair and mouth to make him stand out.

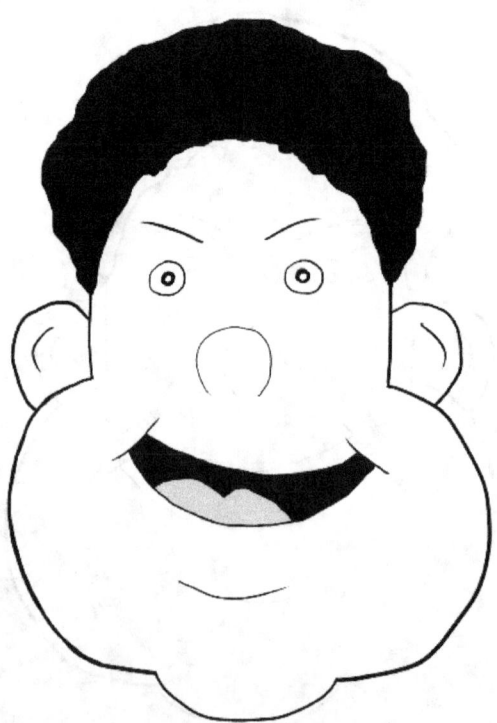

Step 9: Shade his tongue and you're done.

Big Benny

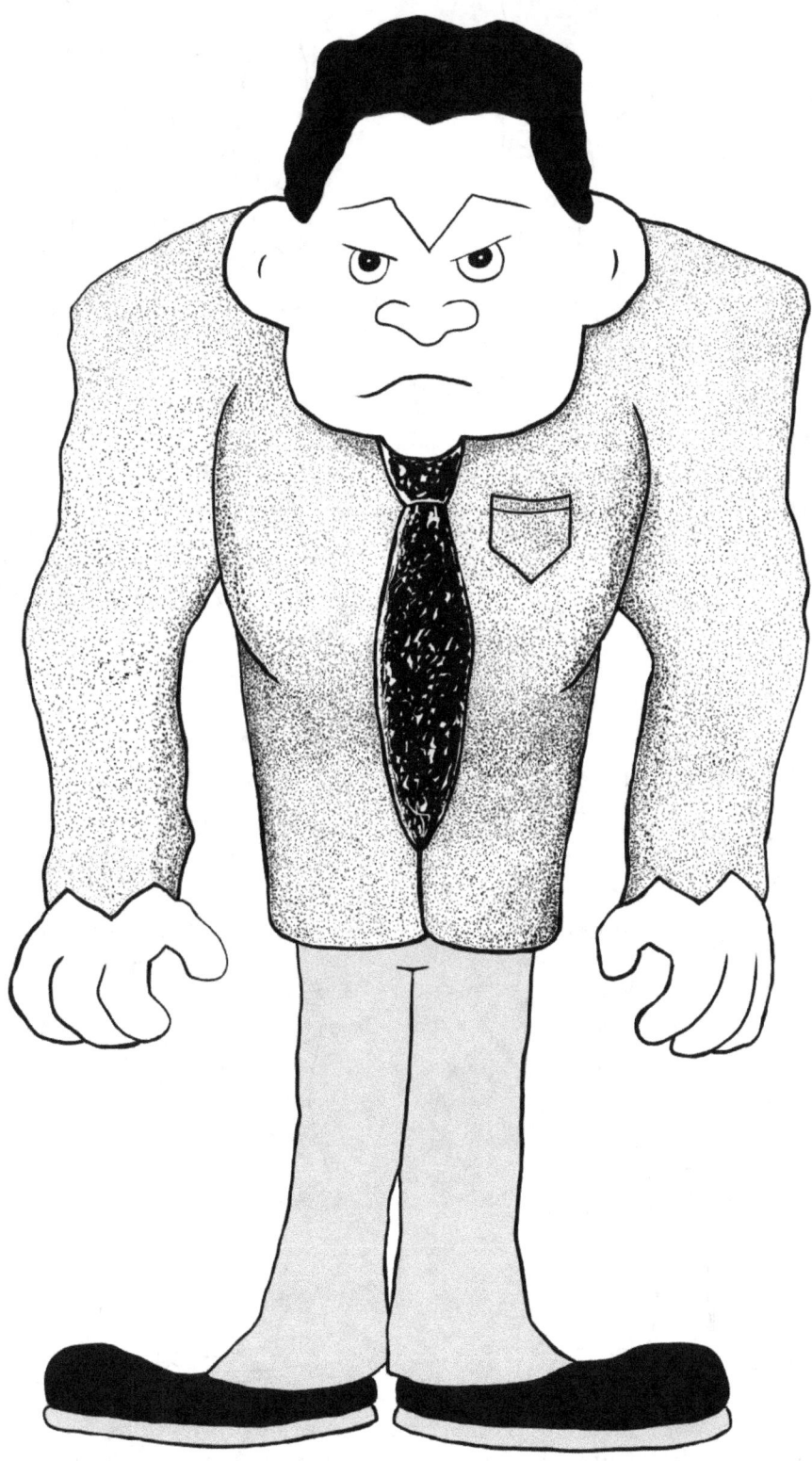

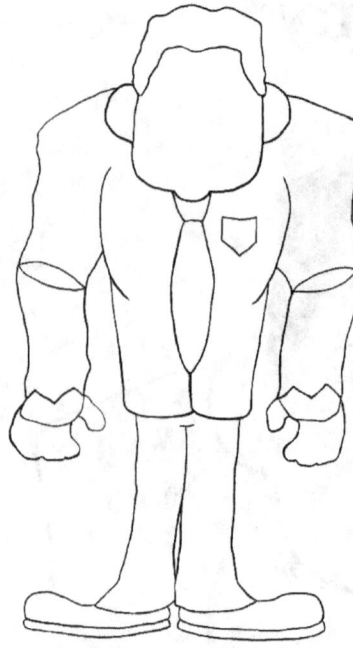

Step 1: Lightly draw the outlines and basic shapes.

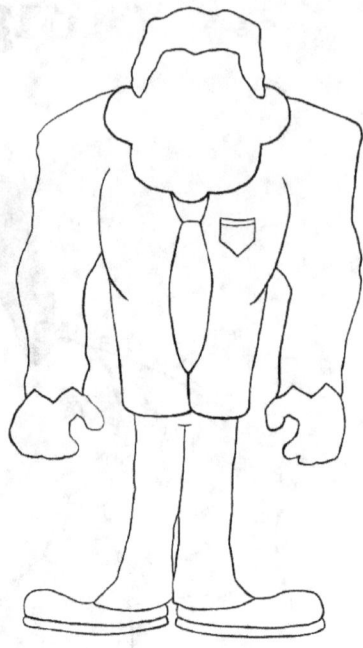

Step 2: Now erase all the unwanted pencil marks around the elbows and hands.

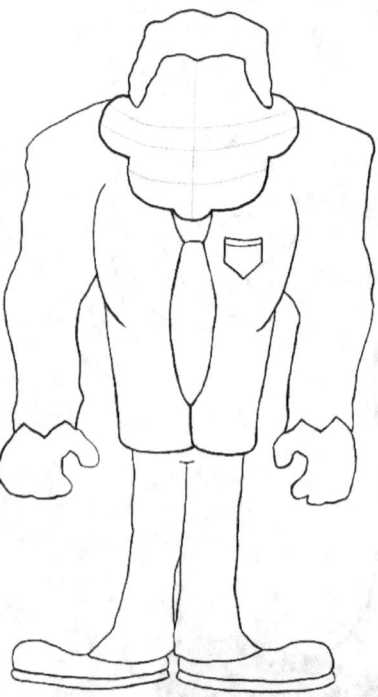

Step 3: Lightly draw guidelines for Ben's eyes, nose, and mouth.

Step 4: Let's give Ben some eyes.

Turn Simple Shapes into Cool Cartoons

Step 5: Ben is big and broad, so we'll draw a large nose.

Step 6: He's also a little frustrated. So, let's give him a frown.

Step 7: Now erase the guidelines. His face is taking shape.

Step 8: Darken Ben's hair, tie, and shoes. This'll help him stand out more. Shade the tie by overlapping little squiggly lines - leave white spaces for texture.

Turn Simple Shapes into Cool Cartoons

Step 9: Shade in his pants and the bottom of his shoes with gray.

Step 10: Add details like the lines for his fingers and the detail inside of his ears.

Step 11: Add texture to his jacket by taking the tip of your pencil or pen and creating little dots. The closer together the dots are, the darker the shading will become. You want to go darker under his chin, chest, and arms. The shading makes him pop off the paper.

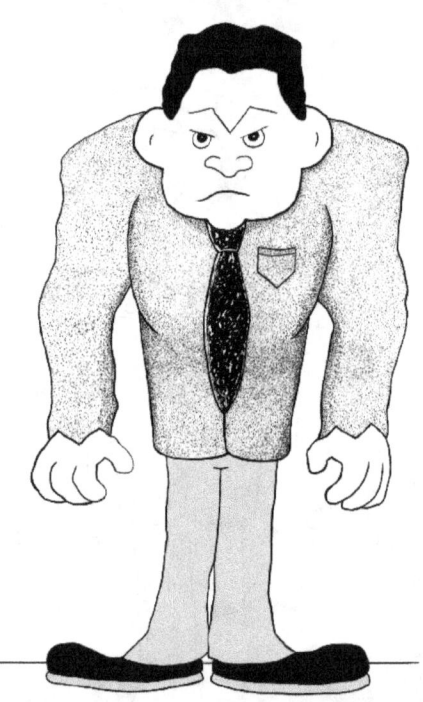

Step 12: The only thing left to do is draw a horizontal line behind Ben's feet. This will make him look like he's got his feet on the ground.

Moody Meg

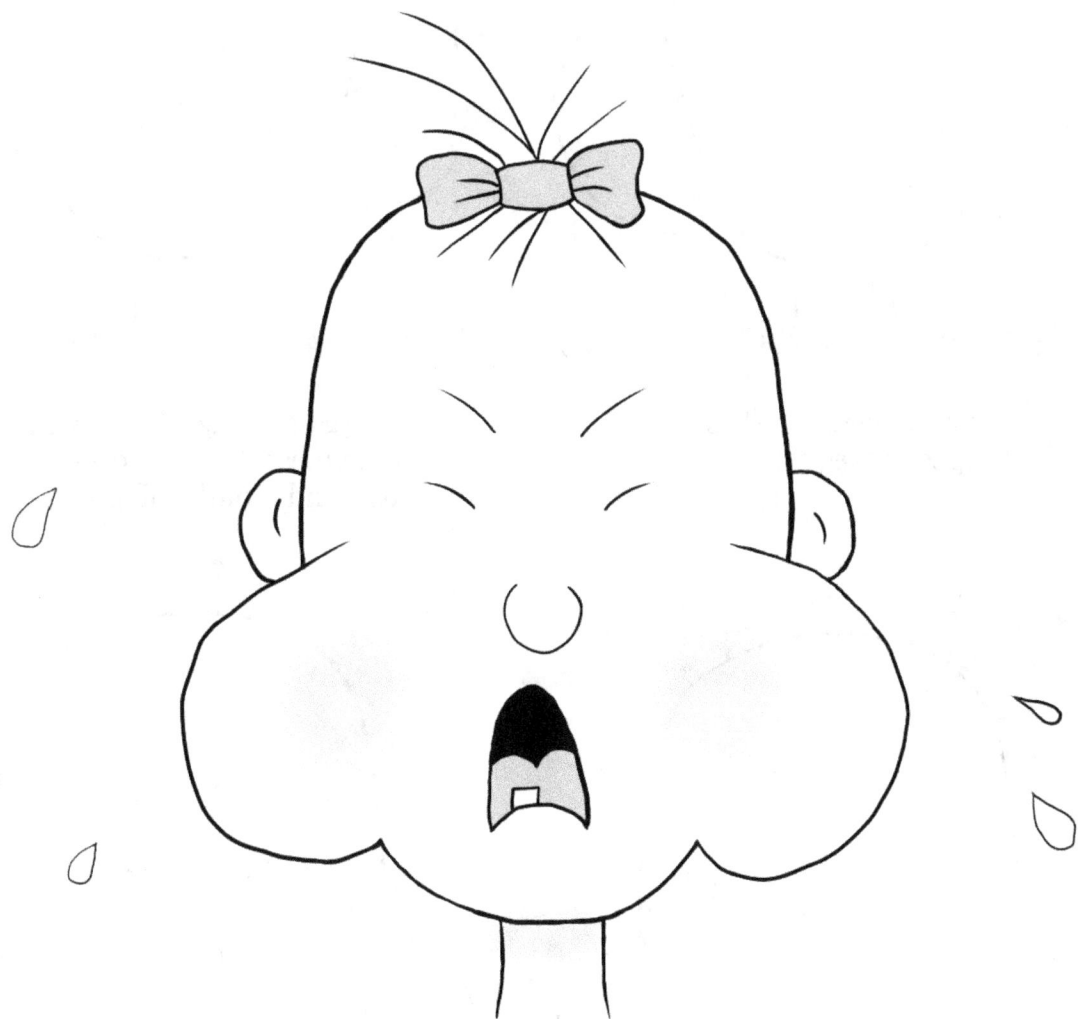

Step 1: Sketch the basic shapes of Meg's face.

Step 2: Now lightly draw the guidelines where the eyes, nose, and mouth will go.

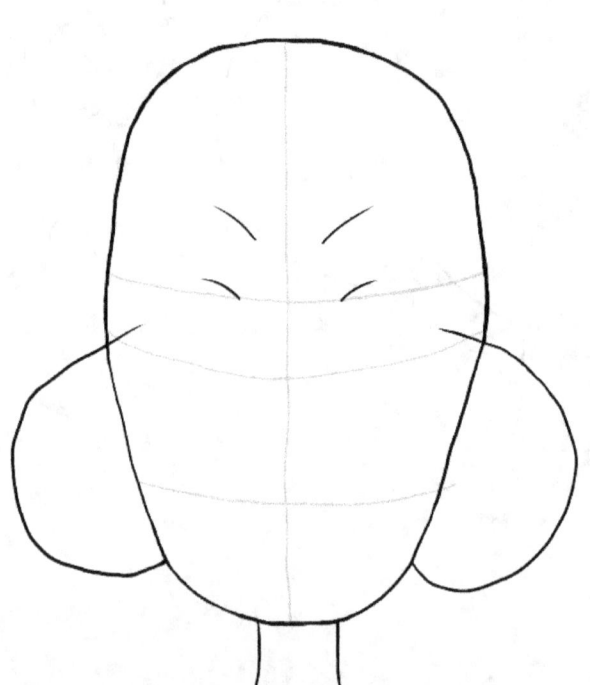

Step 3: Let's give Meg some closed eyes.

Step 4: Then, a button nose...

Turn Simple Shapes into Cool Cartoons

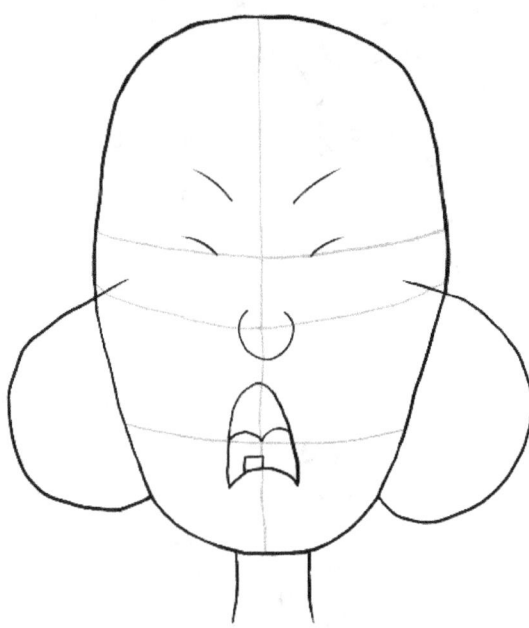

Step 5: ...and a wide-open mouth.

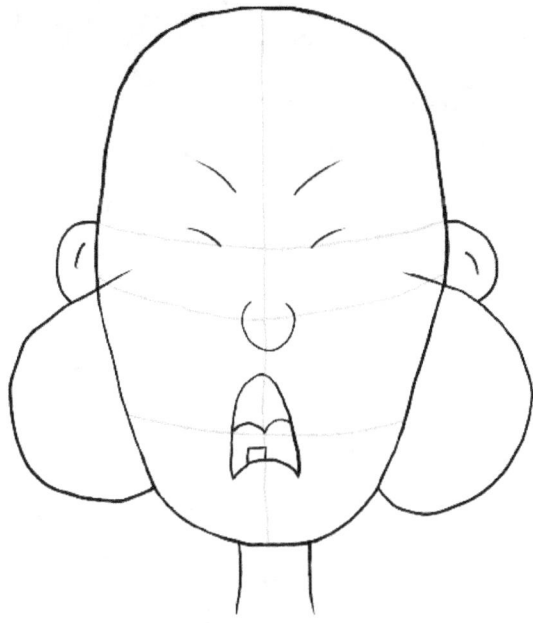

Step 6: Draw her ears.

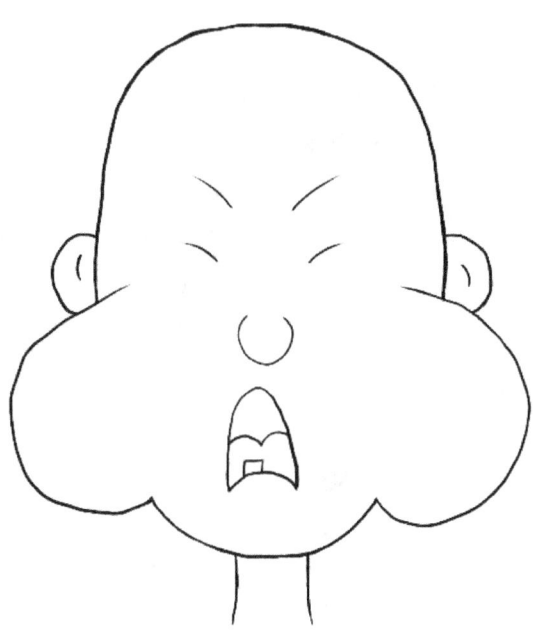

Step 7: Now erase the unwanted pencil marks around her jaw. This will make her cheeks join her body.

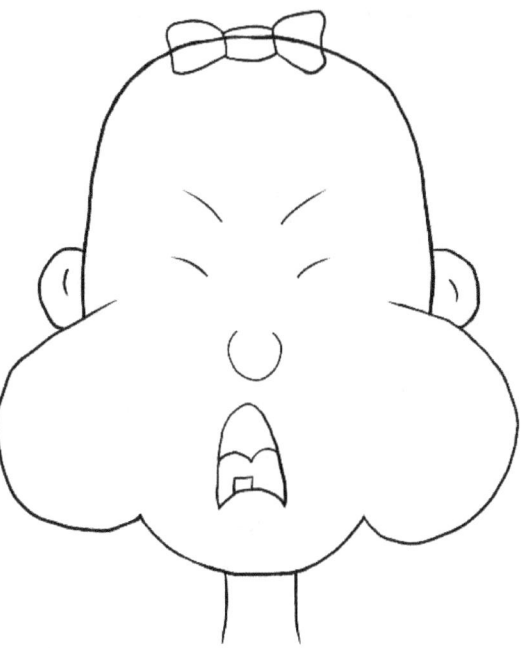

Step 8: Give Meg a bow on the top of her head.

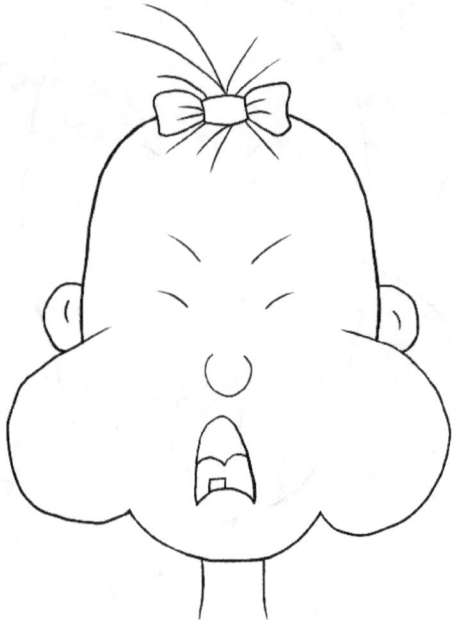

Step 9: Add some hair, erase the unwanted pencil line that runs through the bow, and add some detail lines to the bow.

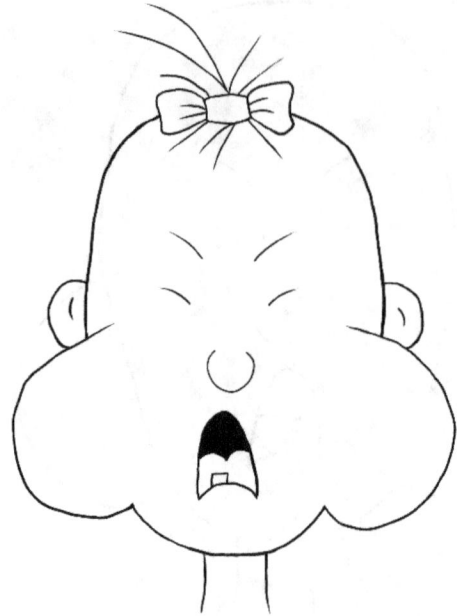

Step 10: Shade in Meg's mouth with black.

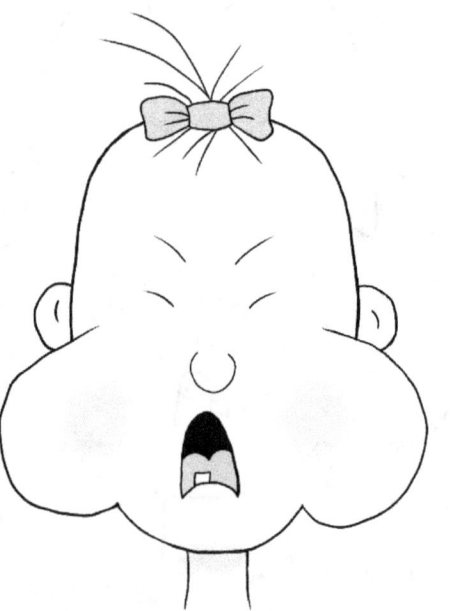

Step 11: Now add some gray tones to her bow, cheeks, tongue, and under her chin.

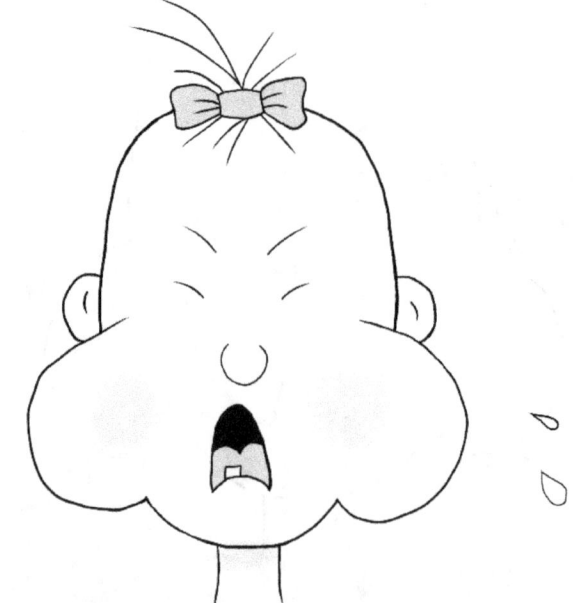

Step 12: Draw some tear drops and Moody Meg is complete. Time for her to take a nap.

Hello from Henry

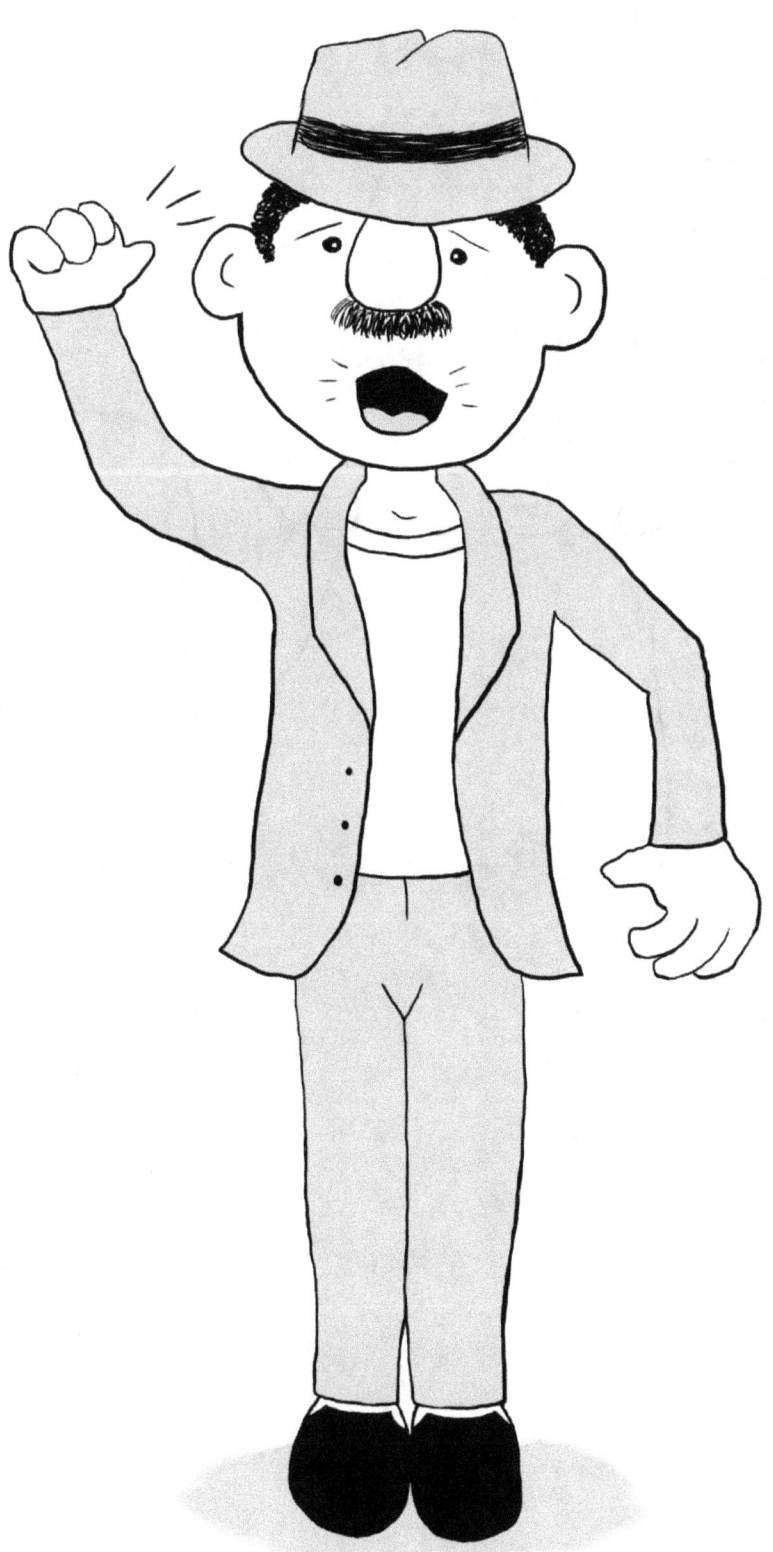

Step 1: Divide Henry into these simple shapes.

Step 2: Draw light guidelines that show where his eyes, nose, and mouth will go.

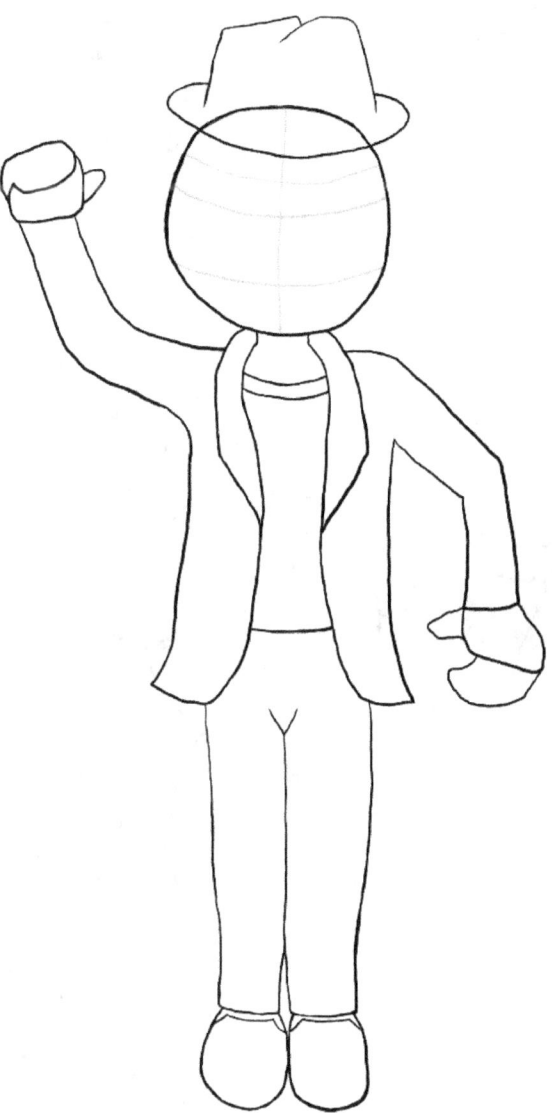

Step 3: Let's give Henry a cool hat.

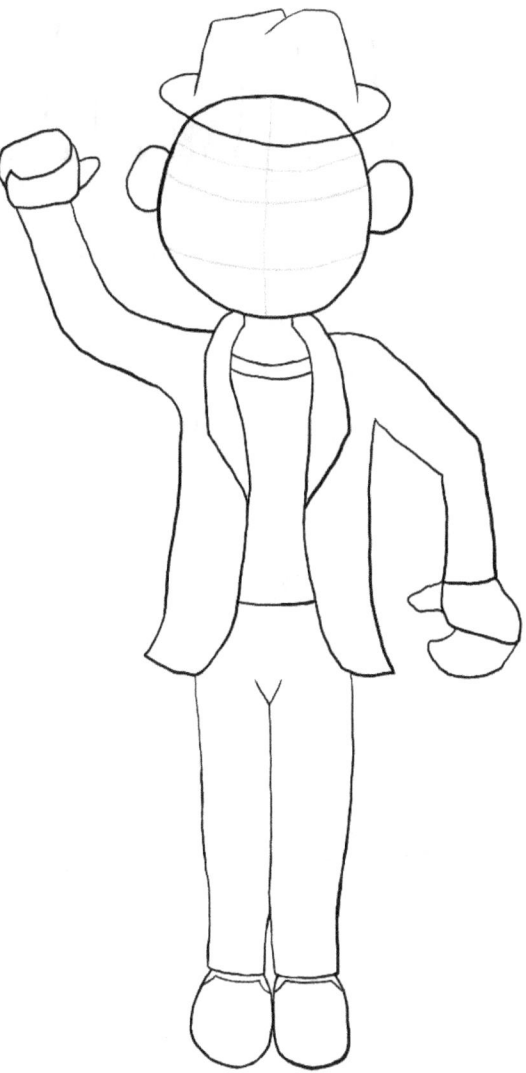

Step 4: Using the guidelines as a reference, draw his ears.

Turn Simple Shapes into Cool Cartoons

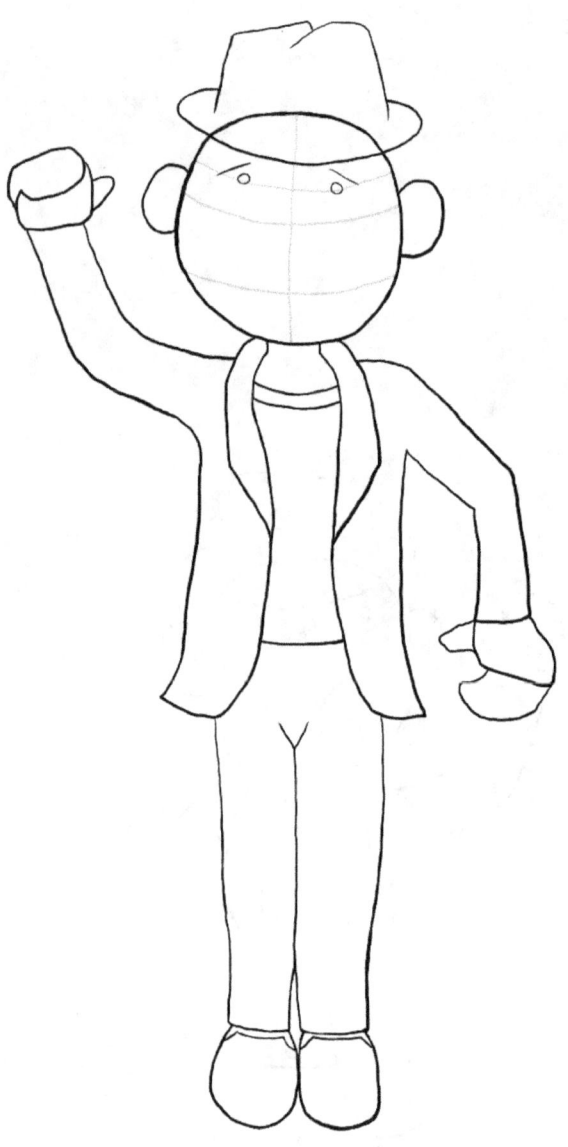

Step 5: Now draw his eyes.

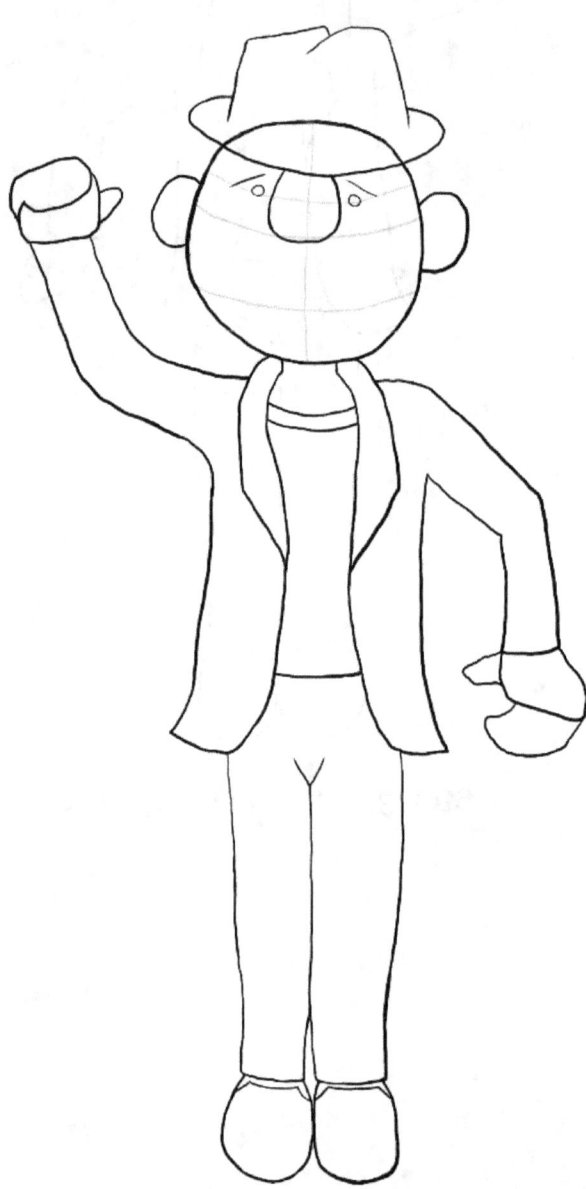

Step 6: Give Henry a big nose poking out from under his hat.

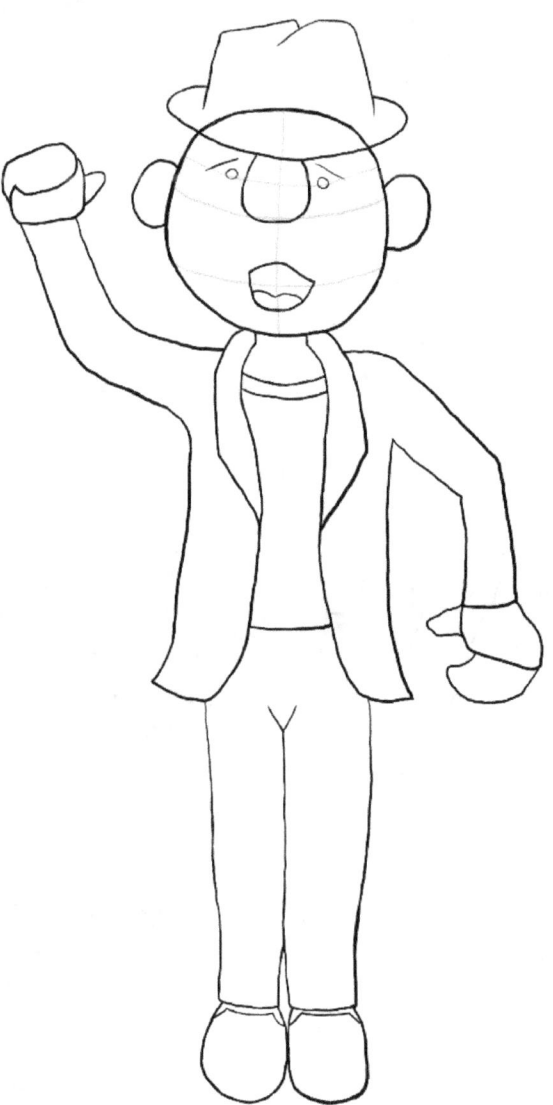

Step 7: Draw his mouth and tongue.

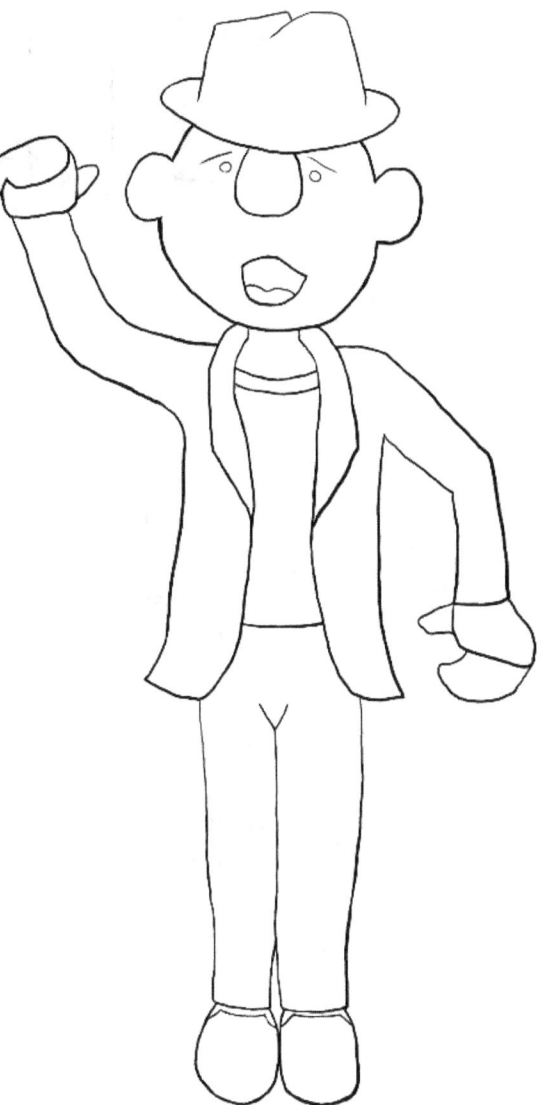

Step 8: Carefully erase the guidelines on his face.

Turn Simple Shapes into Cool Cartoons

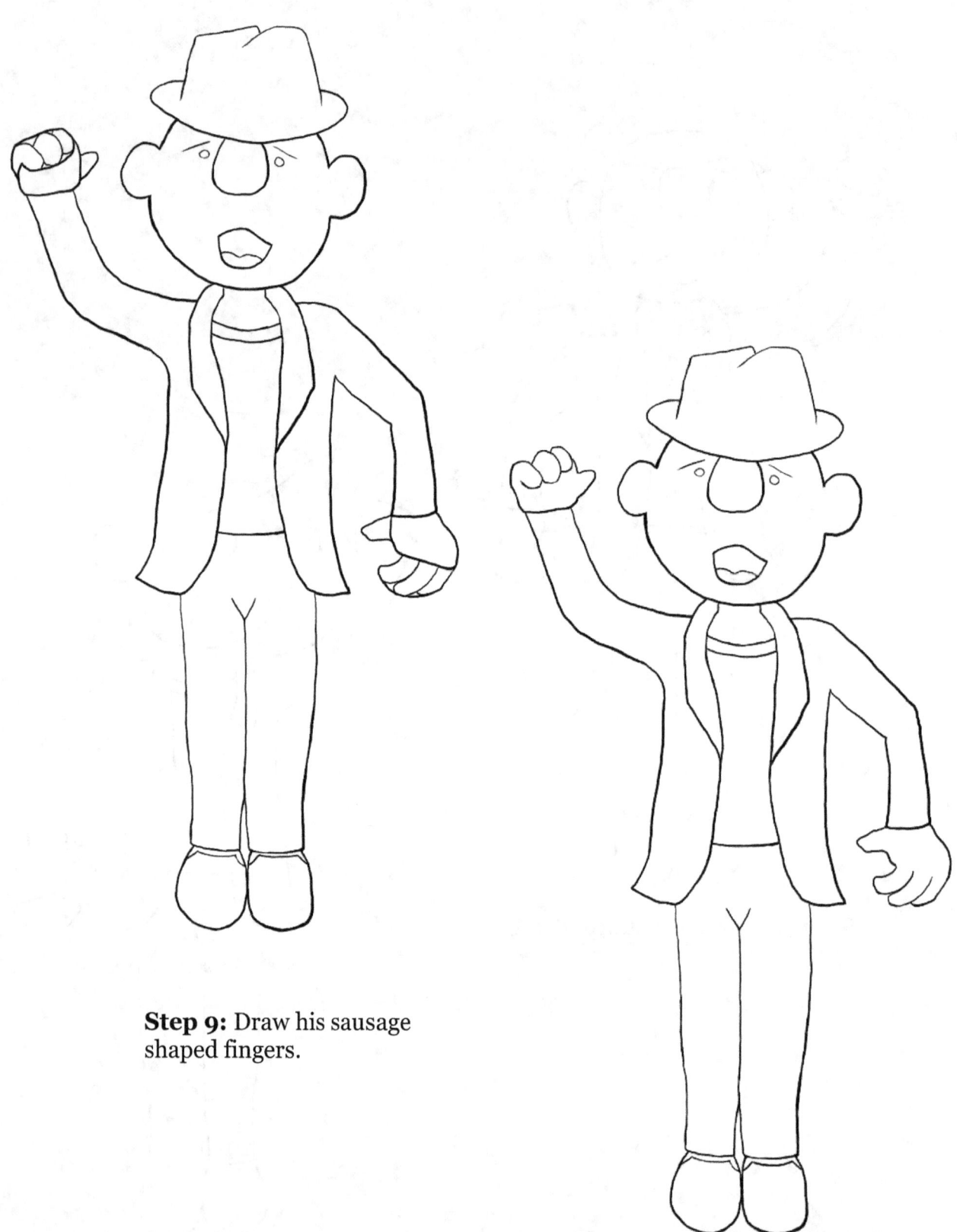

Step 9: Draw his sausage shaped fingers.

Step 10: Erase the stray marks around his fingertips and knuckles.

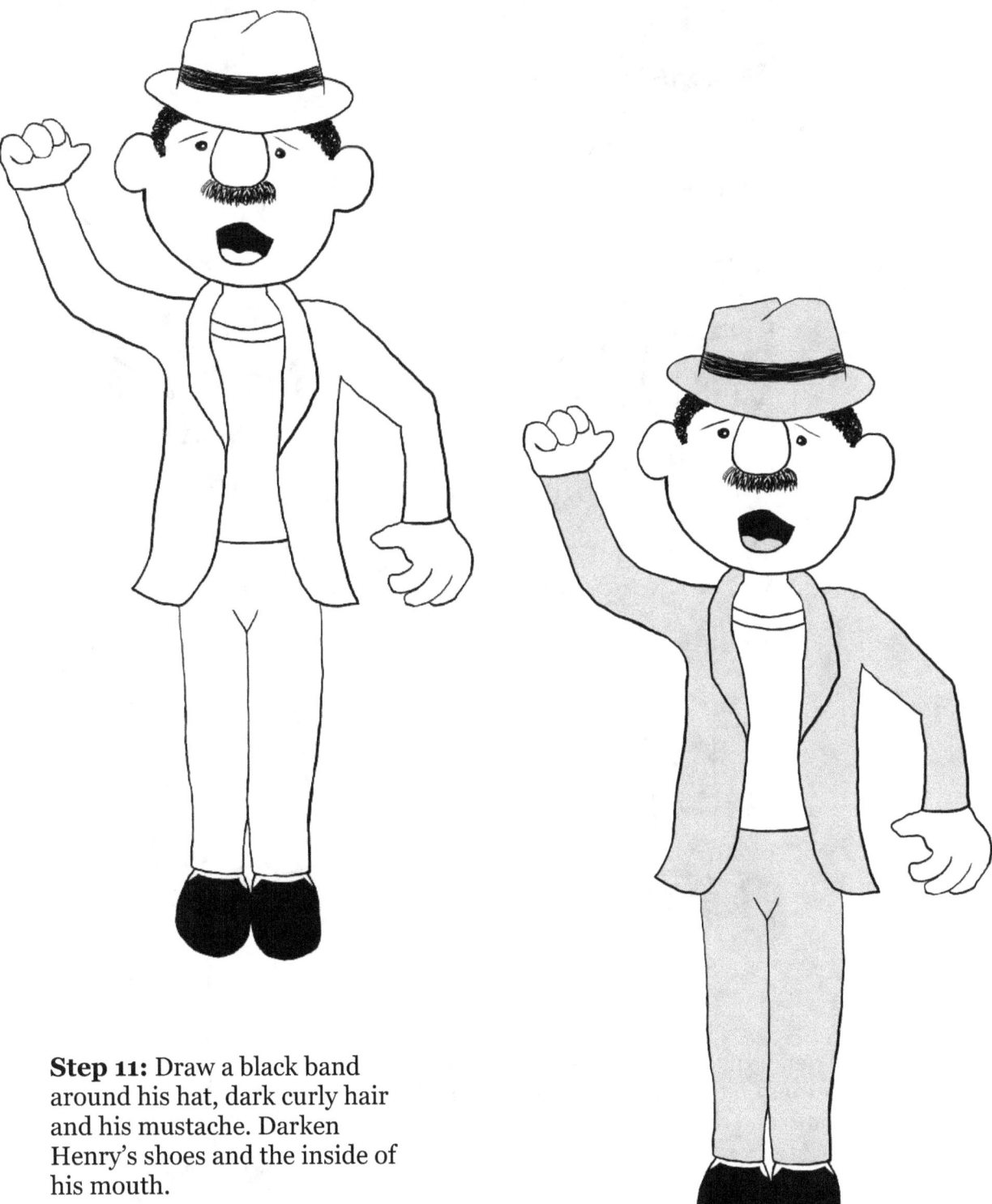

Step 11: Draw a black band around his hat, dark curly hair and his mustache. Darken Henry's shoes and the inside of his mouth.

Step 12: Now shade his hat, jacket, pants, and tongue with grey.

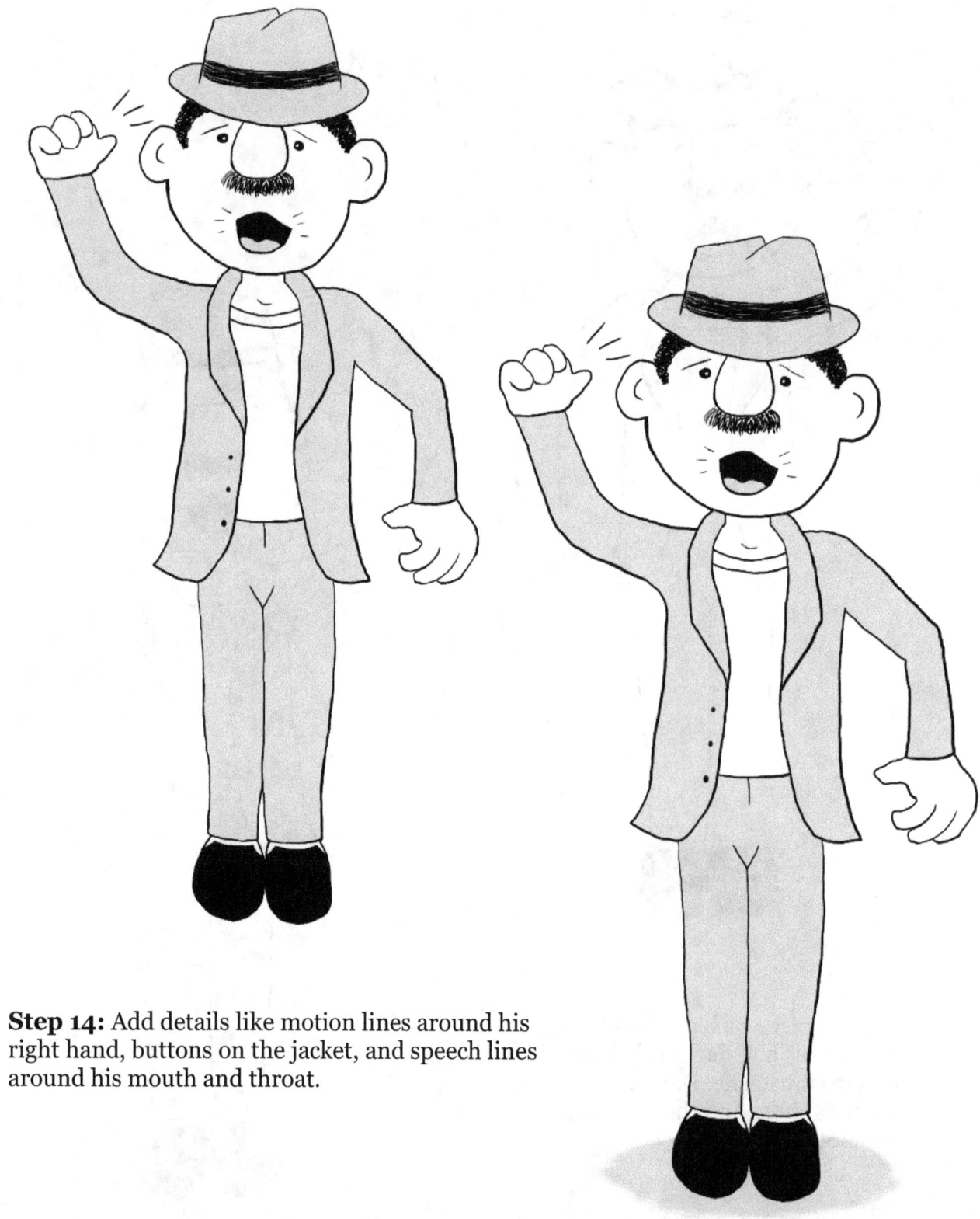

Step 14: Add details like motion lines around his right hand, buttons on the jacket, and speech lines around his mouth and throat.

Step 15: Finally, shade the ground underneath Henry's feet.

Singing Sara

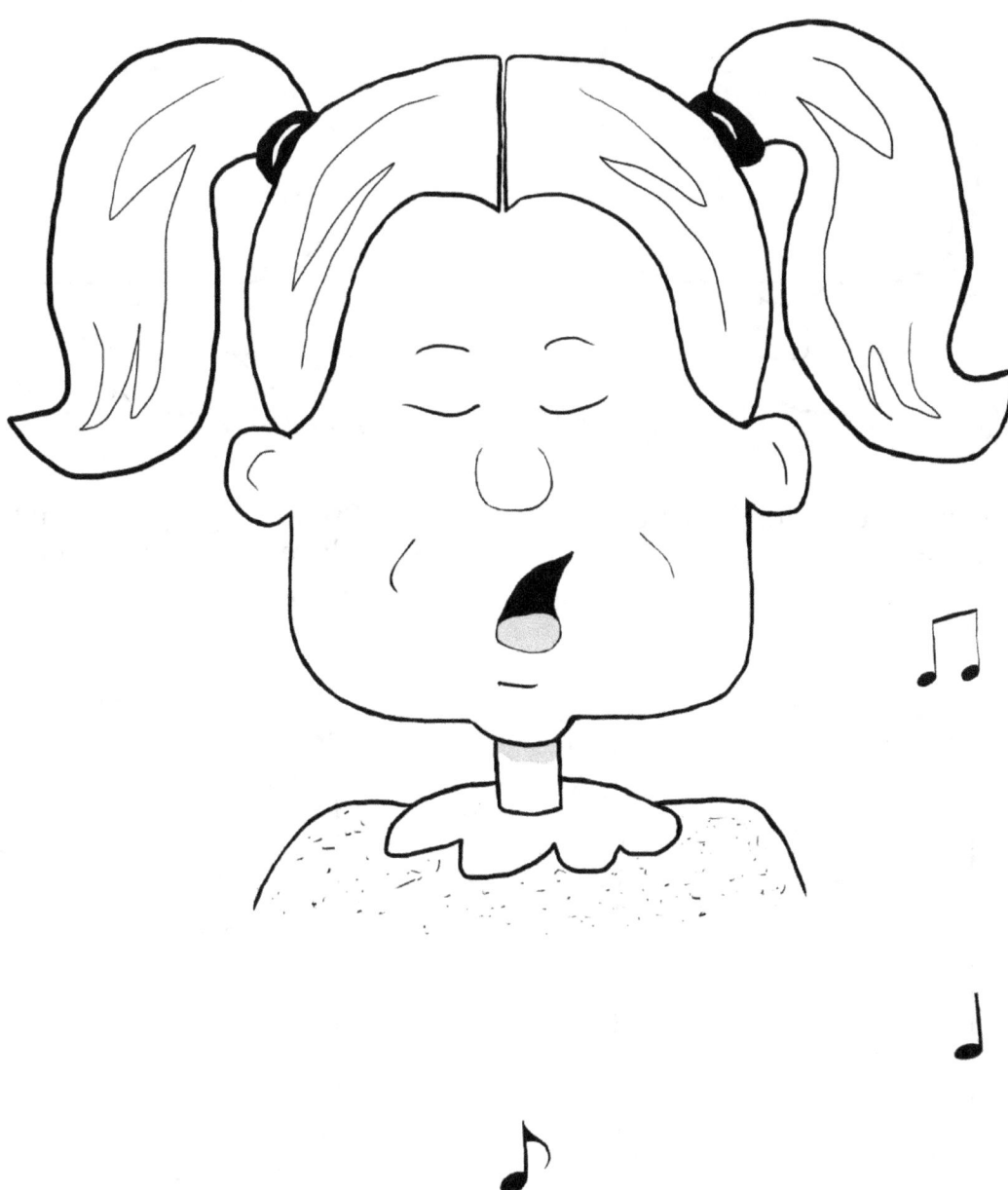

Step 1: Start with the basic shapes.

Step 2: Lightly draw guidelines where the eyes, nose, and mouth will go.

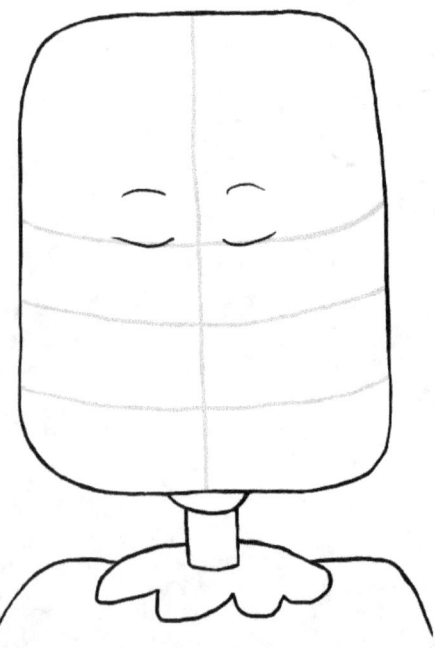

Step 3: Draw Sara's eyes.

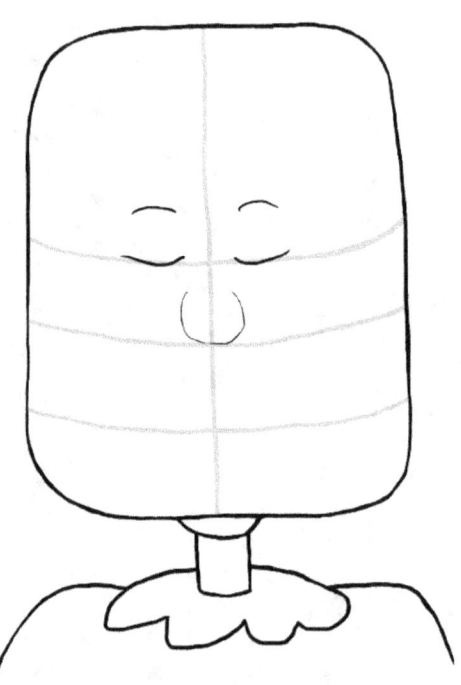

Step 4: Sketch her nose.

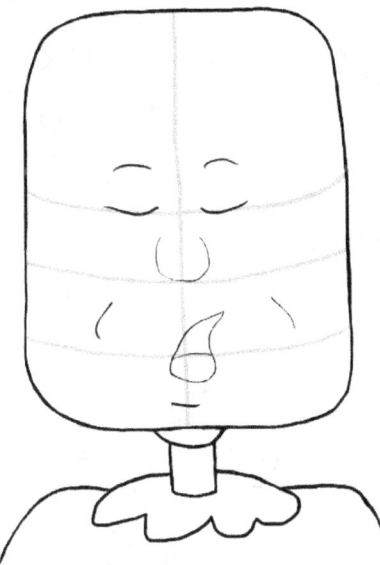

Step 5: Now draw her mouth and the facial lines around it.

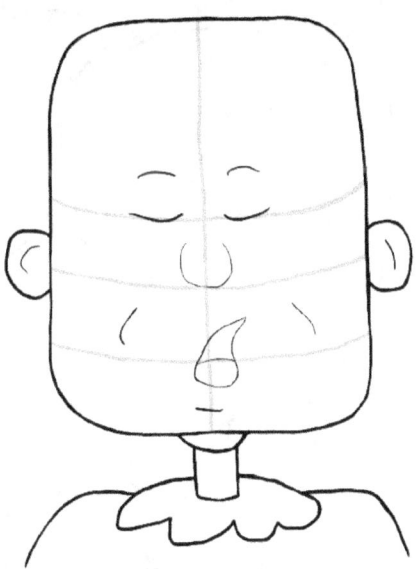

Step 6: Using the guidelines as a reference, draw the ears.

Step 7: Now carefully erase the guidelines and the lines that separate Sara's ears from her face.

Step 8: Sketch her hair.

Step 9: Erase the stray line that runs through her hair.

Step 10: Shade Sara's tongue and underneath her neck with grey.

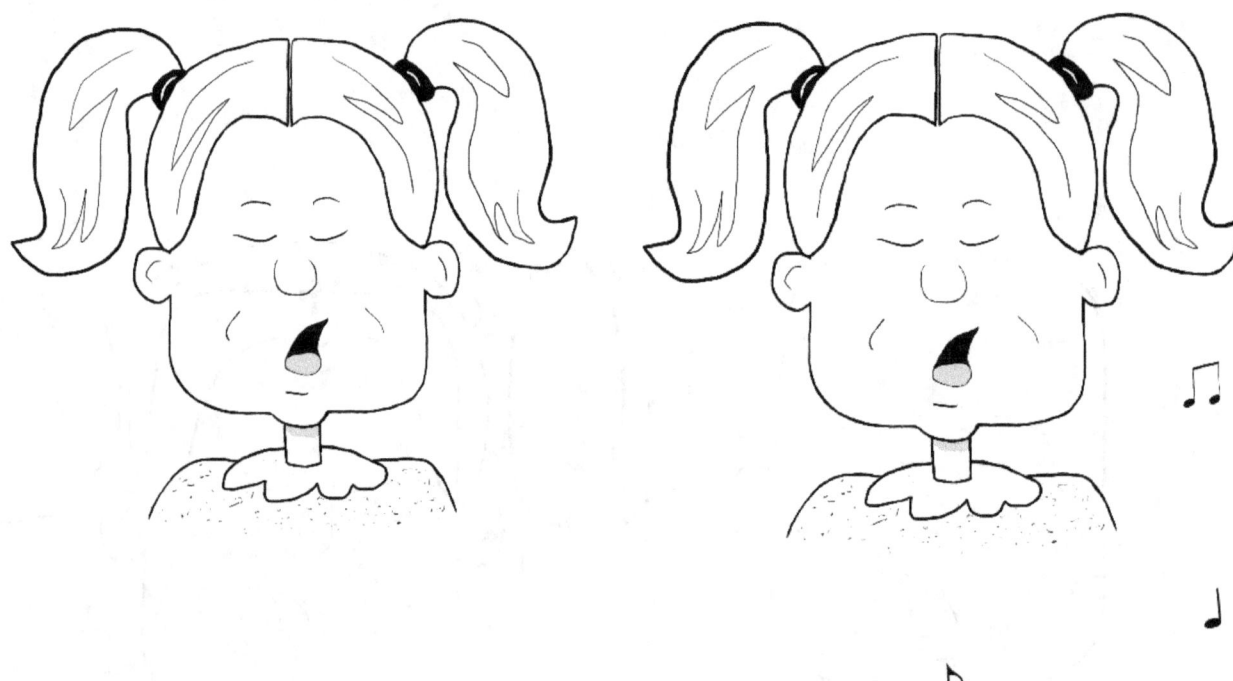

Step 11: Darken her mouth and the bands around her ponytails. Add detail lines to her hair. For texture on her shirt, use stippling. This is a technique done by tapping the point of your pencil on the paper to create a dot. Continue to create dots until the shirt is as dark as you'd like it.

Step 12: One last thing. Add some music notes to let the viewer know she's singing. I wonder if she takes requests.

Cici the Fortune Teller

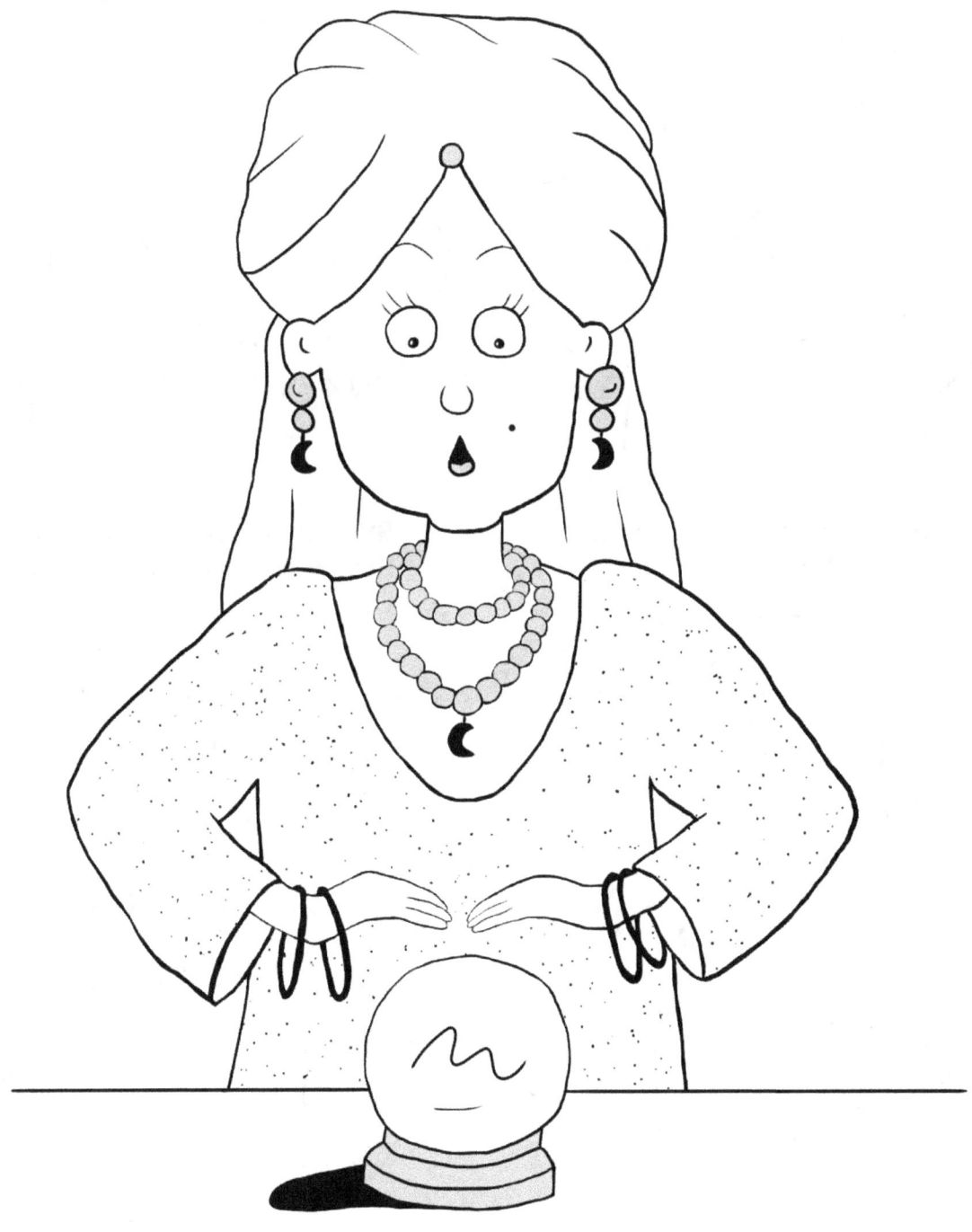

Turn Simple Shapes into Cool Cartoons

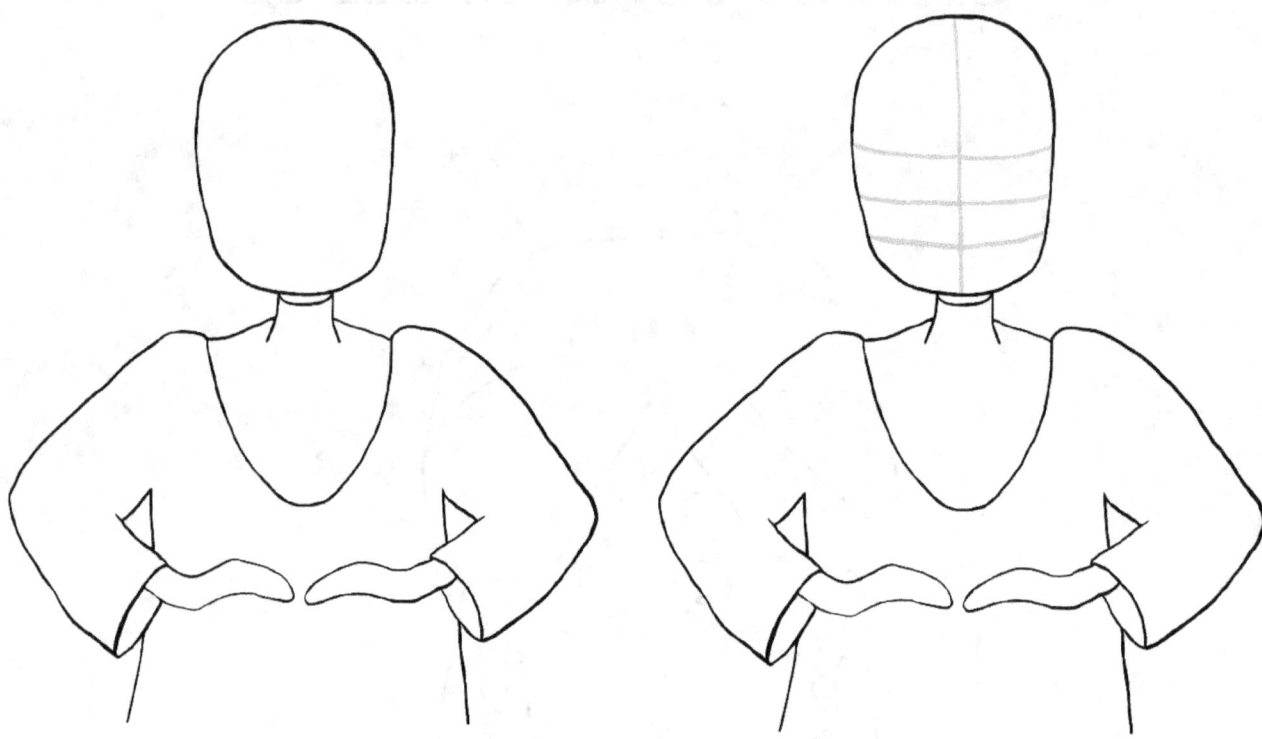

Step 1: Start with an outline and basic shapes.

Step 2: Lightly draw guidelines where the eyes, nose, and mouth will go.

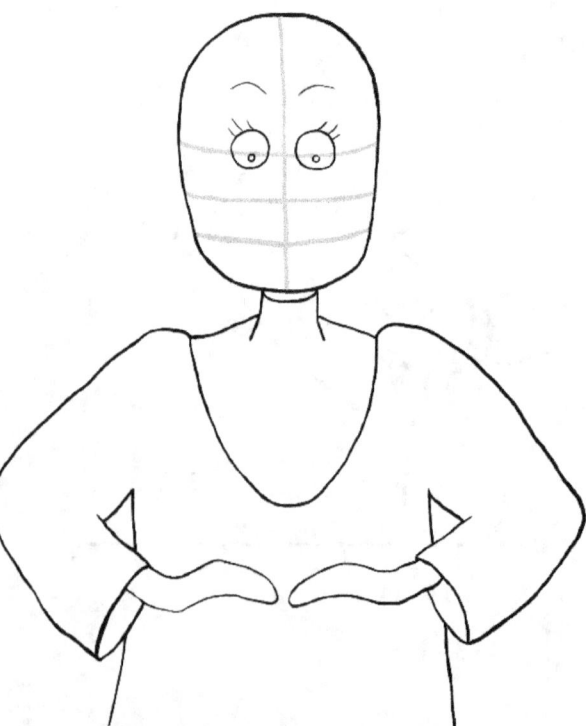

Step 3: Next, draw the eyes.

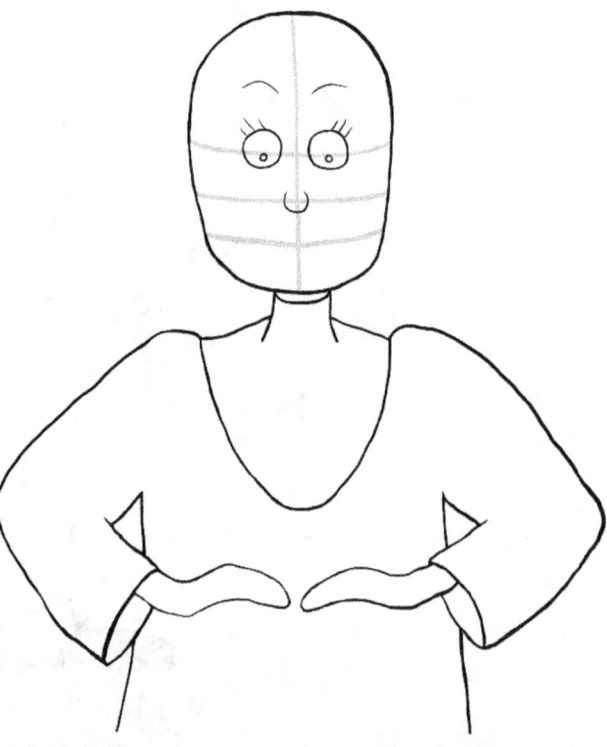

Step 4: Give Cici a button nose.

Step 5: Sketch her mouth.

Step 6: Draw her ears using the guidelines as a reference.

Step 7: Gently erase the guidelines.

Turn Simple Shapes into Cool Cartoons

Step 8: Draw the scarf on Cici's head.

Step 9: Erase the unneeded lines that run through her headscarf, ears, and chin.

Step 10: Add details to her headscarf and give her a beauty mark on her cheek.

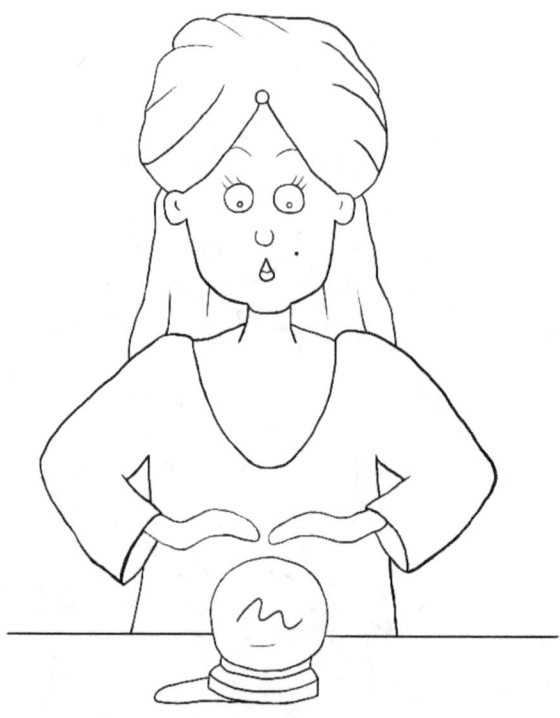

Step 11: Draw a horizontal line for the table and the crystal ball.

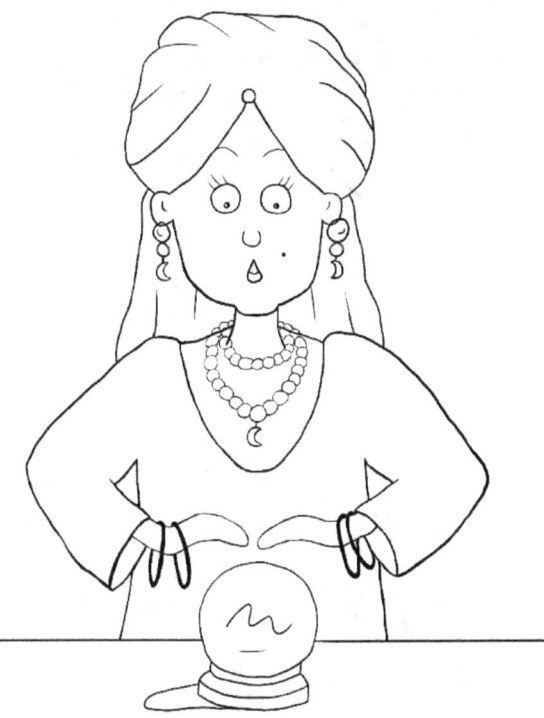

Step 12: Cici loves jewelry. So, let's give her some earrings, two necklaces and some bracelets.

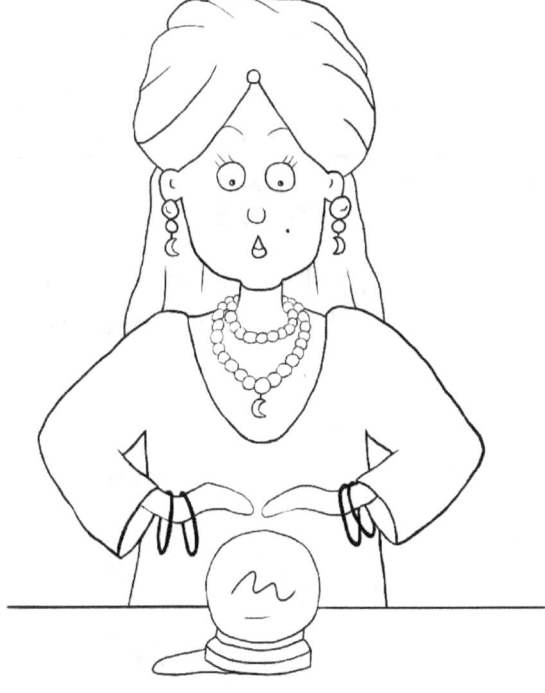

Step 13: Erase the ear lines that run through the earrings and shoulder lines that run through the necklace.

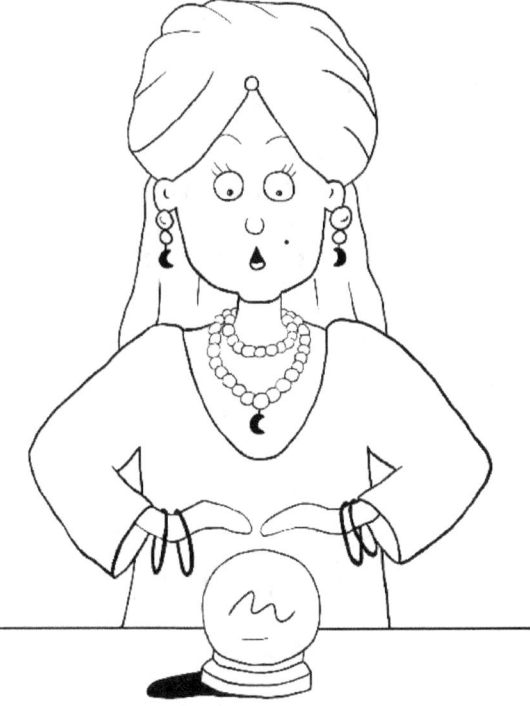

Step 14: Now darken her mouth and the moon shapes on her earrings, and necklace. Give the crystal ball a shadow.

Turn Simple Shapes into Cool Cartoons

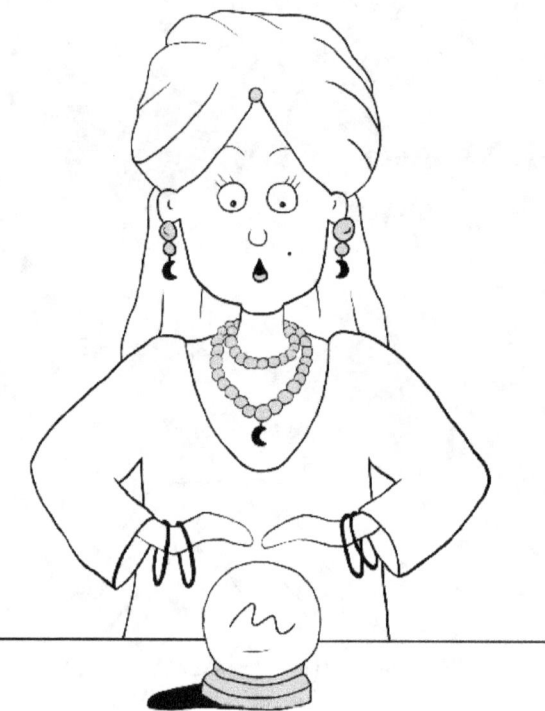

Step 15: Shade the jewelry and the bottom of the crystal ball grey.

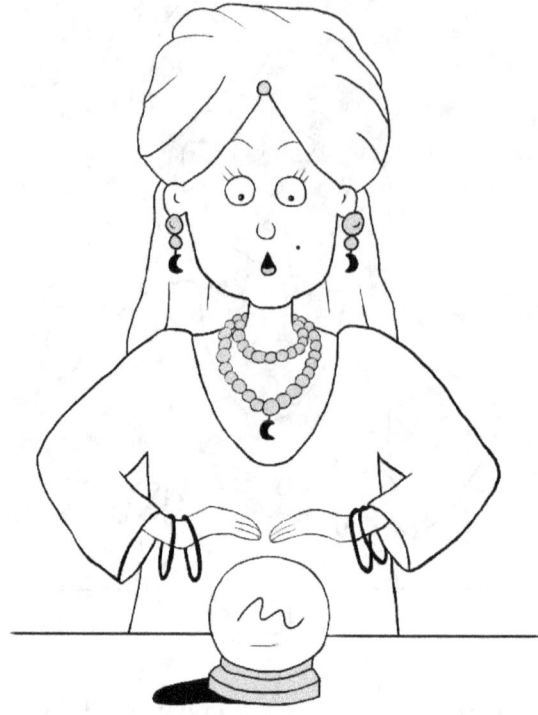

Step 16: Now draw her fingers.

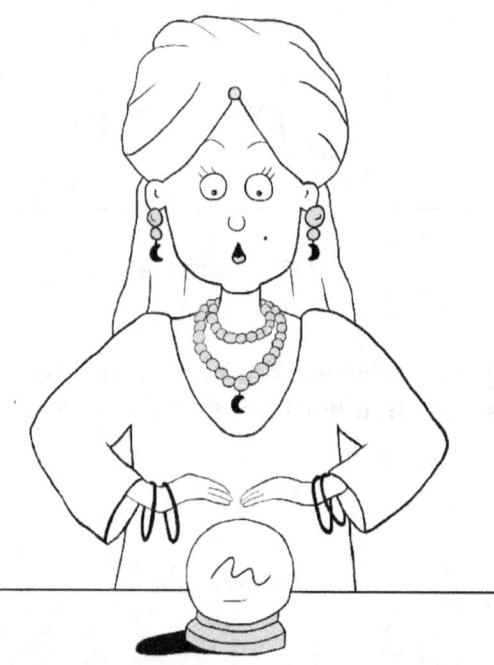

Step 17: Clean up the hands and erase any unwanted pencil lines.

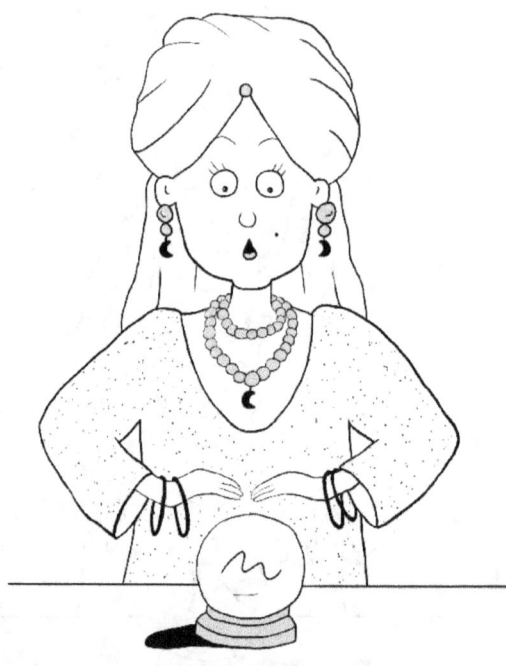

Step 18: Give her clothes some texture by taking the tip of your pencil and tapping the paper. This will create a dot. Continue placing dots on her clothes until your happy with the result. Cici is ready to predict the future.

Steamed Stan

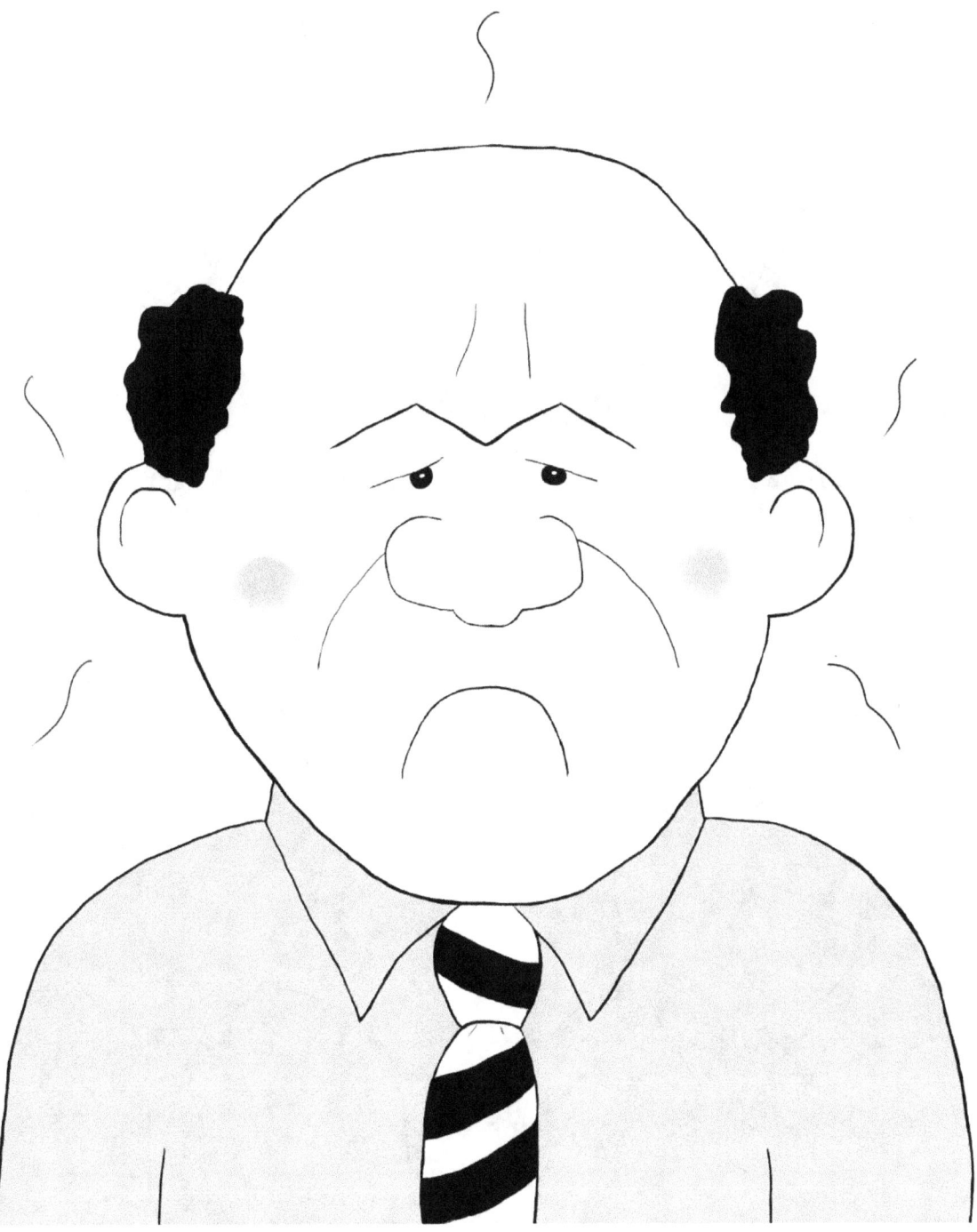

Turn Simple Shapes into Cool Cartoons

Step 1: Draw Stan's basic outline using simple shapes.

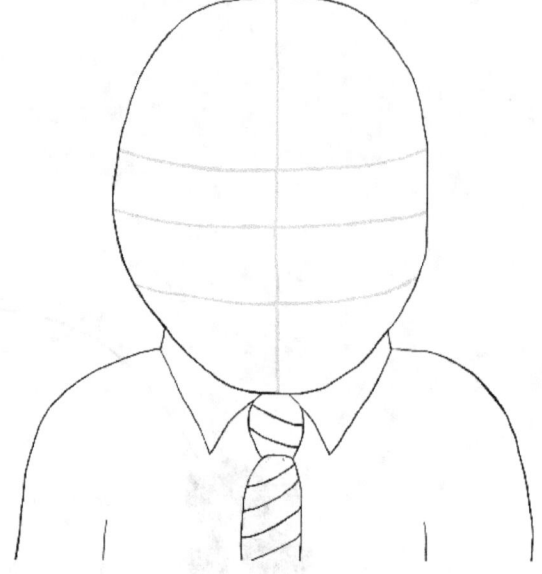

Step 2: Sketch light guidelines where you'd like Stan's eyes, nose, and mouth to go.

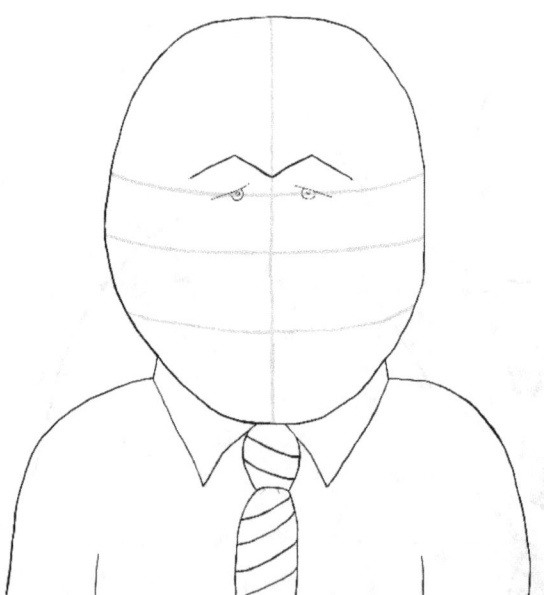

Step 3: Now draw the eyes.

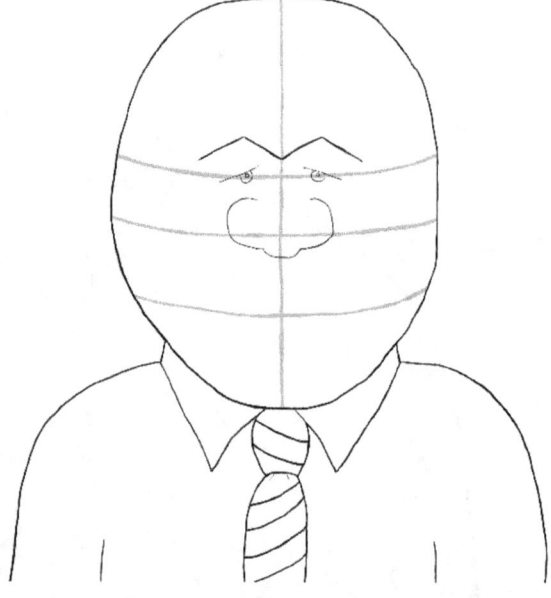

Step 4: Give Stan a big nose.

Turn Simple Shapes into Cool Cartoons

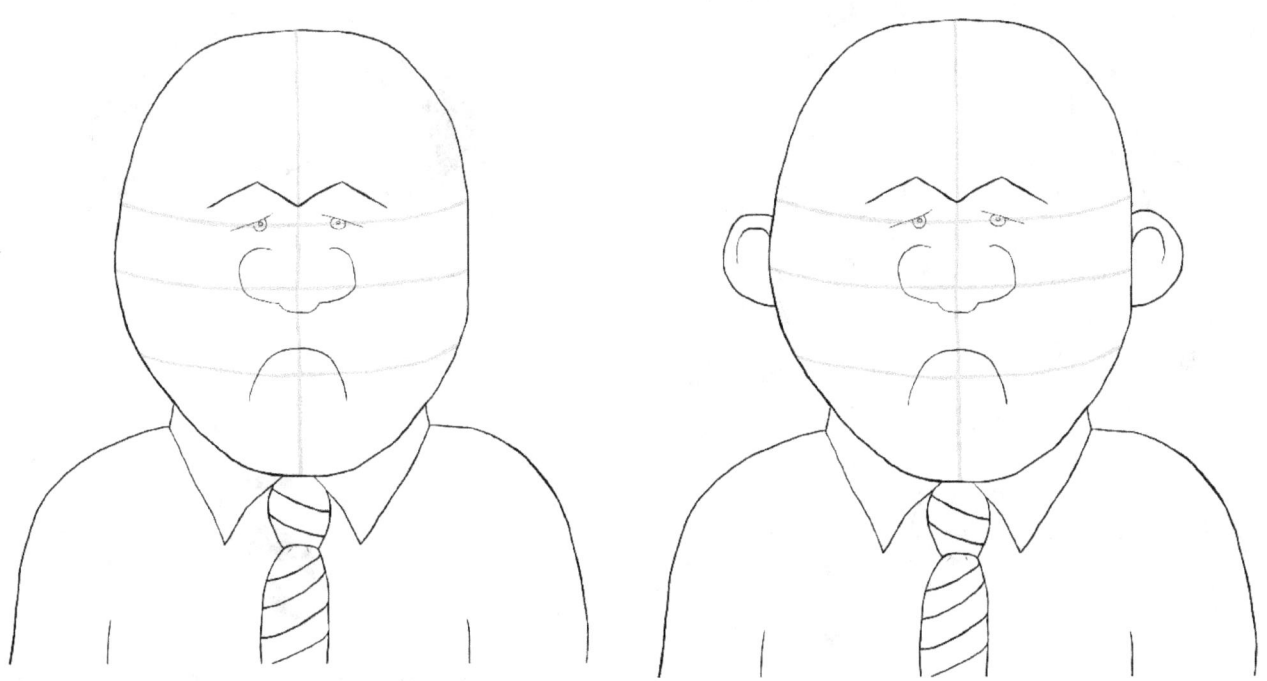

Step 5: Sketch a grumpy mouth.

Step 6: Now draw his ears.

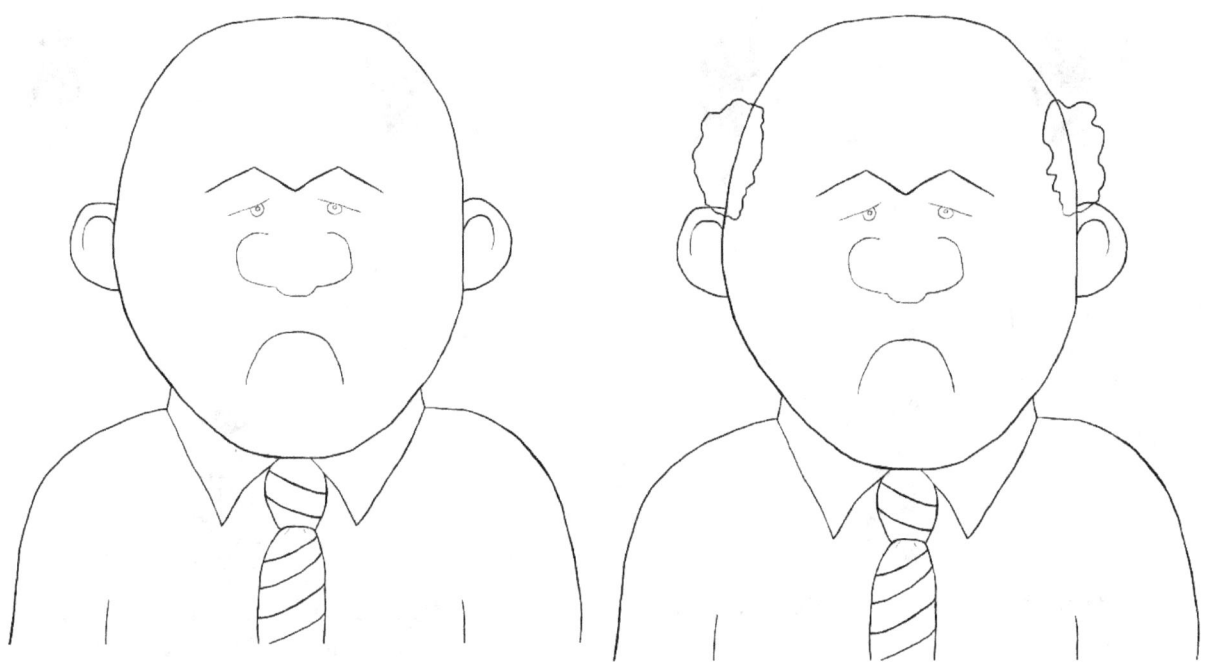

Step 7: Erase the guidelines.

Step 8: Draw Stans hair.

Turn Simple Shapes into Cool Cartoons

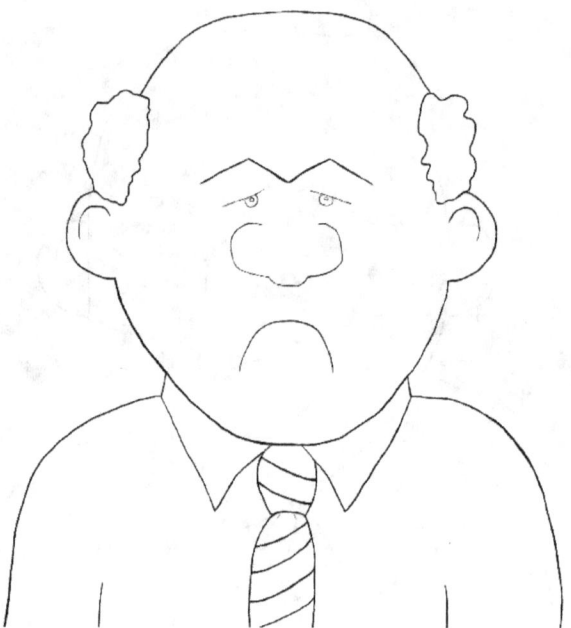

Step 9: Erase the unwanted lines that run through his hair.

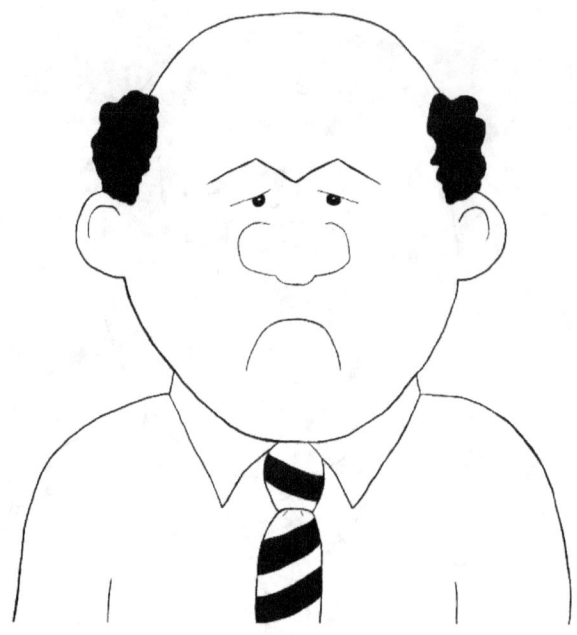

Step 10: Now darken in his hair and the stripes on his tie.

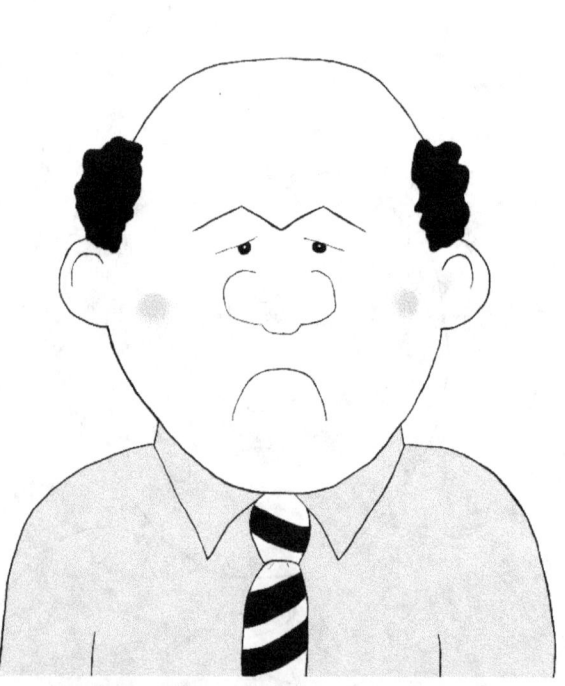

Step 11: Shade in Stan's shirt and cheeks with grey.

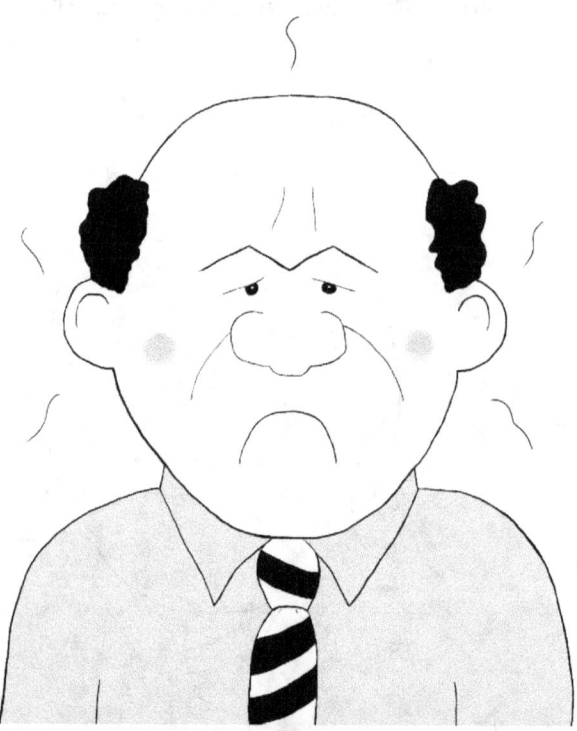

Step 12: Add scowl lines on his cheeks, and forehead. Draw wrinkles on Stan's cheeks, and steam coming from his head. He's not a happy camper.

Turn Simple Shapes into Cool Cartoons

Messy Mike

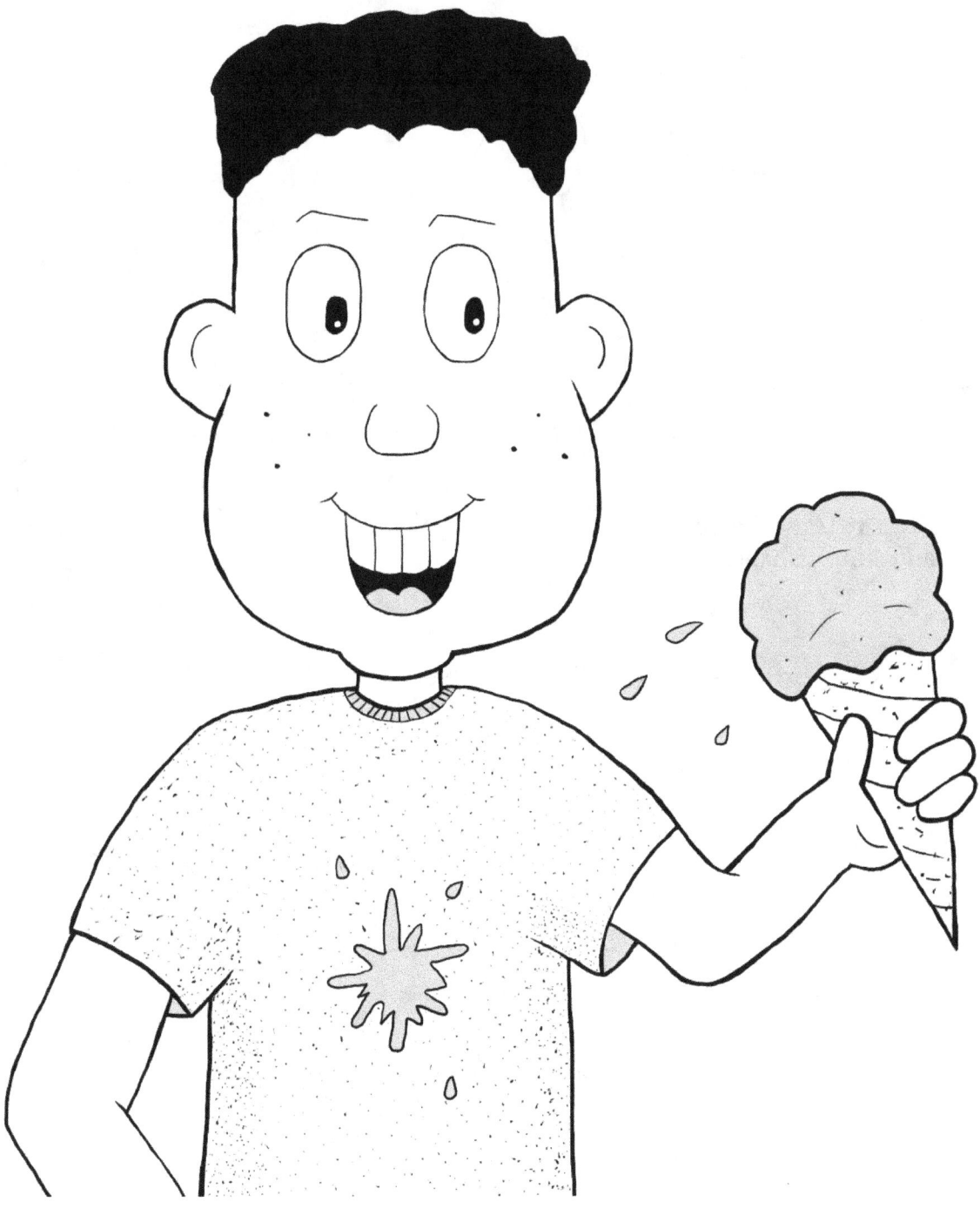

Turn Simple Shapes into Cool Cartoons

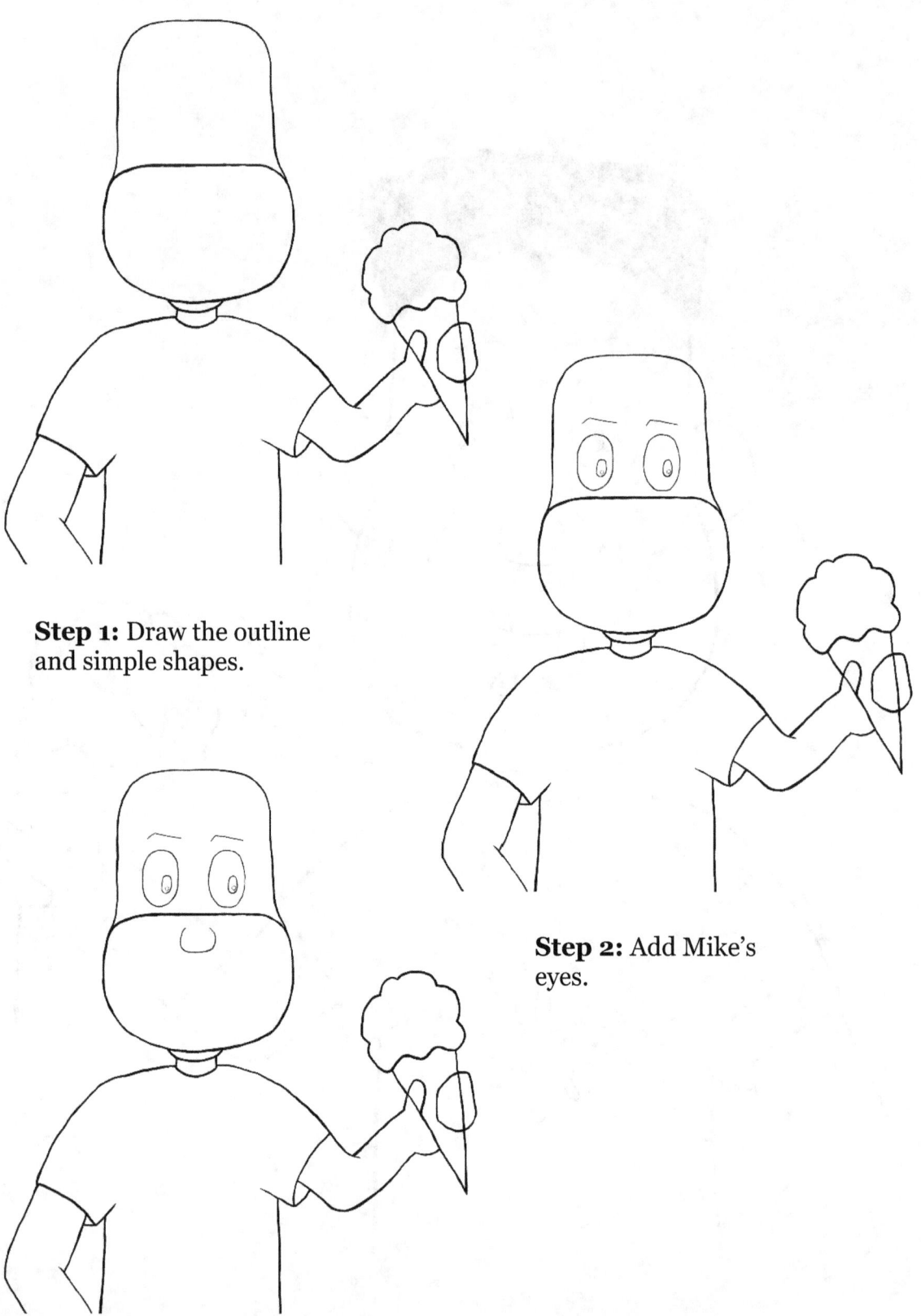

Step 1: Draw the outline and simple shapes.

Step 2: Add Mike's eyes.

Step 3: Sketch his nose.

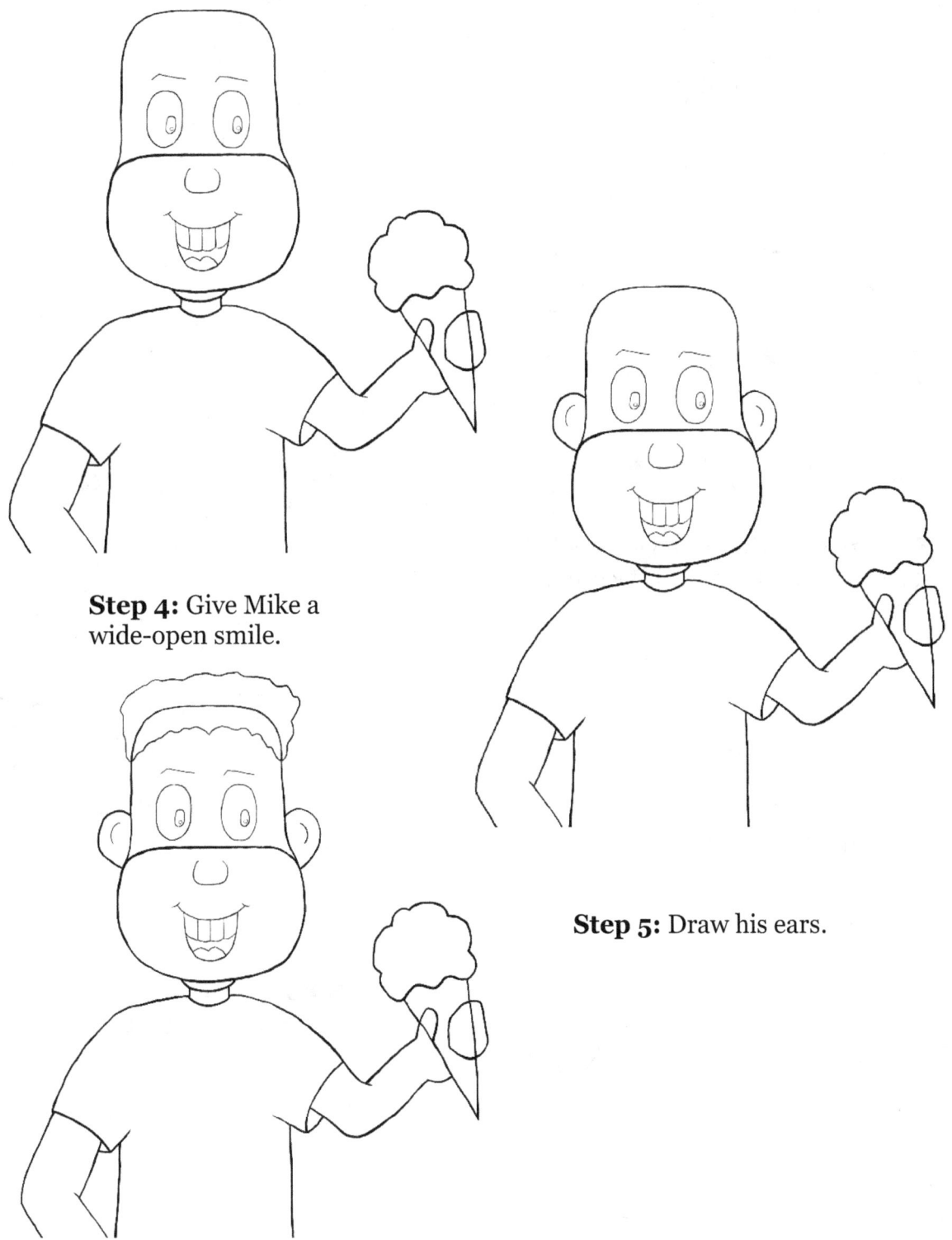

Step 4: Give Mike a wide-open smile.

Step 5: Draw his ears.

Step 6: Next draw Mike's hair.

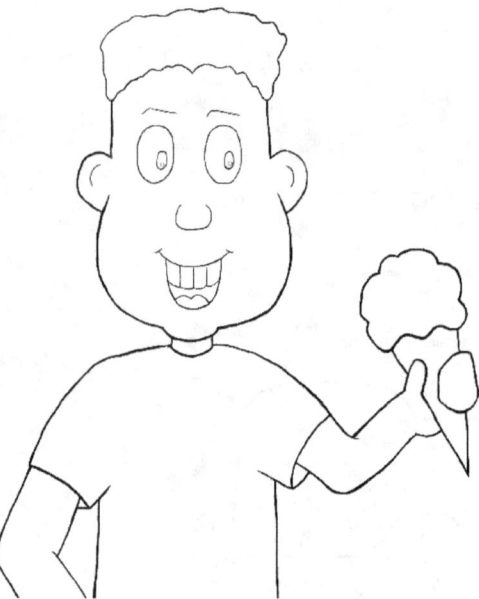

Step 7: Erase the no-longer-needed lines that run through his face and hair.

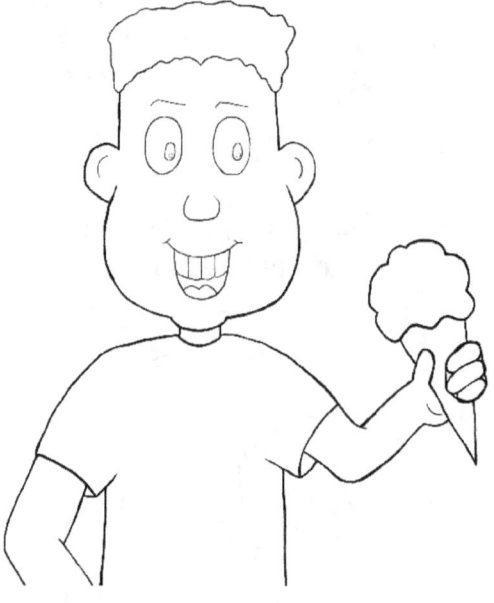

Step 8: Now add his sausage-shaped fingers.

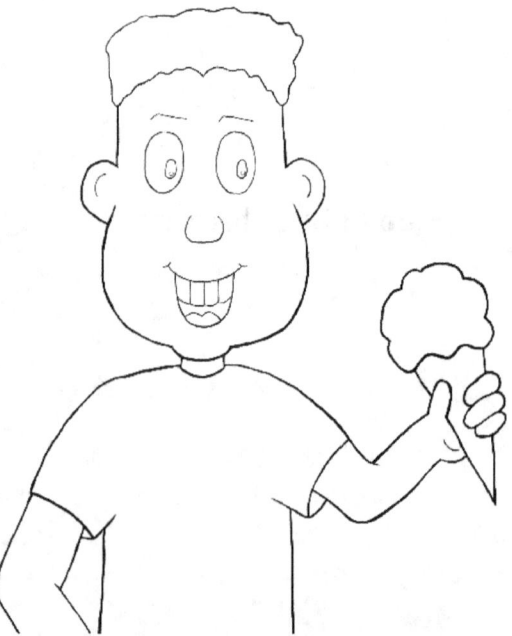

Step 9: Erase the unwanted lines at the tip of his fingers and knuckles. This will separate his fingers.

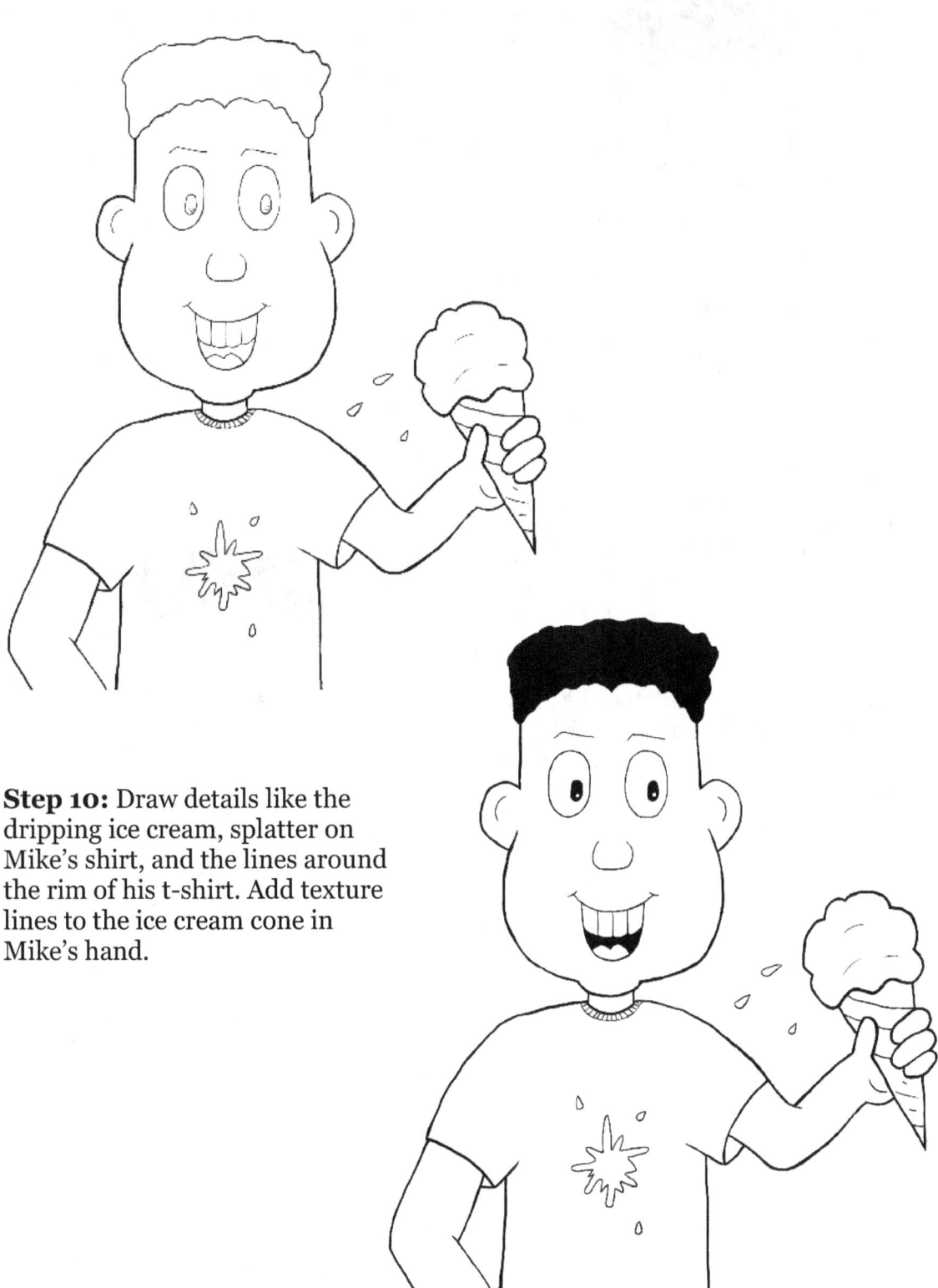

Step 10: Draw details like the dripping ice cream, splatter on Mike's shirt, and the lines around the rim of his t-shirt. Add texture lines to the ice cream cone in Mike's hand.

Step 11: Darken his eyes, hair, and mouth.

Turn Simple Shapes into Cool Cartoons

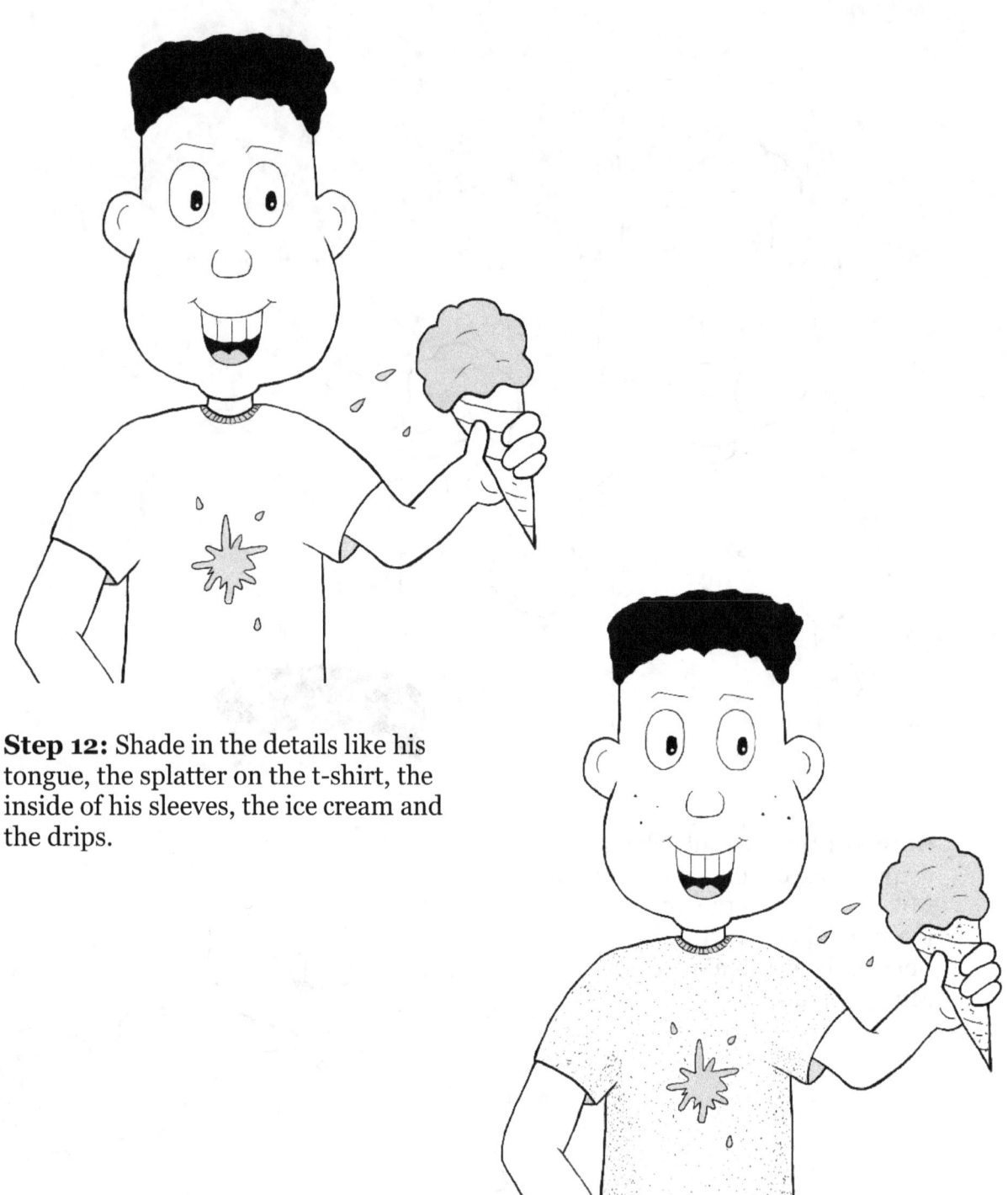

Step 12: Shade in the details like his tongue, the splatter on the t-shirt, the inside of his sleeves, the ice cream and the drips.

Step 13: To give the t-shirt texture, just take the point of your pencil and tap it on the paper. Continue tapping until you've covered the t-shirt with dots. You can make an area darker by placing dots closer together and lighter by placing them further apart. You're done all that work and he's not sharing any ice cream.

A FINAL WORD...or two

Keep Drawing

www.ingramcontent.com/pod-product-compliance
Lightning Source LLC
Chambersburg PA
CBHW080551220526
45466CB00010B/3117